P9-DFV-417

How To Draw And Paint
DRAGONS

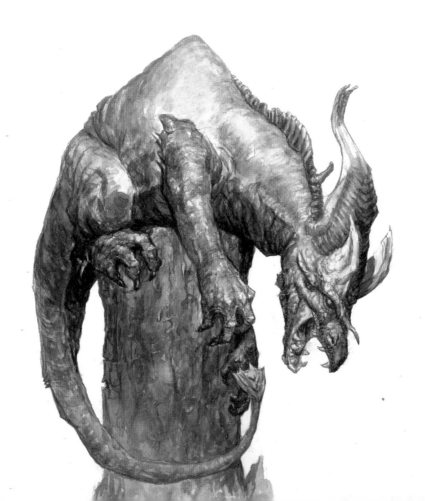

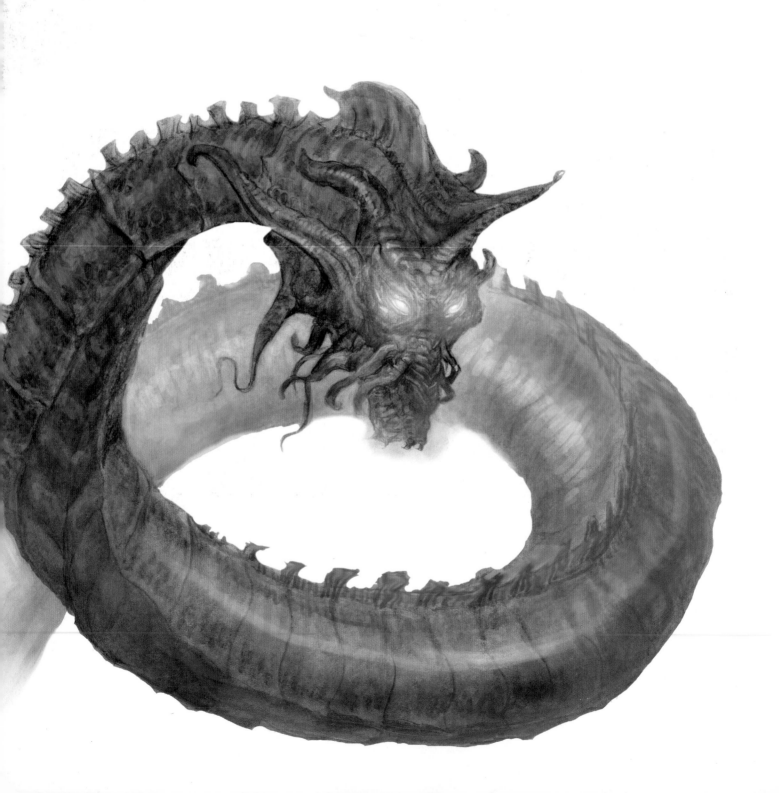

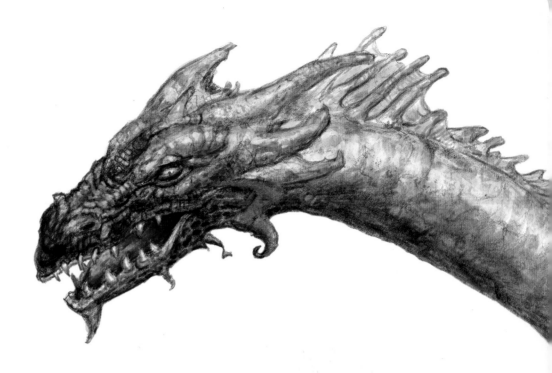

HOW TO DRAW AND PAINT

DRAGONS

*A complete course built around
these legendary beasts*

TOM KIDD

BARRON'S

A QUARTO BOOK

First edition for North America
published in 2010 by
Barron's Educational Series, Inc.

Copyright © 2010 Quarto Inc.

All rights reserved.
No part of this book may be reproduced
or distributed in any form or by any means
without the written permission of the
copyright owner.

All inquiries should be addressed to:
Barron's Educational Series, Inc.
250 Wireless Boulevard
Hauppauge, New York 11788
www.barronseduc.com

Library of Congress Control No.:
2009938373
ISBN-13: 978-0-7641-4386-1
ISBN-10: 0-7641-4386-7

QUAR.DPD

Conceived, designed, and produced by
Quarto Publishing plc
The Old Brewery
6 Blundell Street
London N7 9BH

Project Editor: Emma Poulter
Art Editor: Emma Clayton
Designer: Karin Skånberg
Design Assistant: Saffron Stocker
Picture Researcher: Sarah Bell
Copyeditor: Claire Waite Brown
Proofreader: Clare Hubbard
Indexer: Dorothy Frame
Art Director: Caroline Guest

Creative Director: Moira Clinch
Publisher: Paul Carslake

Color separation by
PICA Digital Pte Ltd, Singapore
Printed in Singapore by
Star Standard Industries (Pte) Ltd

9 8 7 6 5 4 3 2 1

CONTENTS

Foreword

The dragon is certainly a mythical creature. There are no dragons on Earth, but my intention with this book is to teach you how to paint them in a way that they seem to live and breathe—fire.

The greatest fun you can have with art is making things up using your imagination. It seems like an easy task, but doing it well is actually more difficult than copying something. Think about it—a test would be a whole lot easier if you were allowed to refer to a textbook when you took it. Painting or drawing something in front of you is like an open-book test. You can certainly learn a lot from drawing or painting from life, but once you've built yourself a visual library, one in your very own head, it's time to start making new things from those great volumes of information. My job here is to teach you a structure you can build on infinitely. The basics of creating dragons are the basics for inventing any creature and, more generally, for any kind of imaginative art.

The world we live in today is filled with digital cameras. You can take millions of photographs of everything you see, and find on the Internet a picture of just about everything on the planet and within the solar system. However, taking a picture doesn't give you an understanding of something. The only way to understand something well is to draw or paint it. (Future doctors, inventors, architects, and scientists should take note.) There are literal and physical levels of understanding. To create dragons, you'll need to explore all levels.

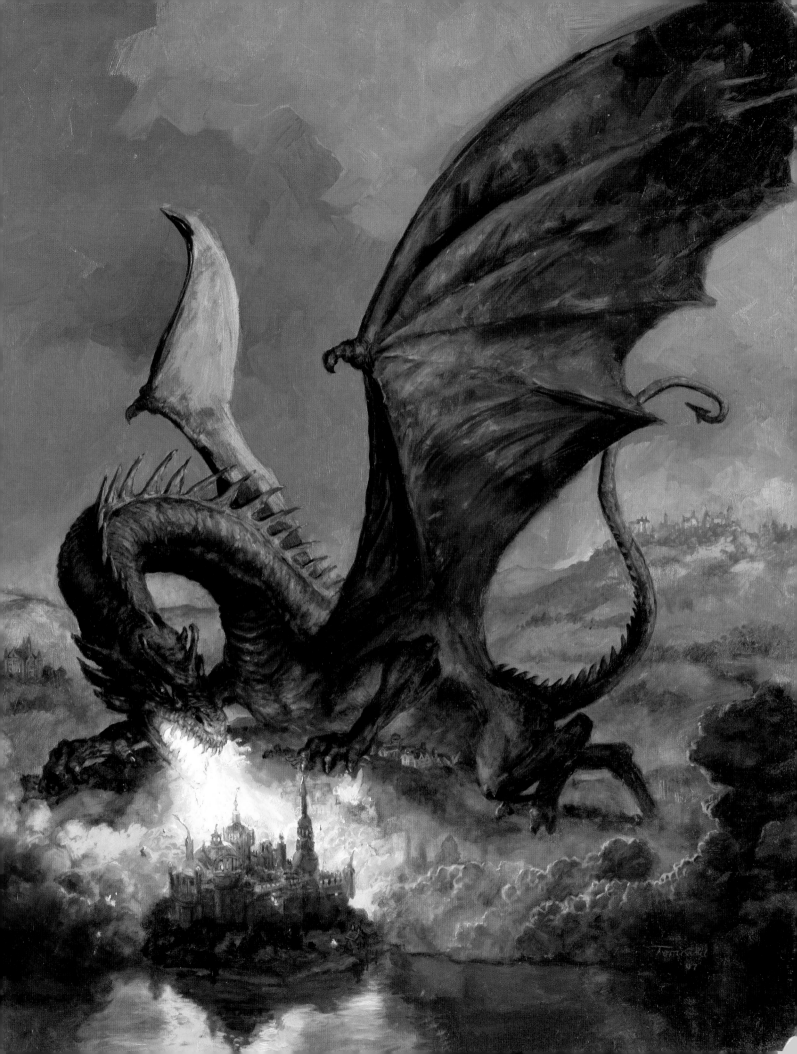

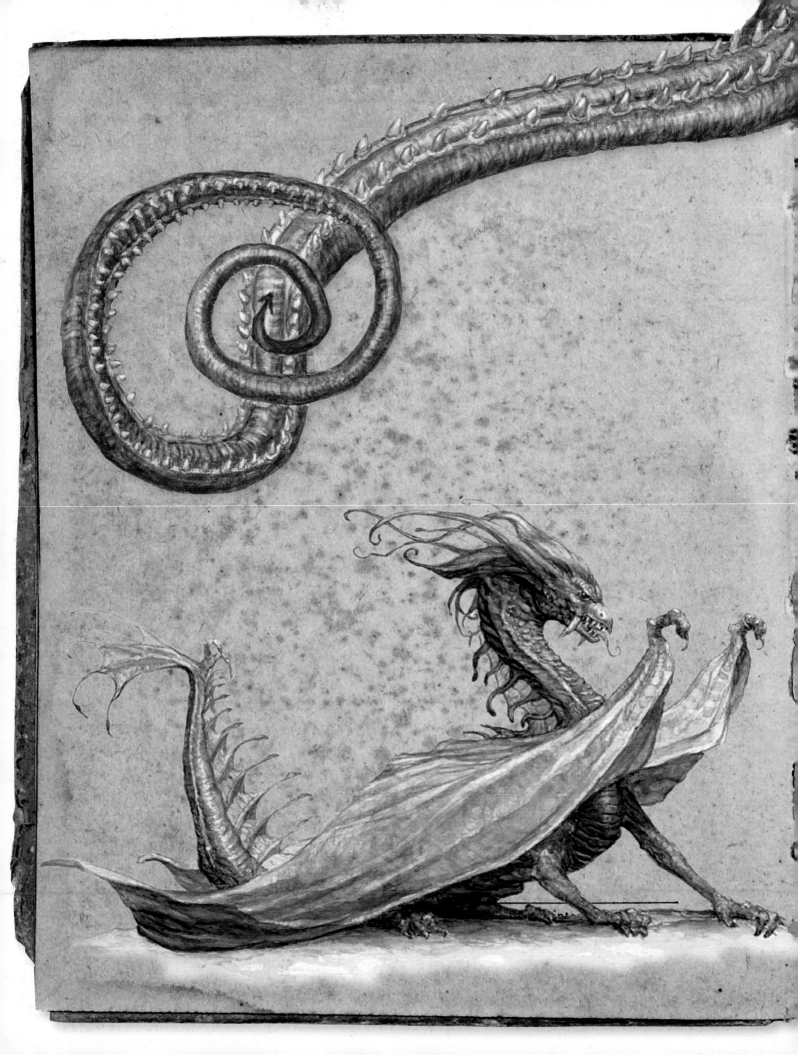

DRAGON ANATOMY

A dragon is much more than the sum of its parts; however, studying those parts separately will help you understand how dragons are structured.

There is a wide range of creatures that fall into the dragon category. Clearly they can't all be members of the same species; the variances between them are too great. Mythology pays little attention to science, but fantasy artists are entrusted with making mythological creatures plausible, and you will find this section integral to that purpose.

Within this section are your tools for invention—basic dragon structure inside and out. Once you know this, you'll be able to draw a variety of expressive dragons doing anything you'd like. I also encourage you to draw your own unique dragon skeletons and build your own dragon muscle and skin.

HEAD AND FACE

A dragon's face has two basic moving parts, the jaw and the eyes. Dragons tend to have a heavy brow, a jaw that opens wide, and the sharp teeth of a predator. Eyes can be placed almost anywhere on the dragon's head, as long as space is allowed for a powerful jaw. Within these parameters, there can be great variation in the look of a dragon's head.

In general, a dragon's head can look like that of a lizard, a horse, or even a lion. Combining various forms will make your dragon more dangerous or more regal. The key to combining forms is best left to your memory, rather than going by reference, because the mind will tend to meld the pieces together in a pleasing, natural manner. When drawing, imagine the skull as a solid structure composed of a series of planes, and you'll do well.

Expression

A dragon's personality manifests itself in its face, so you should give your dragons expressive faces. There is a wealth of personality traits that can be applied. In literature you will find many stories about very clever dragons. If you're making a sentient dragon, its face must show intelligence. The best way to do this is to give the dragon a humanlike expression; for example, by including a raised eyebrow, a kind smile, or a thoughtful gesture. Similarly, an aggressive dragon will need to show its fangs.

The color studies on these pages were done digitally. While not quite as intimate as watercolor, digital work does allow you to change colors, values, and textures easily. You can paint and import textures or portions of paintings (see Working with digital media, pages 64–67).

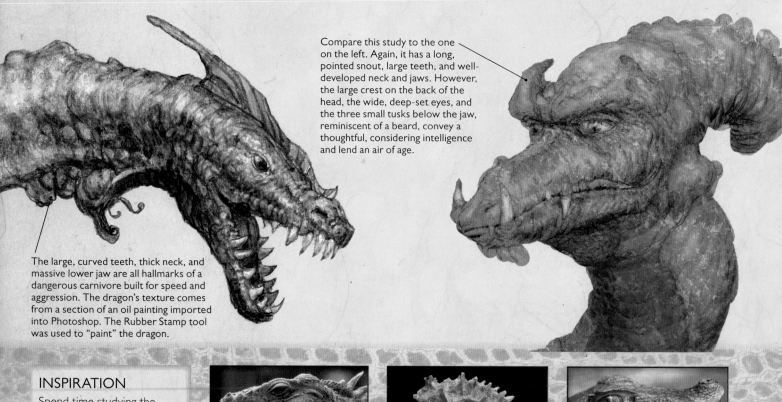

Compare this study to the one on the left. Again, it has a long, pointed snout, large teeth, and well-developed neck and jaws. However, the large crest on the back of the head, the wide, deep-set eyes, and the three small tusks below the jaw, reminiscent of a beard, convey a thoughtful, considering intelligence and lend an air of age.

The large, curved teeth, thick neck, and massive lower jaw are all hallmarks of a dangerous carnivore built for speed and aggression. The dragon's texture comes from a section of an oil painting imported into Photoshop. The Rubber Stamp tool was used to "paint" the dragon.

INSPIRATION

Spend time studying the vast variety of head shapes present in the animal kingdom. Note where jaw hinges appear and the array of expressions revealed by different creatures.

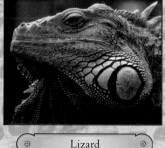

Lizard

Sea horse

Alligator

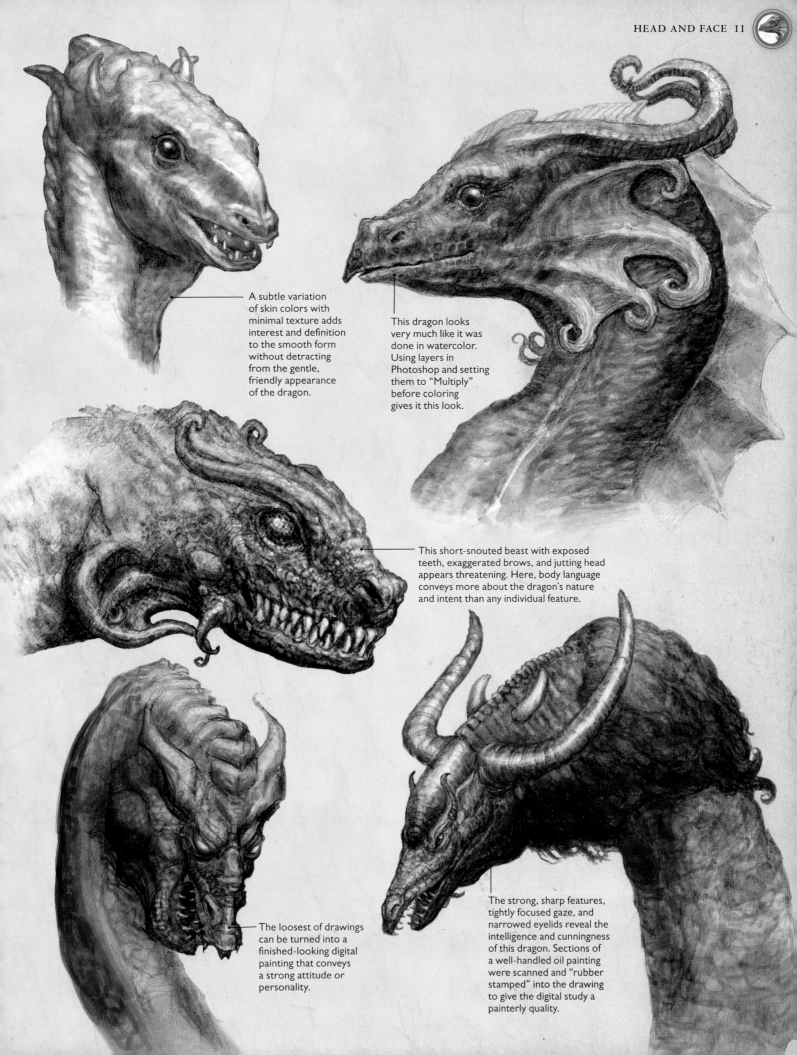

A subtle variation of skin colors with minimal texture adds interest and definition to the smooth form without detracting from the gentle, friendly appearance of the dragon.

This dragon looks very much like it was done in watercolor. Using layers in Photoshop and setting them to "Multiply" before coloring gives it this look.

This short-snouted beast with exposed teeth, exaggerated brows, and jutting head appears threatening. Here, body language conveys more about the dragon's nature and intent than any individual feature.

The loosest of drawings can be turned into a finished-looking digital painting that conveys a strong attitude or personality.

The strong, sharp features, tightly focused gaze, and narrowed eyelids reveal the intelligence and cunningness of this dragon. Sections of a well-handled oil painting were scanned and "rubber stamped" into the drawing to give the digital study a painterly quality.

EYES

A dragon's eyes can take on many forms. They can range from small to large, from insect to reptile to mammal, and may appear anywhere on the dragon's skull. It's not even required that a dragon has two eyes; you can make it have as many as you want. The only real requirement is that the dragon has to look like a dragon.

The face of a dragon can be composed of the faces of many animals. If you take the time to study a variety of animals, you'll find that the features in their faces, particularly the eyes, come naturally to you as you draw a dragon. Those forms mix and match in the imaginative part of your mind. But first you have to study them, and the best way to do that is to draw them. Ultimately, your observing eye is the key to making effective and interesting dragons.

Eye placement

An animal that is a hunter tends to have eyes that face forward for the sake of binocular vision. With dragons, however, this is not a solid rule, so you can place your dragon's eyes where you feel they look best. It's standard practice to put the dragon's eyes on the sides of the skull, but you can place them in between the front and the sides.

To place a dragon into a specific environment, you need to have a plausible explanation for the form and for its purpose. A good example of interesting eye placement is that of the crocodile. Its eyes are positioned on top of its head because it lurks beneath the water waiting for its prey to come near.

The color studies on these pages were done in watercolor over a pencil drawing. Watercolors' natural properties create texture, subtlety, variation, and a strong cohesiveness. Different types of paper, from hot pressed to cold pressed, will accentuate or minimize these effects, giving you an even wider range of effects.

The large, insect-like eyes give this dragon an alien quality. The forward thrust of the head and the beak-like snout emphasizes the forward direction of the eyes and conveys the dragon's predatory nature.

Your dragon can take on the characteristics of different animals. This dragon resembles an alligator, but his big eyes and heavy lids make him seem devilishly clever like a fox.

INSPIRATION

Draw your inspiration from nature, reference books, and the Internet. With thorough research, you'll hit upon the right eye shape and eye color for your dragon.

Fly

Fish

Frog

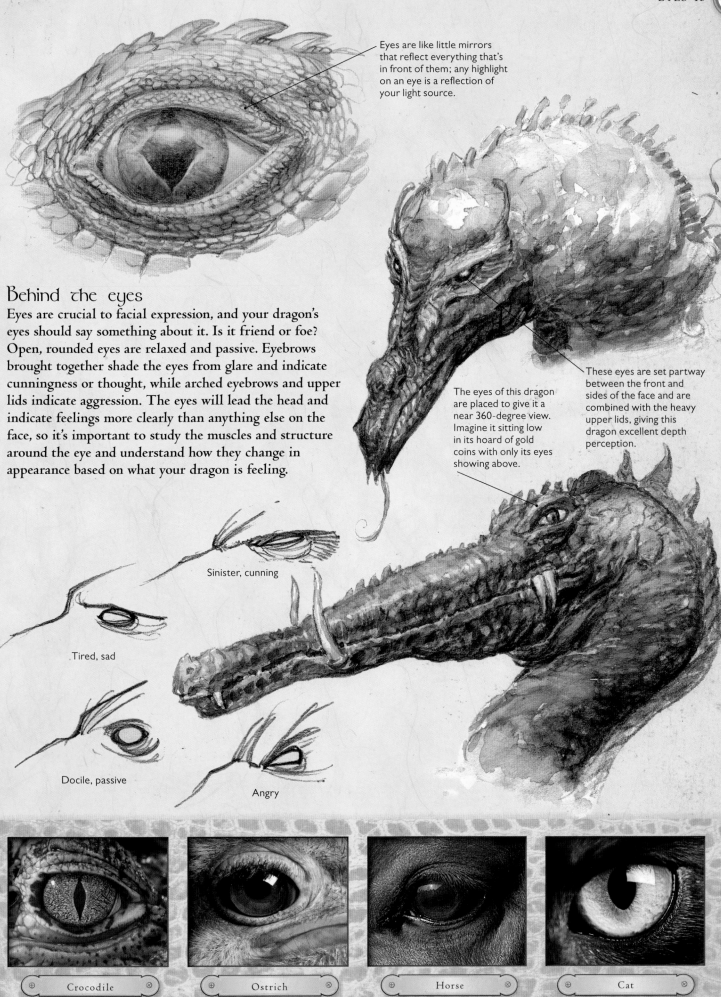

Eyes are like little mirrors that reflect everything that's in front of them; any highlight on an eye is a reflection of your light source.

Behind the eyes

Eyes are crucial to facial expression, and your dragon's eyes should say something about it. Is it friend or foe? Open, rounded eyes are relaxed and passive. Eyebrows brought together shade the eyes from glare and indicate cunningness or thought, while arched eyebrows and upper lids indicate aggression. The eyes will lead the head and indicate feelings more clearly than anything else on the face, so it's important to study the muscles and structure around the eye and understand how they change in appearance based on what your dragon is feeling.

These eyes are set partway between the front and sides of the face and are combined with the heavy upper lids, giving this dragon excellent depth perception.

The eyes of this dragon are placed to give it a near 360-degree view. Imagine it sitting low in its hoard of gold coins with only its eyes showing above.

Sinister, cunning

Tired, sad

Docile, passive

Angry

Crocodile

Ostrich

Horse

Cat

WINGS

A dragon's wings are made of bone and skin and are similar to bat wings. A dragon can wrap itself in its wings or close them tightly at its sides. Of course, you are not held to the bat form for the dragon wing, but it's worth studying closely.

The skin is stretched out tight between the "fingers" of the dragon wing, much like the fabric of an umbrella when it's opened. In both the dragon and the bat, the small muscles in the wing can control the wing much better than the locked stretchers of an umbrella control the umbrella.

Because the skin is stretched thin on a dragon wing, it is translucent. In many cases you can see the light coming through, silhouetting the wing bones. This is something you should consider carefully when drawing and painting your dragon's wings.

Special qualities of dragon wings

Most birds have wings that can be easily tucked in out of the way. It's hard to tell they have wings at all when they're not flying, because the wings fit the curved form of their bodies so well. In the insect world, the winged creatures vary quite a bit in terms of their wings' contracting ability. Bat and dragon wings are distinctly different from birds' wings, in that they don't fit quite as neatly when tucked in. At times, you'll need to have your dragons in activities with their wings pulled in, so you'll need to know how the skeleton of the wing compresses. To aid you in your understanding, study the human hand, since its structure is similar to that of the dragon wing (see opposite).

Learning to fly
Mom is seen here giving her young a gentle nudge to send them off on their first flight. The dragon's inner wing is lit from above and shows the dragon's wing structure in silhouette. Note the translucency of her wings and how that illustrates the hand-like quality of them (see page 15).

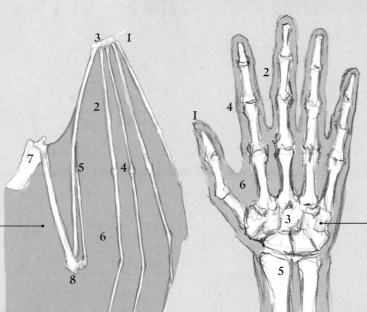

Wing details

In these drawings, the dragon wing is equated closely with the human hand, as the hand has skin stretched between the fingers. Rather than have the digits expand out from one point on the wrist, however, the wrist is expanded to give greater strength to the wing. Take particular note of the points of contact between the bones and the skin.

Dragon wing
Compare the structure of these bones and their joints with the human hand shown opposite.

1 Thumbs
2 Fingers
3 Palms
4 Knuckles
5 Wrist bones
6 Skin between fingers
7 Scapula
8 Elbow

Human hand
In the lower part of the human hand, the ligaments hold together the finger bones ending at the knuckles. In dragon wings, these bones can work independently.

Using light and tone to define structure

This image emphasizes the dragon's wing structure. You need not draw it at this level of detail, but it's important to understand the wing structure you see here. Compare the wings of this dragon to those of the dragon on page 14.

This dragon's exposed inner wing is lit by direct light and has lights and shadows, whereas the dragon on the opposite page is lit from above.

Note how the bones and muscles are dark against the lighter area of the stretched dragon skin.

Take a kneaded eraser, create ridges in its surface, and press it into an area of pencil toning to create texture and add highlights.

If you want texture from a pencil, set it on its side and twist it between your fingers to randomize the stroke.

INSPIRATION

There are a variety of animal and bird wings to aid you in the structure of your dragon wings, but you should also look to the natural world for inspiration on color and a range of textures.

Dried leaf

Cracked paintwork

Lichen on stone

Wing movements
This sequence illustrates some standard wing positions for forward flight. Note that the dragon's head lifts up and down and that its arms move a little; however, the dragon will be most aerodynamic if it tucks in its arms, as you can see when the dragon's wings are up.

Multiuse wings

Unlike birds, both bats and dragons can use their wings for things other than flying. Bats use the "thumbs" of their wings for grasping, and so do dragons. Depending on the type of dragon, they'll use their wings differently. If your dragon has two legs and two wings, it will likely have to use its wings for walking, the same way a bat does. The dragon will move the same way you'd expect a four-legged animal to move about but will be a bit awkward. A six-limbed dragon will walk on its four legs and keep its wings tucked in as it proceeds, leaving them free for use in battle. The thumbs will then become weapons similar to an ice pick. Because a dragon's wings have a very long reach, with the longest bones in a dragon's body, this will be a deadly weapon indeed—only second to its ability to breathe fire.

Thinning the paint
The simplest thing you can do to make a natural pattern texture with paint is to make a wash by thinning your paint and applying it to a surface with a brush, sponge, or rag. Use turpentine or linseed oil for oils, and water for watercolor and acrylic.

Photographic texture
If you're painting digitally you can use photographs as your textures. To transfer this pebble texture to a drawing, drag it over and make it a "Multiply" layer, or place the "Rubber stamp" tool on the center of the picture and paint over your drawing with it. This approach will require additional layers of color and tone to be effective.

Patting the surface
For a mottled effect, take a rag and press it into the paint. Pat the rag repeatedly against the surface you'll be painting on. Use the same technique to apply different colors of paint. Let the paint dry, and begin again on the dried surface to add even more texture.

Using turpentine
Take a dry surface you've already toned with color, and paint over it with oil paint mixed with some linseed oil. Place the surface at an angle and drip turpentine on it from a brush until it starts flowing downward. This will expose the color underneath, creating a random, natural pattern.

Borrow from nature
You'll come across interesting textures everywhere. Make a mental note of them, or carry a small digital camera around and photograph them. This is a picture of tree bark and it works perfectly for mottled dragon skin. You can see this in use on page 11. It's used for the center left dragon head.

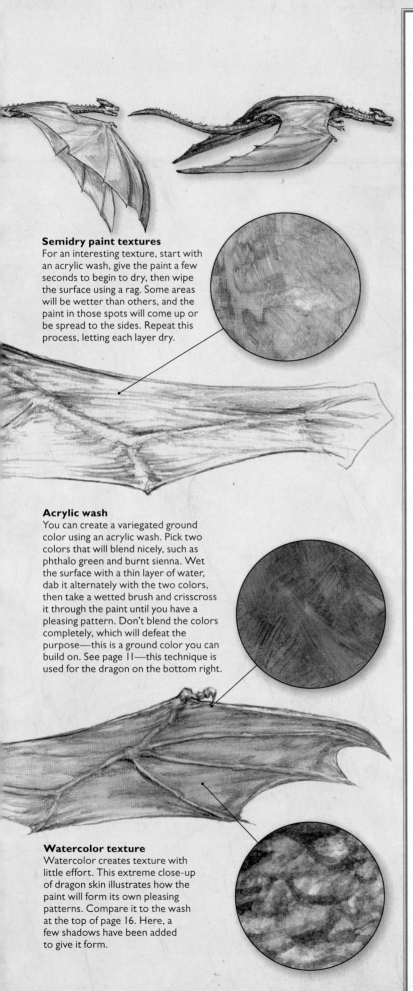

Semidry paint textures

For an interesting texture, start with an acrylic wash, give the paint a few seconds to begin to dry, then wipe the surface using a rag. Some areas will be wetter than others, and the paint in those spots will come up or be spread to the sides. Repeat this process, letting each layer dry.

Acrylic wash

You can create a variegated ground color using an acrylic wash. Pick two colors that will blend nicely, such as phthalo green and burnt sienna. Wet the surface with a thin layer of water, dab it alternately with the two colors, then take a wetted brush and crisscross it through the paint until you have a pleasing pattern. Don't blend the colors completely, which will defeat the purpose—this is a ground color you can build on. See page 11—this technique is used for the dragon on the bottom right.

Watercolor texture

Watercolor creates texture with little effort. This extreme close-up of dragon skin illustrates how the paint will form its own pleasing patterns. Compare it to the wash at the top of page 16. Here, a few shadows have been added to give it form.

WING POSITIONS

These drawings were done with a Pigma Micron pen, a permanent marker that's available in many different thicknesses. These pens are great for doing ink drawings on the spot without the risk of spillage that comes with a dip pen or quill. They don't have the flexibility of a quill, though, so you'll need to use different pens to change your line thickness, or go back over your lines to thicken them.

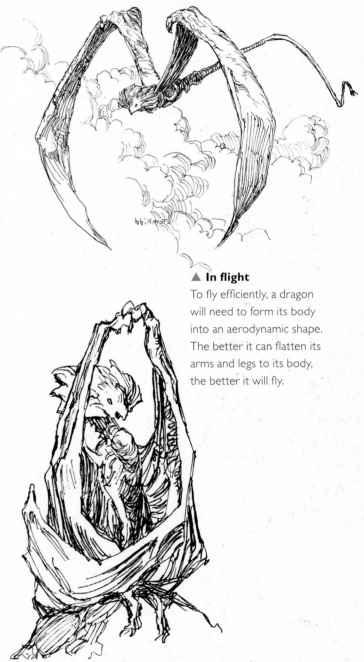

▲ In flight

To fly efficiently, a dragon will need to form its body into an aerodynamic shape. The better it can flatten its arms and legs to its body, the better it will fly.

▲ Protective poses

Conversely, a dragon can fold its wings around itself to create a pocket of warmth or to protect its face from wind and sandstorms. In this case, the dragon is using its wings to block the glare of the sun from its eyes.

Decorative details
Spikes on the head and neck attract mates and impress competitors. Always strive to be inventive with these types of details. Draw many random lines and erase to keep the ones you like the best.

NECKS AND TAILS

Although the simplest parts of the dragon, the long neck can propel the dragon's head forward to take a terrible bite or swell to spit fire, while the tail, full of fierce movement and grace, reveals the dragon's feelings and illustrates its actions.

Coiling neck
This dragon's coiling neck can spring its head forward with terrific speed, much like a springing python. Note that the neck is segmentally armored. A dragon's neck is normally its weak spot, so its thick, scaly sections protect it from attack.

The key to drawing dragon necks and tails is to first think about movement—not real movement, but the sense of it. Your eye will follow a dragon's neck and tail like you would a curvy path. When drawing a dragon in action, the neck and the tail are your main components to carry that action, so your drawing needs to be accurate if you are to convey your chosen pose effectively. The tail can coil about to add elegance to any dragon pose and reveals whether a dragon is relaxed, happy, or poised for attack, while the neck moves only with purpose.

Drawing the tail and neck gives you the opportunity to experiment with little details and ornamentation that you can use throughout the dragon, allowing you to think wholly about design. Almost anything goes in terms of the horns, appendages, fins, spikes, and bumps on these body parts. The difference between the two is that the neck will often have a more complex muscle arrangement than the tail; however, it is usually covered by details that hide these muscles.

Look closely

Studying other animals' necks and tails is integral to creating interesting and believable dragon equivalents. For example, look at how a cat's tail moves and positions itself. There is a lot of emotion to be seen in the nature of its movements. And don't forget to study the animal that is all neck and tail (depending on your point of view!), the snake. You can use the memories of these complicated forms to make some interesting dragon tails.

INSPIRATION

There are a range of creatures from the land and sea to inspire you. Pay close attention to the curves and lines of each, and use these as the base from which to build your dragon's neck and tail.

⊕ Giraffe ⊗

⊕ Sea horse ⊗

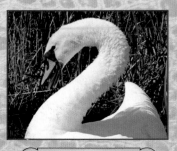

⊕ Swan ⊗

TAIL USES

■ Balance

Without its tail, the long-necked dragon is poorly balanced, so when drawing your dragon, you should consider how these two components can be equally matched.

■ Emotion

The tail can coil about unconsciously, and by looking at its tail you can tell when a dragon is content, excitable, or ready to attack. Your drawing should successfully illustrate a dragon's feelings.

■ Defense

Dragons' tails are quite often covered in sharp, deadly ridges or have a club-like end. Never forget that the dragon can use its tail as a deadly weapon.

A twist in the tail
Keep in mind that the skin of your dragon's tail will wrinkle where it bends.

Flat tail
A dragon's tail isn't always round or oval. This dragon has a flat tail, while others are square or U-shaped when viewed as a cross section. A flat tail like this will move like a ribbon fluttering in the wind.

Painting tails
If you're working in paints, let the paint guide you. A dragon's tail is an organic thing, and applying paint loosely is a great way to bring out interesting textures and tail detail.

Tail colors
You can paint a dragon's tail with any combination of colors. Look at tropical fish or birds. Keep in mind that color can be produced with pigment or prismatically, as is often the case with bird colorations. Prismatic colors are usually much brighter than pigment-based colors.

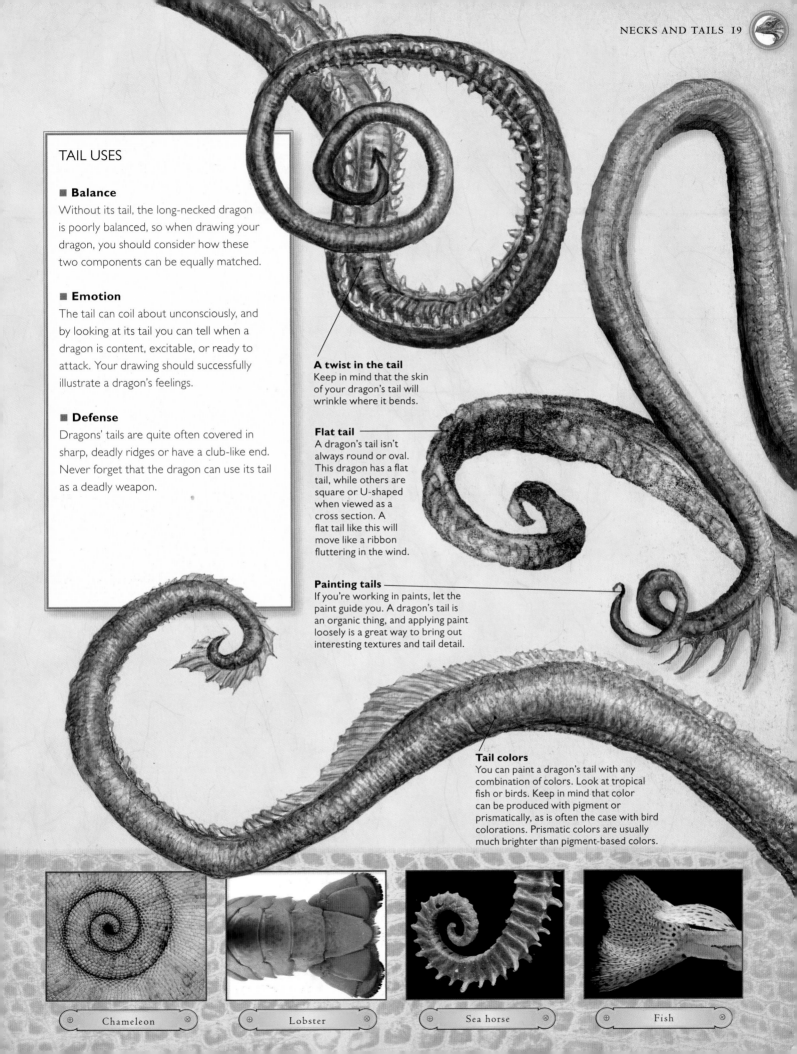

Chameleon

Lobster

Sea horse

Fish

TALONS AND TEETH

The most foreboding part of the dragon is its terrible toothy smile. Next to that in evoking great fear are the dragon's powerful claws. One or the other can pierce and harm a human body in awful ways.

On tip toe

A dragon doesn't walk flat-footed but on its toes (much like someone wearing high-heeled shoes does), so it's important to keep this in mind when drawing a dragon's hind legs. Imagine this as a human foot but with a claw on the heel. Rather than flat toenails, its claws grow thickly upward out of where the toenails are on a human foot, and then curve downward.

The dragon's claws can be a particular problem. Quite often dragons use their forelegs as arms and their claws as hands. If this is the case, you'll need to compromise on this structure to make it work in both cases. Women with unusually long fingernails are often unable to perform simple tasks required of the normal hand; therefore, an intelligent dragon with a library should not have excessively long claws.

Look in the dragon's mouth and you may see huge fangs or small, menacing, razor-sharp canines. A good way to make a dragon even more menacing is to pull back its lips to expose the gums. It's perfectly fine to place the dragon's teeth on the outside of its mouth.

It's quite unusual to look into a dragon's mouth and see the teeth of a herbivore, no matter how peaceful that dragon is. However, your dragon doesn't have to have teeth at all to be a dragon; a deadly bite is all that matters.

A handy tip

A good way to imagine a dragon's front paw is to look at and draw from your own hand. Adjust the proportions in your drawing so your hand no longer looks human, and greatly exaggerate every bump, stretch of skin, and wrinkle on it. After that, add some scales and some talons to complete the serpentine look.

INSPIRATION

Although talons across the animal kingdom vary in their colorings and skin or scale coverings, all share similarities to the human hand in their formation.

Eagle

Iguana

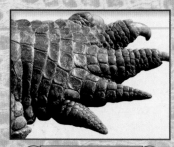

Alligator

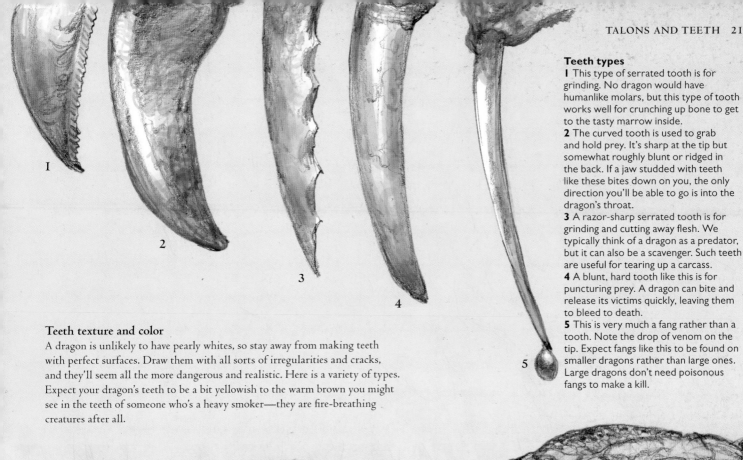

Teeth types

1 This type of serrated tooth is for grinding. No dragon would have humanlike molars, but this type of tooth works well for crunching up bone to get to the tasty marrow inside.

2 The curved tooth is used to grab and hold prey. It's sharp at the tip but somewhat roughly blunt or ridged in the back. If a jaw studded with teeth like these bites down on you, the only direction you'll be able to go is into the dragon's throat.

3 A razor-sharp serrated tooth is for grinding and cutting away flesh. We typically think of a dragon as a predator, but it can also be a scavenger. Such teeth are useful for tearing up a carcass.

4 A blunt, hard tooth like this is for puncturing prey. A dragon can bite and release its victims quickly, leaving them to bleed to death.

5 This is very much a fang rather than a tooth. Note the drop of venom on the tip. Expect fangs like this to be found on smaller dragons rather than large ones. Large dragons don't need poisonous fangs to make a kill.

Teeth texture and color

A dragon is unlikely to have pearly whites, so stay away from making teeth with perfect surfaces. Draw them with all sorts of irregularities and cracks, and they'll seem all the more dangerous and realistic. Here is a variety of types. Expect your dragon's teeth to be a bit yellowish to the warm brown you might see in the teeth of someone who's a heavy smoker—they are fire-breathing creatures after all.

The dragon's toothy smile

Don't be surprised if your dragon looks like it's smiling. When you smile you bare your teeth, so it's quite similar to the threatening gesture of a snarling dragon.

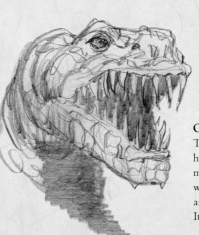

Open wide

The larger a dragon's teeth are, the wider its mouth will have to open. Note how in this drawing the dragon's mouth resembles the wide-open mouth of a lion, but with a great deal more teeth. Keep in mind that there are no rules for how wide a dragon can open its mouth. It can unhinge its jaw like a snake if need be.

Dinosaur studies

You can't go wrong studying dinosaurs if you want to create some terrific dragon teeth. Like dinosaurs, a dragon would likely have new teeth growing in all the time. Note the smaller teeth growing in here.

INSPIRATION

You can borrow a wealth of ideas from nature when you imagine your dragon's teeth. In addition to looking at size and shape, check the positioning, and look closely at textures and tones.

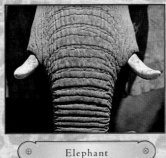

Elephant

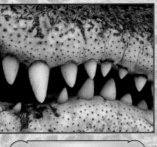

Alligator

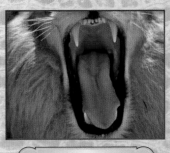

Lion

SKIN

No matter how sensitive to insult a dragon may be, it will be drawn and painted with thick skin. Its skin can be smooth like a dolphin's, or it can have the tough hide of an elephant or the scales of a lizard.

A nice thing about dragon skin is that it helps describe the animal's form. When you're painting or drawing a mythical creature, it's sometimes necessary to give a few extra indications of the form. The natural skin texture of the dragon helps you do this.

Keep in mind that there is a tonal and color texture to a dragon, as well as a physical, tactile texture. Think of these as two layers of dragon skin. You'll also have to keep in mind highlights and shadows separately from texture, concepts that are illustrated in the step-by-step sequence on pages 78–79.

Choosing your skin

Are dragons mammals, reptiles, or dinosaurs? They are what you want them to be, so you can give them any type of skin you want. It can look much like a dinosaur's skin or a reptile's. Go to a zoo and study rhinoceroses and elephants. All types of animals have scales on parts of their bodies, and they provide great reference for the creation of your own art. A variety of horns and spines cover dragons. Have fun inventing your own.

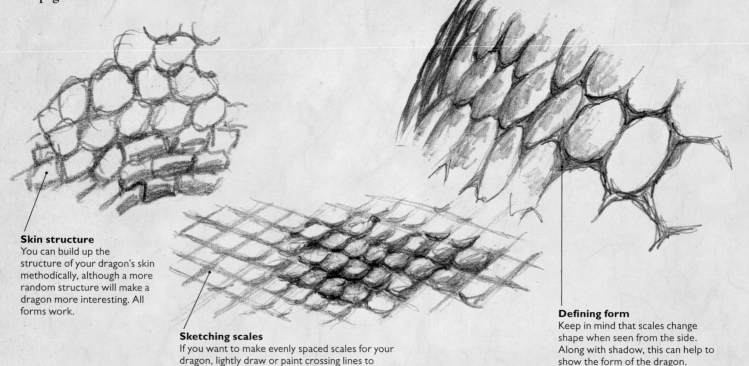

Skin structure
You can build up the structure of your dragon's skin methodically, although a more random structure will make a dragon more interesting. All forms work.

Sketching scales
If you want to make evenly spaced scales for your dragon, lightly draw or paint crossing lines to make diamond shapes. Then fill in the details.

Defining form
Keep in mind that scales change shape when seen from the side. Along with shadow, this can help to show the form of the dragon.

INSPIRATION
Look at the textures of the world around you. You can find some very dragon-like skin on animals, plants, and trees. Nature is a great source of reference and is also free!

⊕ Fish ⊗

⊕ Alligator ⊗

⊕ Reptile ⊗

Building texture and color

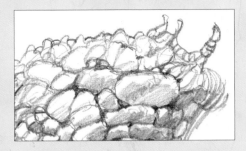

◀ Step 1: The drawing

First build your skin structure. In this example, a random structure of scales is drawn as the basis for a dragon's skin.

▶ Step 2: The base coat

Using Photoshop, scan a section of an existing painting with interesting texture and drag that onto the drawing. Make it a "Multiply" layer. Alternatively, paint over your drawing with transparent watercolor, acrylic, or transparent oils.

◀ Step 3: Defining form

To define the skin edges, erase around the edges of your drawing, or paint white around it. If you're using Photoshop you can change the color of the drawing using "Image/Adjustments/Color Balance" to better fit the imported layer.

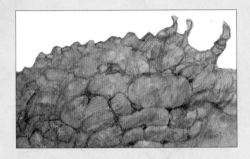

▶ Step 4: Glazing and shading

Using Photoshop and a drawing tablet, create a Multiply layer. Set your brush to "Multiply," set it to "Pen Pressure," and then add shading. If working in traditional paint, use a transparent color such as Payne's Gray to glaze in shading.

◀ Step 5: The opaque layer

If you are working digitally, make a normal (opaque) layer, set your pen to 100% opacity (set for Pen Pressure), and use it to add highlights and lowlights on the skin. If working traditionally, glaze this layer with an opaque layer of watercolor, acrylic, or oil paint. If working with oil, put down a thin layer of a clear medium, such as Liquin or linseed oil, to paint into first.

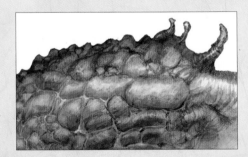

Skin effects

Building it up slowly

You can, of course, paint all the details individually. You'll need a detailed sketch before you begin. This is a good example of shiny dragon skin. Dragon skin will vary in its shininess or, rather, in the amount of specular highlights you see in it.

Painting in oils

This is an example of using the paint's inherent irregularities and drybrush—pulling a brush with little paint on it over a rough surface to leave behind a rough, speckled texture—to make a rather detailed skin-like surface with less effort than you'd expect.

Glazing the surface

Once you have a textured surface, you can glaze into it with transparent paint for your darks and translucent paint for your lights. This approach works well to protect the texture beneath. You can also do this in Photoshop or Painter using layers.

Elephant

Python

Hedgehog

Reptile

COMPARATIVE ANATOMY

This step-by-step transmogrification is an important study in comparative anatomy because you will become the dragon. Once you can see yourself as a dragon, you'll be able to draw and paint one with great empathy and striking verisimilitude.

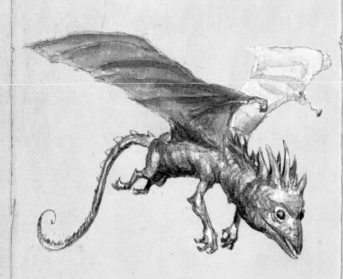

As you sketch you'll find yourself unconsciously moving your body into the dragon's pose, and when you've perfected your imagining you'll be able to use your powerful webbed arms and hands to take flight. Be warned, however, that in order to make this change, some disturbing images will be created.

▼ Step 1: Typical male human form

Unlike most of his kind, this somewhat lean and muscular man is a completely hairless creature, shown from behind not so much out of modesty but because this is where the first important changes will take place. Pay close attention to the areas listed below as the human changes into dragon form.

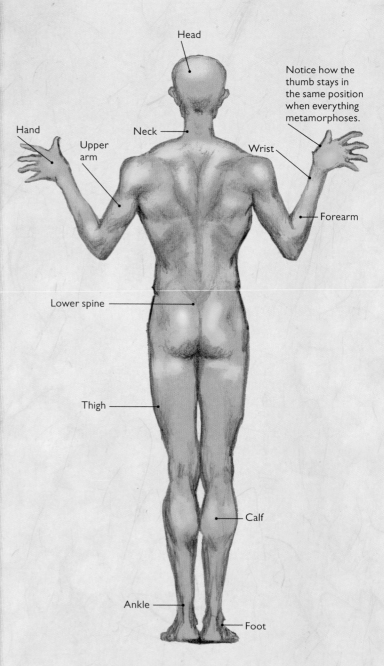

Head

Notice how the thumb stays in the same position when everything metamorphoses.

Hand

Neck

Upper arm

Wrist

Forearm

Lower spine

Thigh

Calf

Ankle

Foot

▼ Step 2: Human starts to take on dragon form

It would be easy enough to draw wings coming out of your back, but there's nothing to be learned by doing that. You'll learn more by turning your arms into wings. Start by lengthening your fingers and your feet, and your tailbone into a tail. More important, webbing needs to grow between your forearms, upper arms, and torso. From now on, you'll stand on your toes. Oh yes, and this is a bit freaky, you'll grow a second set of arms out of your ribs. At this point they remain vestigial.

▼ Step 3: Mid-transformation

At this stage of the transition you've become a clumsy-looking creature. Don't worry, though; we'll turn this ugly duckling into a swan in the end. Your wings are enlarged hands, but they're largely worthless as such. At this point, although it's unseen, your bones have begun hollowing, making your body lighter. Note how your head becomes longer.

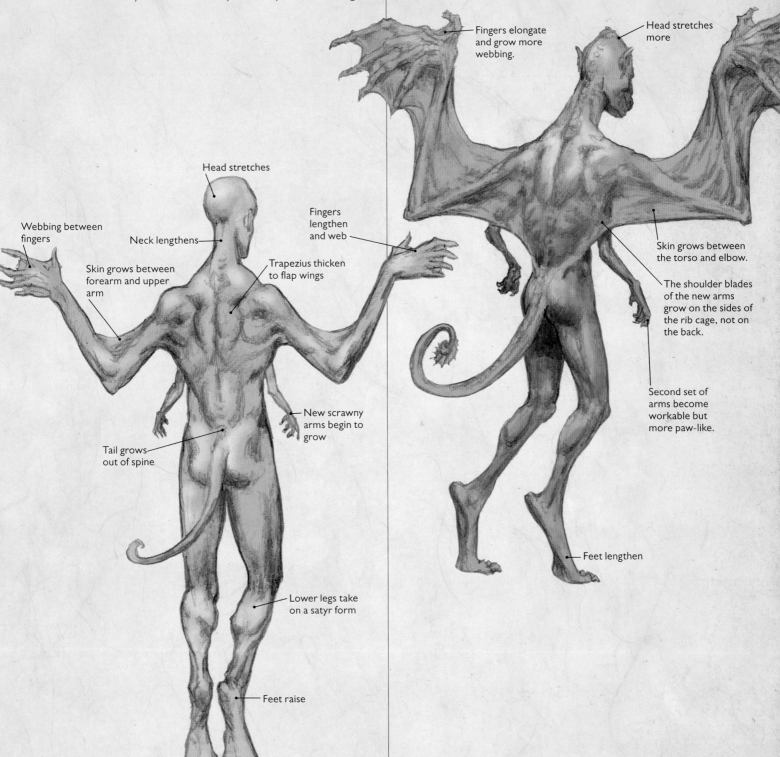

Fingers elongate and grow more webbing.

Head stretches more

Head stretches

Fingers lengthen and web

Webbing between fingers

Neck lengthens

Skin grows between forearm and upper arm

Trapezius thicken to flap wings

Skin grows between the torso and elbow.

The shoulder blades of the new arms grow on the sides of the rib cage, not on the back.

New scrawny arms begin to grow

Tail grows out of spine

Second set of arms become workable but more paw-like.

Feet lengthen

Lower legs take on a satyr form

Feet raise

▶ **Step 4: Preparing to run**

Now the ligaments holding your knuckles together and the bones that form the palm of your hand come loose so that your fingers can spread out farther. Your neck has stretched considerably but will lengthen even more. Those new arms of yours still dangle and are not quite strong enough to run on. They don't have shoulders as such, but are held in tight on the sides of your thorax to a set of scapulas that are perpendicular to the scapulas that support your wings. You've been flapping those wings so much that you've now grown huge pectoral and trapezius muscles.

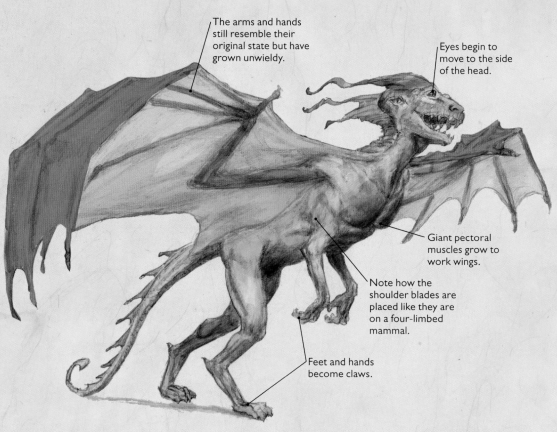

The arms and hands still resemble their original state but have grown unwieldy.

Eyes begin to move to the side of the head.

Giant pectoral muscles grow to work wings.

Note how the shoulder blades are placed like they are on a four-limbed mammal.

Feet and hands become claws.

HUMAN VS. DRAGON THORAX

Looking at the difference between the human and dragon thorax shows you how it will need to change to go from man to four-legged beast. This elongation is important to allow for four scapulas to fit.

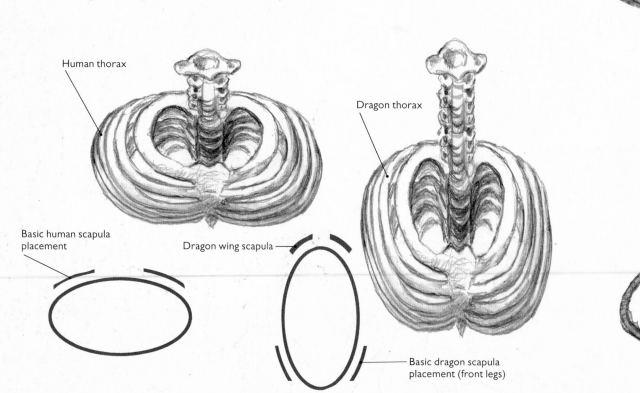

Human thorax

Dragon thorax

Basic human scapula placement

Dragon wing scapula

Basic dragon scapula placement (front legs)

▶ Step 5: Onto all fours

Now that your new arms and back legs are nearly equal in size and strength, you're finally down on all fours running along, full of excitement. As you run you notice how well your hands, now claws, grip the ground. Your birdlike, batlike hollow bones and your lean body make you light and powerful. Each leap you take is longer as your ever-growing wings catch the air.

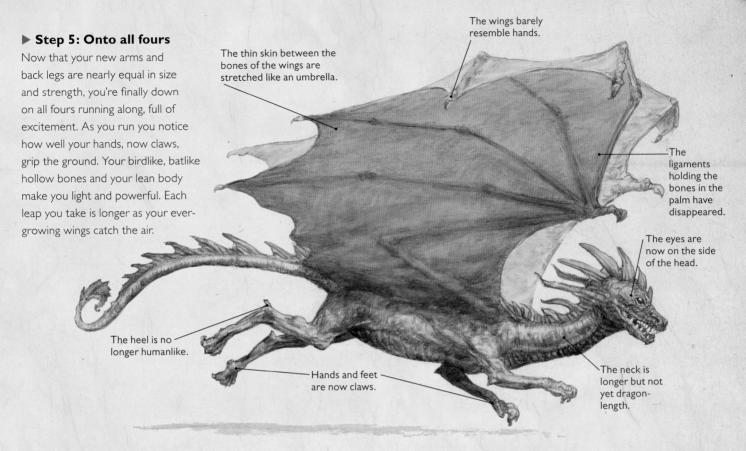

The wings barely resemble hands.

The thin skin between the bones of the wings are stretched like an umbrella.

The ligaments holding the bones in the palm have disappeared.

The eyes are now on the side of the head.

The heel is no longer humanlike.

Hands and feet are now claws.

The neck is longer but not yet dragon-length.

▼ Step 6: And into the air

Finally your wings reach their full size and you hold your head high on your very long neck. Your skin is now tougher, the same way your strength is now several factors greater. It's time for a final mighty leap that takes you into the air. The earth can no longer hold you, and all will fear your legendary ferocity. You are a dragon.

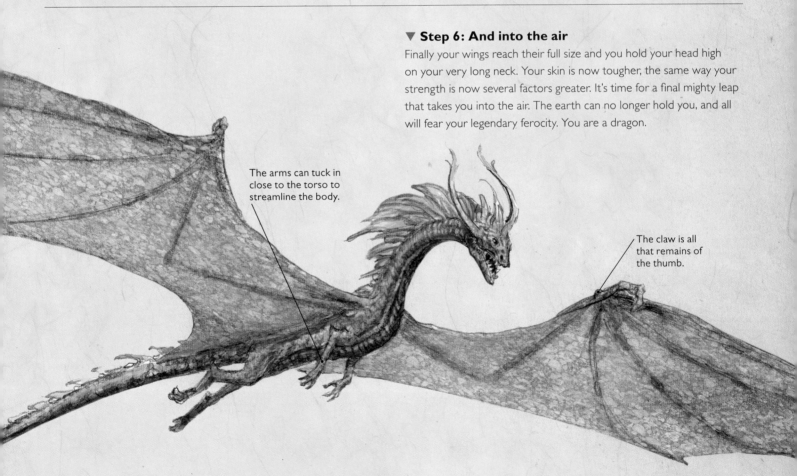

The arms can tuck in close to the torso to streamline the body.

The claw is all that remains of the thumb.

ANATOMY AND PROPORTION

In this section you will strip the flesh off a dragon, then put it all back on. Rather than study the anatomy of the wingless dragon or the serpent dragon, we will study the six-limbed dragon (see Dragon types, pages 32–37), because removing the wings from these dragon drawings easily makes a wingless dragon, and removing everything else but the spine makes a limbless-type dragon. You need to go no further than the serpent to study the limbless dragon.

On Earth there are no reptilian or mammalian six-limbed creatures. If a dragon has four legs to run on and two wings to fly with, it has six limbs. The only earthly creatures, outside of mythology, that have six limbs are insects or insect-like creatures in the classification of hexapoda. (On a side note, a flying insect, such as a dragonfly, has six legs and two wings, but unlike a dragon there are no bones in an insect's wings, while most dragons have bones forming their batlike wings.) After you've spent some time on the visualization lessons on pages 40–41, you'll have expanded your ability to visualize greatly, and will find the issue of proportion much easier to understand and apply. An impatient person may want to skip ahead, and in this instance you can certainly learn dragon anatomy at the same time as carrying out earlier or later lessons.

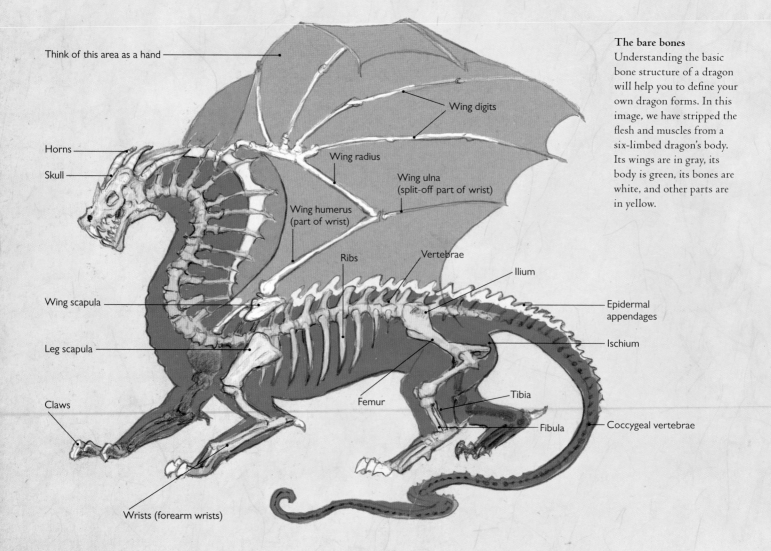

Think of this area as a hand

Wing digits

Horns

Skull

Wing radius

Wing ulna (split-off part of wrist)

Wing humerus (part of wrist)

Ribs

Vertebrae

Ilium

Wing scapula

Epidermal appendages

Leg scapula

Ischium

Femur

Tibia

Claws

Fibula

Coccygeal vertebrae

Wrists (forearm wrists)

The bare bones
Understanding the basic bone structure of a dragon will help you to define your own dragon forms. In this image, we have stripped the flesh and muscles from a six-limbed dragon's body. Its wings are in gray, its body is green, its bones are white, and other parts are in yellow.

Creating a plausible dragon

In general, what is it that makes up a dragon? As shown on the opposite page, it is a torso, four legs, a long neck, and wings. The fun in making a dragon is that it is so ill defined that you can play with the proportions of these elements to a great degree. However, the relationship and proportions of elements still need to be considered carefully in order to create a plausible creature.

Using projection for proportion

Projection is a useful drawing technique and a nifty way to help you draw your dragon in proportion. By using corresponding lines to guide you, you can make sure your dragon stays the same proportionally from different angles and continues to look like the dragon it's supposed to be. Short of making a sculpture or a 3-D version of your dragon on a computer, this is the best method to get consistent proportions from different angles.

Consider projection as an exercise or a way to solve drawing problems, but it can also have a practical application. If you are an illustrator, you may be asked to design a figurine and show how it might look from different angles, so that a sculptor can use it as reference and match it from all the different angles. Although you can eyeball most of it, the projection method is a nice way to check how well you've done. Similarly, if you've designed a dragon character to be used in a cartoon or comic, you're going to want to make sure that it stays the same throughout. Using a graphic like the one shown below is a useful tool to refer back to.

Your dragon lineup
Imagine you've posed your dragon on a pedestal, but once you've done one careful drawing of him, he then flies away. How are you to do three more accurate drawings of him? You'll need to use your imagination, but you can also measure accurately from your first drawing.

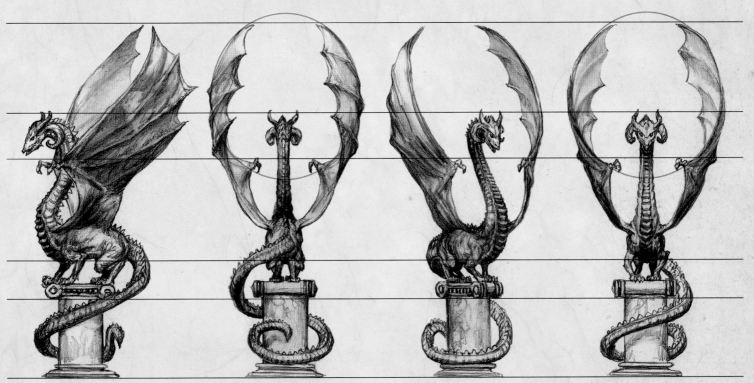

Profile view
Start with a profile drawing of your dragon on the left side of the page. Starting from the top of the drawing and moving down, take a ruler and carefully mark the important details. To the right, place a horizontally corresponding mark. This is the beginning of your "dragon lineup."

Back view
Starting from each of the important points highlighted on the first profile drawing, carefully draw horizontal lines across the page. As you alter the view of your dragon, these lines will guide you in your drawing. Next, draw the dragon from the back view, lining up the important parts so they are level with the corresponding points in the profile view. Note that from behind you can more easily see that the knees of the rear legs are angled outward.

Three-quarter view
Use the same process to draw your dragon from a three-quarter view, referring closely to the previous two drawings. This view tends to tell you more about a subject. Note that from this view alone, you can see that the wings and legs aren't on the same plane as their opposing parts, as they might seem in the profile.

Facing view
An oval was used to recreate the same curve to the wings as seen from the back view. The front and back views could almost be mirror silhouettes of each other. You may find it useful to use ovals or other shapes to help you draw your dragon parts in proportion. Note that from this view, the elbows of the front legs are angled outward.

DRAGON TYPES

There are six basic types or physical forms of dragons. Most are fictional. None of these categories make sense in terms of scientific classification and none of the dragons are connected along any evolutionary path. These are discrete creatures even though they are all dragons by name. Still, you need to know these basic forms and how they move if you are to paint or draw them. Fortunately it all follows somewhat logically.

Serpent or wyrm
(nullus-limbis serpentis)

The serpent dragon is like a snake, eel, or worm, with no arms, legs, or wings and a lion-like or reptilian head. Despite its lack of wings, the serpent type can still achieve flight. This dragon can also be a sea serpent or sea dragon—there is a real fish called a sea dragon, but it is not the same thing.

VITAL STATISTICS

Habitats:
Foggy lower lands, clouds, and waterways: lakes, seas, oceans

Personality:
Sneaky, duplicitous, clandestine, and ravenous

Diet:
Carnivorous, fond of warm-blooded animals, especially humans

Size:
Anywhere from snake-sized to the circumference of a planet

Special characteristics:
Tempt people to be immoral

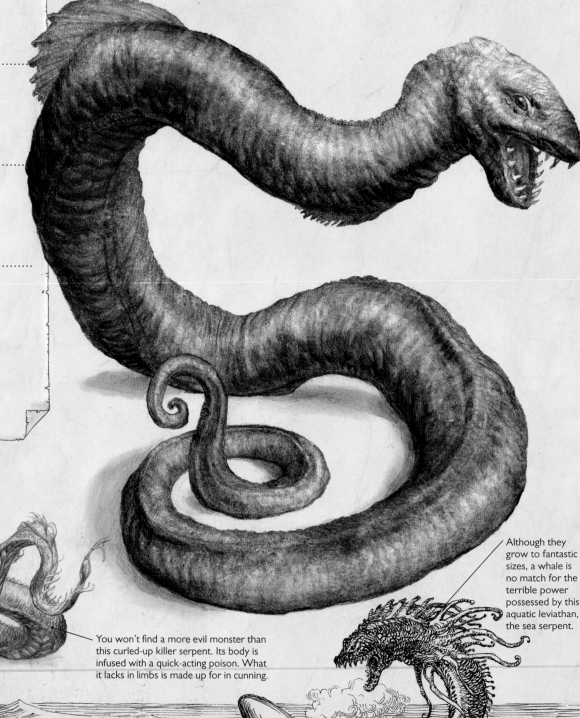

You won't find a more evil monster than this curled-up killer serpent. Its body is infused with a quick-acting poison. What it lacks in limbs is made up for in cunning.

Although they grow to fantastic sizes, a whale is no match for the terrible power possessed by this aquatic leviathan, the sea serpent.

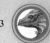

Winged serpent
(pennatus serpentine)

A popular dragon form in literature is exactly like the serpent dragon, except that it has wings and no other limbs. The wings are typically attached near the head and it can fly. This can also be a sea creature.

VITAL STATISTICS

Habitats:
Ancient gardens, dreams, nightmares, and waterways

Personality:
Mischievous, angelic, deadly, and mysterious

Diet:
Ghosts, fond of warm-blooded animals, especially fairies

Size:
Anywhere from snake-sized to the circumference of the moon

Special characteristics:
Can be ghost-like, ephemeral, or magical

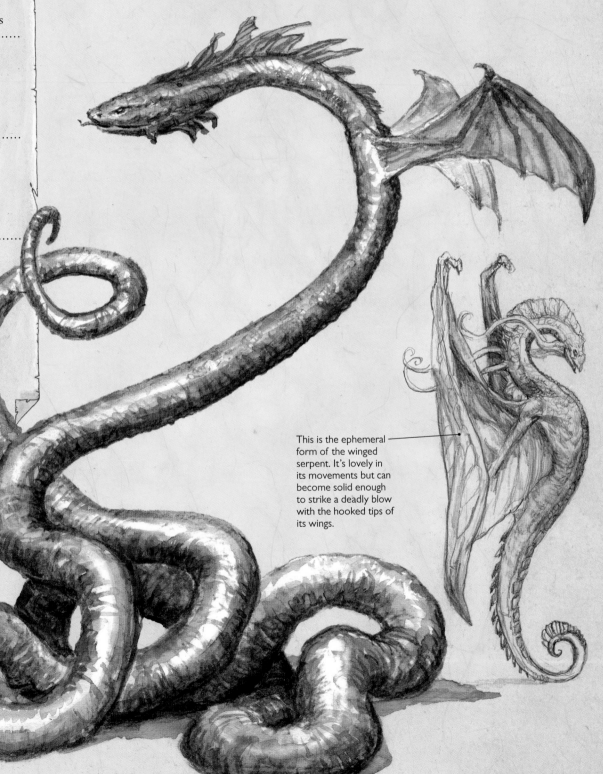

This is the ephemeral form of the winged serpent. It's lovely in its movements but can become solid enough to strike a deadly blow with the hooked tips of its wings.

Pre-modern fable
(fore-bipedis pennatus serpenti)

Perhaps the strangest dragon form is this one, which is quite snake-like but with wings and forearms though no rear legs. In this form it can run the range of reptilian to mammalian characteristics.

Although winged, this dragon flies as if it's lighter than air. As it twists through the sky it spots prey, swooping down and seizing it with its powerful forearms.

VITAL STATISTICS

Habitats:
Rocky lands, tunnels, and forests

Personality:
Clever, nasty, curious, philosophical, and ravenous

Diet:
Carnivorous, fond of warm-blooded animals, especially dwarves

Size:
Human- to polar-bear sized

Special characteristics:
Does not observe physical laws, magical

Contemporary mythical
(quadru-limbis pennatus draconi)

The two-winged, two-legged dragon is structured much like a bat, with two wings and two rear legs. The wings are used as arms as well as for flying. This type of dragon uses its thumb for grabbing and holding objects or for walking. It rarely walks far on its hind legs. Birds are physically similar to this type of dragon, but birds use their feet for holding objects and not their wings, as bats do.

VITAL STATISTICS

Habitats:
Rocky lands, mountains, caves

Personality:
Clever, friendly, deadly, sentient

Diet:
Carnivorous, fond of warm-blooded animals, especially human virgins

Size:
Bat- to skyscraper-sized

Special characteristics:
A keen fire-breather, hoards gold and jewels, keeps a library, interest in literature, can talk

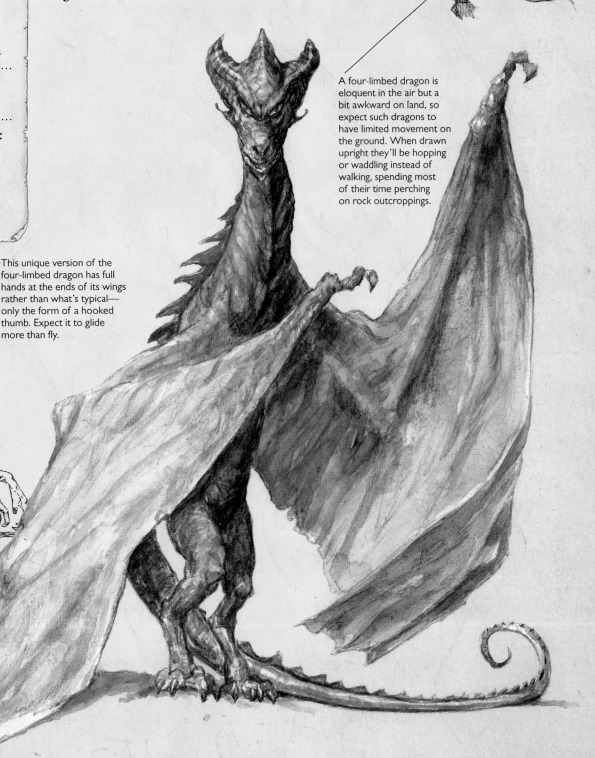

A four-limbed dragon is eloquent in the air but a bit awkward on land, so expect such dragons to have limited movement on the ground. When drawn upright they'll be hopping or waddling instead of walking, spending most of their time perching on rock outcroppings.

This unique version of the four-limbed dragon has full hands at the ends of its wings rather than what's typical—only the form of a hooked thumb. Expect it to glide more than fly.

Flightless dragon

(quadrupedis draconic or varanus typis)

This type of dragon comes in two forms—both move along on four legs and cannot fly. The mythological type moves like a dog, lion, or horse. It looks much like a standard dragon and can gallop. The actual earthly dragon, the Komodo dragon, is a lizard and does not gallop, but waddles, moving the way a fish does through water, swinging its body horizontally with each step. If you want to give this lizard wings, you certainly can. There are no hard and fast rules.

<div style="float:left">

VITAL STATISTICS

Habitats:
Rocky lands, mountains, caves, and forests

Personality:
Clever, deadly, brutish

Diet:
Carnivorous

Size:
Human- to whale-sized

Special characteristics:
Possibly belonging to species of living dinosaurs in remote areas, usually not sentient, extant reptilian version is the Komodo dragon

</div>

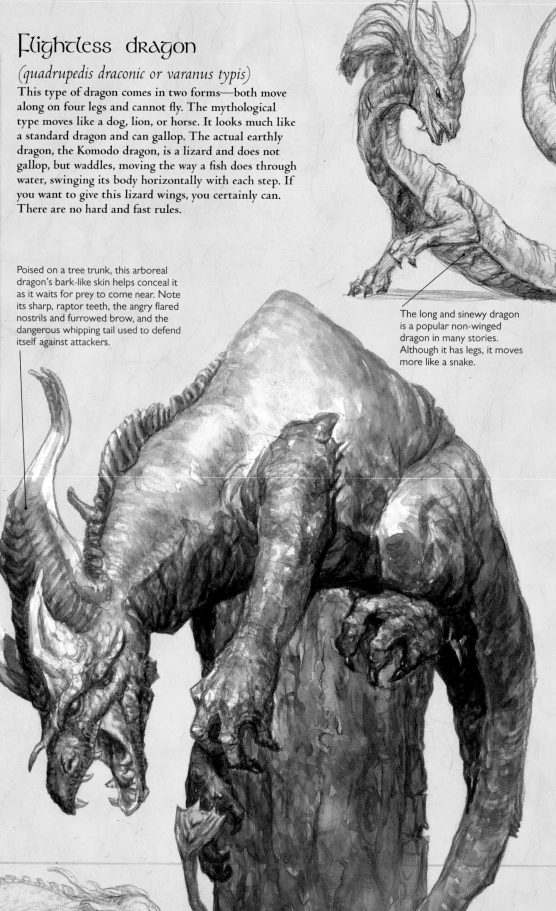

Poised on a tree trunk, this arboreal dragon's bark-like skin helps conceal it as it waits for prey to come near. Note its sharp, raptor teeth, the angry flared nostrils and furrowed brow, and the dangerous whipping tail used to defend itself against attackers.

The long and sinewy dragon is a popular non-winged dragon in many stories. Although it has legs, it moves more like a snake.

This guy is a low walker. Even though it is a quadruped, it doesn't move like the dragon of legend but more like a lizard.

Legendary classic

(hexa-limbis pennatus draconis)

To some, the six-limbed dragon is the true dragon form. It runs and walks on all fours, and its forearms can be arms as well as legs. It has huge wings to fly with and it can breathe fire. In mythology and literature, it comes in many different sizes. It is also the most difficult dragon to paint or draw.

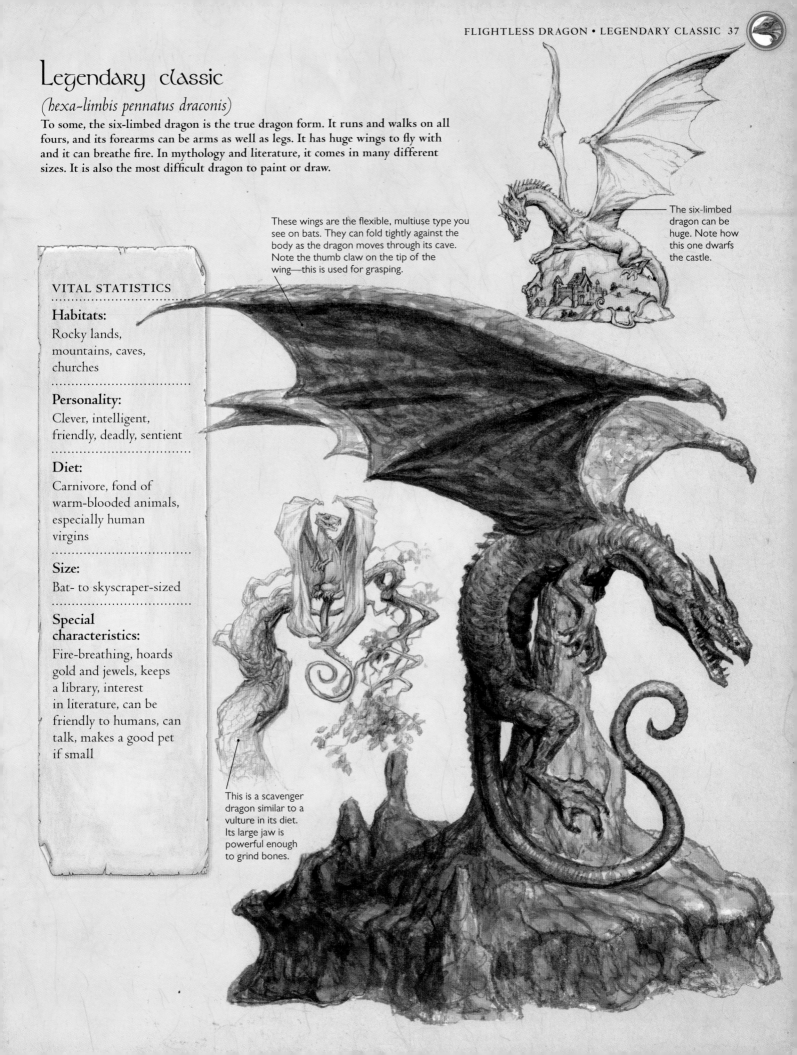

The six-limbed dragon can be huge. Note how this one dwarfs the castle.

These wings are the flexible, multiuse type you see on bats. They can fold tightly against the body as the dragon moves through its cave. Note the thumb claw on the tip of the wing—this is used for grasping.

VITAL STATISTICS

Habitats:
Rocky lands, mountains, caves, churches

Personality:
Clever, intelligent, friendly, deadly, sentient

Diet:
Carnivore, fond of warm-blooded animals, especially human virgins

Size:
Bat- to skyscraper-sized

Special characteristics:
Fire-breathing, hoards gold and jewels, keeps a library, interest in literature, can be friendly to humans, can talk, makes a good pet if small

This is a scavenger dragon similar to a vulture in its diet. Its large jaw is powerful enough to grind bones.

BRINGING YOUR DRAGON TO LIFE

You have to feel the life in something you're making up. You'll want to mentally have the dragon in the room with you: sense its weight as the floorboards creak under it, touch its form, and feel its texture. You need to be exposed to its full ferocity, intelligence, or playfulness. The more you use your imagination, the better you'll become at seeing what's not truly there. This approach is, by far, the best at bringing your dragon to life.

LEARNING TO VISUALIZE

To make your own unique dragons, you'll need to expand your ability to visualize. The following three lessons will help you to do just this, and should be carried out as regularly as possible for at least a year.

Although there are many theories regarding what makes humans different from other animals, it could be argued that our greater ability to visualize is what has given us an evolutionary edge over our ancient forebears. Other animals and early hominids have used tools, but what other animal makes representational art? Our ability to visualize is so great that we can make a picture of our visualizations by hand. This ability is not a lightweight one either. It is the start of every great human project: architecture, tool making, machines, bridges, and boats to ocean liners all come when people visualize their plans.

The lessons that follow are designed to exercise the visual cortex in your brain and encourage it to grow larger, enabling you to see and draw more accurately.

LESSON 1:
Observe and translate

Look for a man-made object of moderate complexity. It should be a solid object that you can easily see all the sides of, such as a toy, a fire hydrant, a fan, a shoe, a mailbox, or a tool. Take your time and study the object carefully, moving it or walking around it.

Now close your eyes and try to visualize the object. What are its various shapes: squares, rectangles, ovals, or spheres? How is it proportioned? Open your eyes and study the object more closely. Then try again to visualize it with your eyes closed.

When you are satisfied that you're seeing the object well, move to a place where you can't see it, and draw it. A simple line drawing will do. Don't worry about tone. When your drawing is complete, return to your subject and compare it to the drawing. Notice where you may have forgotten something, or where an element may be slightly out of proportion. Find out what other people think of the drawing compared to the object.

Repeat this first lesson several times over a period of days with different objects, and your observational skills will definitely improve.

▲ LESSON 2:
Drawing living creatures

Drawing from life is essential practice, and working back and forth from imagining to drawing from life is a very quick way to learn.

Try visiting a zoo and drawing the animals there, or, if you have pets, watch how they move and draw them both from life and from your imagination. Your library will likely be an excellent place to find books and DVDs featuring animals. Using your television to draw and study animals is a fine way to learn, especially when you can pause a DVD player on your subject in order to draw it. The better you understand animals, the better you'll be able to create dragons with great variety to them. The more you draw, the easier and quicker your visualizing will become.

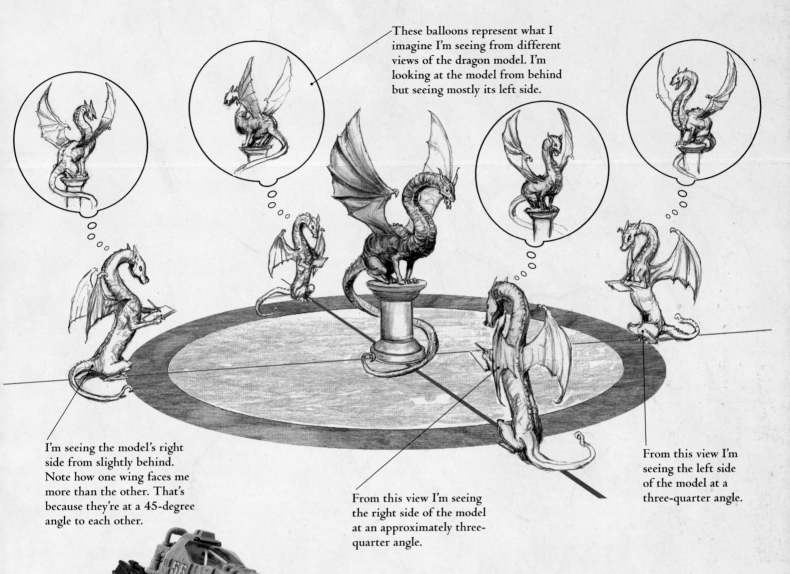

These balloons represent what I imagine I'm seeing from different views of the dragon model. I'm looking at the model from behind but seeing mostly its left side.

I'm seeing the model's right side from slightly behind. Note how one wing faces me more than the other. That's because they're at a 45-degree angle to each other.

From this view I'm seeing the right side of the model at an approximately three-quarter angle.

From this view I'm seeing the left side of the model at a three-quarter angle.

◀ ▲ LESSON 3: Visualizing in 3D

Here's another neat way to give your visual cortex some exercise. This is an advanced assignment, probably best attempted after you've learned some anatomy. You may want to start with simple objects first.

Find a figurine or sculpture of a person or animal. A sculpture is the ideal subject, something fairly realistic and fully three-dimensional, although a toy, plastic dinosaur, bust, or doll of some kind will do if positioned interestingly.

Here's the tough part of the assignment: you'll be drawing the sculpture not from the angle you're seeing it at, but from a view that is a one-quarter turn from where you are. When you have finished, compare what you drew to the actual view from that angle.

The point of this exercise is to get you to see and think in three dimensions. This is very important when you want to make a lifelike and believable dragon.

As a further test, draw or work from a drawing of a dragon from this book. Then imagine that you're alternately positioned like one of the four young dragon art students, pictured above.

A different point of view
If you look at the thought balloons above each of the dragons' heads, you'll see what they see from their particular angle. Note that none of the drawings are how you see the dragon model yourself. All the thought balloon drawings are at a lower eye level (the level of the dragon students) than yours and are from a different point on the circle. Also note that the students are all in the same position but turned a quarter turn.

STARTING POINTS FOR A DRAWING

The best way to approach a complex subject is to break it down into its component parts. Painting a fully realized dragon requires knowledge of dragon anatomy, light, color, and texture. There are a number of ins, outs, twists, and turns. To better understand how a dragon's body is structured, simplify its form into rectangles and then into more complex planes.

You may not necessarily want to begin your drawings based on the methods here, but use them to better understand dragon form. If you can think of your dragon in terms of basic geometric shapes, it should help you project it into the third dimension as well as give you the ability to draw it from a number of angles. It will also help you to understand how to shade your dragon.

Method 1:

Take a quick gesture drawing that looks flat, and draw a rectangular box around it to get a better sense of the dimensions. Ultimately, this is a way of thinking that allows you to see form in a more concrete manner. Even though light, shadow, and highlights are how you can show the shape of a dragon, these elements can just as easily confuse you when you're first understanding its structure.

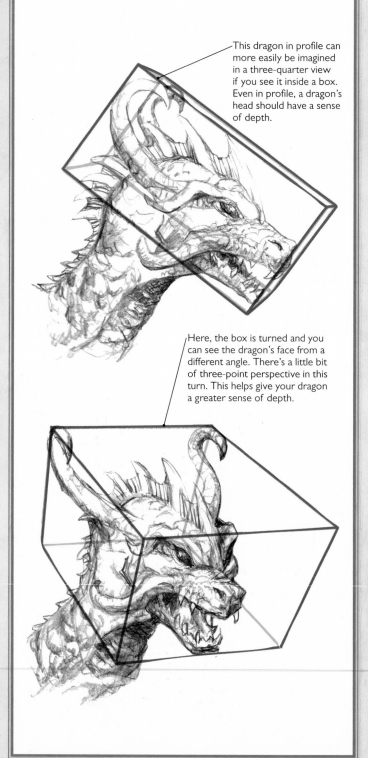

This dragon in profile can more easily be imagined in a three-quarter view if you see it inside a box. Even in profile, a dragon's head should have a sense of depth.

Here, the box is turned and you can see the dragon's face from a different angle. There's a little bit of three-point perspective in this turn. This helps give your dragon a greater sense of depth.

Method 2:

Start by breaking the dragon up into basic rectangular shapes. Lightly draw the rectangles at the angle you want your dragon to be, and then begin to "flesh out" the shapes. Once you've done this a few times, you'll find that you'll be able to imagine the third dimension without drawing the shapes at all.

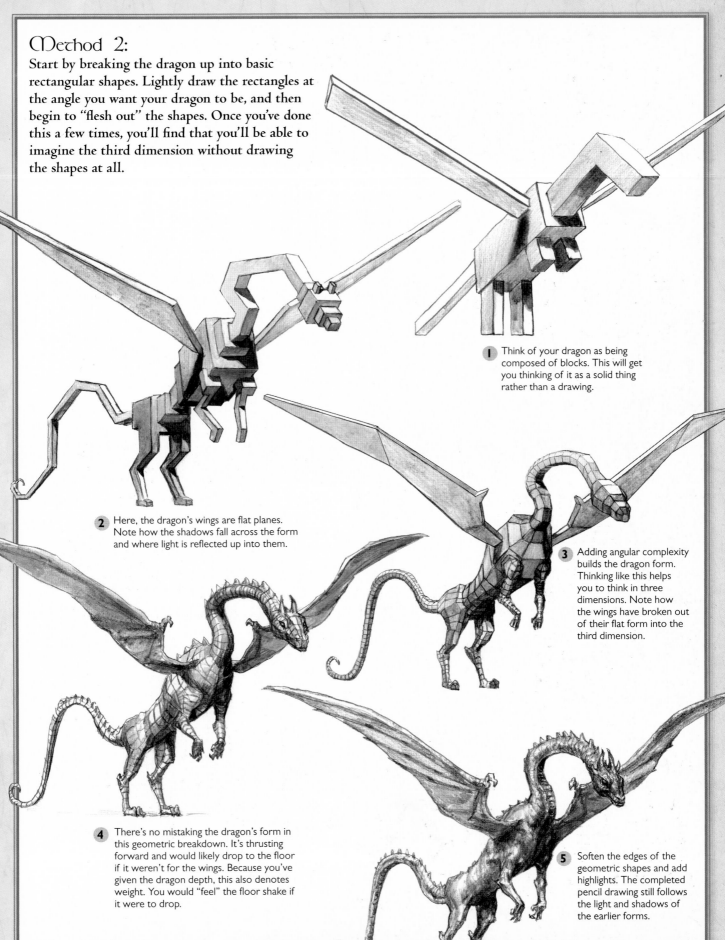

1 Think of your dragon as being composed of blocks. This will get you thinking of it as a solid thing rather than a drawing.

2 Here, the dragon's wings are flat planes. Note how the shadows fall across the form and where light is reflected up into them.

3 Adding angular complexity builds the dragon form. Thinking like this helps you to think in three dimensions. Note how the wings have broken out of their flat form into the third dimension.

4 There's no mistaking the dragon's form in this geometric breakdown. It's thrusting forward and would likely drop to the floor if it weren't for the wings. Because you've given the dragon depth, this also denotes weight. You would "feel" the floor shake if it were to drop.

5 Soften the edges of the geometric shapes and add highlights. The completed pencil drawing still follows the light and shadows of the earlier forms.

DRAWING MOVEMENT AND GESTURE

Now that you can imagine your dragon's three-dimensional form, and now that you know the bone structure of a dragon, the arrangement of dragon muscles, and the nature of your dragon's skin, it's time to enter the fourth dimension. Cue Twilight Zone music.

Paintings and drawings are flat surfaces but an artist has the potential to give them unlimited depth, inviting the viewer to happily enter or stand transfixed in front of a terrifying scene. What could there be beyond that? Time. And how is time measured? By its movement. This is your fourth dimension.

Gesture drawings

Action tells the story of what is about to happen, what is happening, or what just happened. To illustrate the unfolding drama, you must feel the dragon's power and sense its path. A series of quick action gesture drawings are a good way to accomplish this. Below are several examples. When you draw, you should think about the forces involved: Is your dragon a lightweight or a heavyweight?

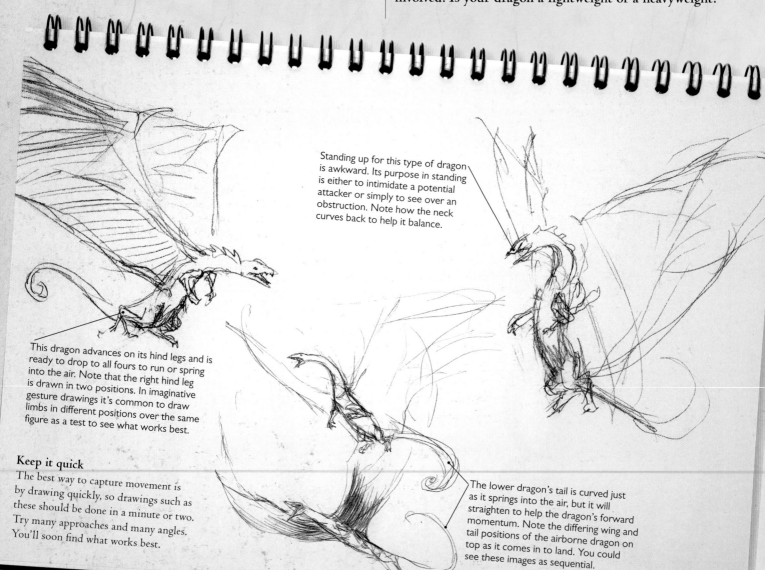

Standing up for this type of dragon is awkward. Its purpose in standing is either to intimidate a potential attacker or simply to see over an obstruction. Note how the neck curves back to help it balance.

This dragon advances on its hind legs and is ready to drop to all fours to run or spring into the air. Note that the right hind leg is drawn in two positions. In imaginative gesture drawings it's common to draw limbs in different positions over the same figure as a test to see what works best.

Keep it quick

The best way to capture movement is by drawing quickly, so drawings such as these should be done in a minute or two. Try many approaches and many angles. You'll soon find what works best.

The lower dragon's tail is curved just as it springs into the air, but it will straighten to help the dragon's forward momentum. Note the differing wing and tail positions of the airborne dragon on top as it comes in to land. You could see these images as sequential.

Using action lines

To feel the force of your dragon, you need to think about the way you as a human move. What position would you take if you were spitting out fire, making a quick turn as you run, or leaping into the air? Imagine yourself as a dragon, and feel this as you draw. To give your action pieces more force, simplify your drawings into action lines, as shown on the right.

Drawing dragons in action isn't an exact science but something you have to feel in the form of body movement. The sense of how your own body and other bodies move is called kinesthesia. If you can access that as you draw it will help you a great deal, but you'll still have to keep in mind how an animal that's different from you will move as well. Anthropomorphizing too much will keep you from creating a greater variety of dragons.

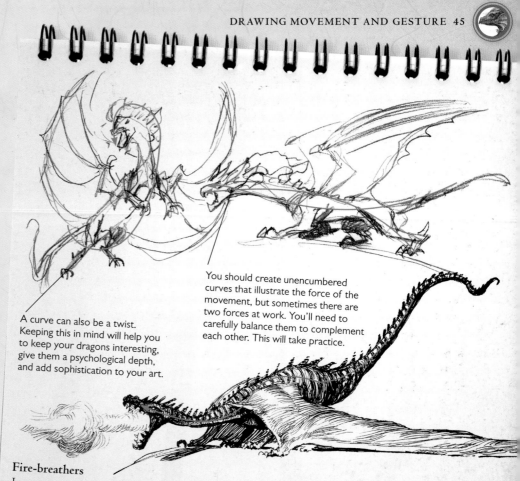

A curve can also be a twist. Keeping this in mind will help you to keep your dragons interesting, give them a psychological depth, and add sophistication to your art.

You should create unencumbered curves that illustrate the force of the movement, but sometimes there are two forces at work. You'll need to carefully balance them to complement each other. This will take practice.

Fire-breathers

In most cases, dragons breathe fire in defense and in anger, so a dragon will take on an angry and defensive posture when it is partaking in the act.

Its gesture will need to be dramatic, and this is something you'll need to bear in mind when drawing or painting your dragon. Where a cat might arch its back and hiss, a dragon will do the same but spray fire. A dragon's lines of action will indicate a forward thrust when it spits out flames.

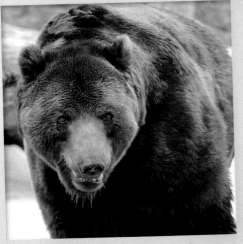

If a human was on his hands and knees, the shoulders would stick out to the side because of clavicle and scapula placement. The bear's don't.

THE BEAR FACTS ON ACTION

You might think that you'll need to do more when you draw a dragon in action than imagine a human in action, so why not look to the bear?

Studying the bear might seem odd, but if you want to study a particular animal in terms of a dragon in movement—other than in flight—the bear moves much like a dragon would. A bear runs on all fours but can easily stand up and grasp objects or even walk on two legs, however awkwardly, for short distances. Bears do not have human-type shoulders and clavicle placement. In fact, from the neck down they are very much like dragons— if you replace the fur with scales, that is.

Although bears and dragons don't have a simian (i.e., human or monkey-type) torso, they can both do much of what humans do, so you can use human gesture movements when making your dragons. It's not out of the question to make a dragon with human shoulders, but that dragon won't run well on all fours and it won't be able to walk like a human.

Anatomical differences

The clavicle and scapula arrangement of animals that run on all fours means they have a greater stride and better shock absorption in their front legs than humans. The bear has a bit more flexibility here than other four-legged animals, and so it is a good animal to refer to as an example of dragon movement.

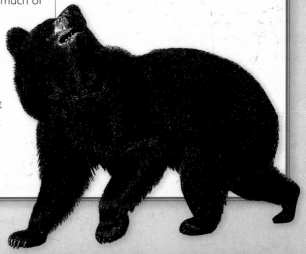

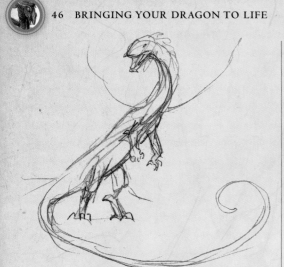

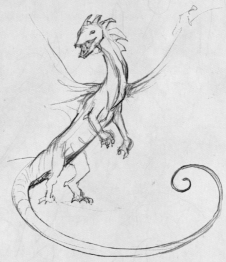

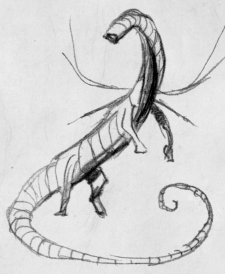

Step 1:

Know the feeling you're going for. It can run the range from subtle to extreme and still come across in very few lines. Establish the dragon's movement with quick lines. Now is not the time to worry about a clean-looking picture.

Step 2:

Remove the lines you don't like from your drawing. Lightly draw in lines for muscle placement. As you draw, try not to give up any of the sense of movement. Details tend to hide movement and you should aim to keep as much as you can.

Step 3:

Movement will always take place through all three dimensions. Do a separate quick sketch like this as a reference guide so as you add your details, your dragon doesn't become flat. Once you do a few of these, thinking like this will become second nature. This is also a nice way to establish your light source and shadows, before adding them to the finished piece.

Developing dragon form

Once you've gotten the action you want with quick gesture sketches, you can use them as a basis from which to draw a fully articulated and detailed dragon. Many artists print out their quick sketches at a larger size and trace over them to match movement closely, although you may prefer to redraw because something new and interesting might happen when you do so. Even when you have a nice action thumbnail you should draw it again even smaller. The smaller you make it, the more likely you'll eliminate the unnecessary lines that interrupt the action.

As you are developing your action drawing, it's important to remember that the more strenuous the dragon's movements are, the more its muscles will stand out. Tendons will pop between the muscles and the joints like tightly banded ropes. Also, the more a muscle is strained, the more angular it becomes. In a lean dragon even the muscle fibers will show. These are important considerations if you are working toward creating a realistic and lifelike dragon.

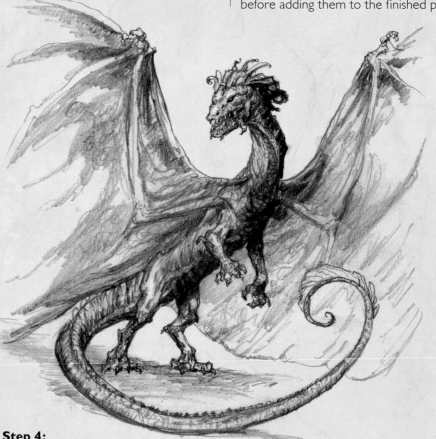

Step 4:

Nothing gives a dragon weight and reality like heavy shadows. This is called chiaroscuro and it works very well at making dragons both powerful looking and dramatic. Taking the established shadows from step 3, lay them in as midtones and darken them when you feel confident in their placement. At this point, if you like, you can look at some sort of photographic reference for surface details.

Giving your dragon a personality

We humans anthropomorphize everything. Several pages in this book are devoted to doing just that with dragons, but only as a tool for understanding. Because we're so homocentric, we see ourselves in everything from pets, trees, and cars, to the weather. Sometimes we even see our deities on burned toast. We're mightily self-centered creatures. The fact is that other animals are different from us and there's a lot we can learn from them, especially when it comes to dragons. Your dragons may certainly possess human qualities, but let's not forget the wide array of possibilities in the vast animal kingdom. At this juncture, toss out your human bones and gestural tendencies in favor of the greater variety offered by other species.

Horse-like dragon

If you want your dragon to stand proudly, study the stance of a horse and incorporate key aspects into your dragon's pose.

Animal demeanor

We've looked at how you can study animal anatomy to better understand how a dragon is constructed, but what about animal personality? Every creature has its own collection of demeanors, and you can capitalize on that when creating your dragons. You can make your dragon ferocious by thinking of lions when you draw it; or it can be a curled-up, lazy fellow comparable to a house cat. Alternatively, imagine a playful puppy and it can easily take on the quality of a happy-go-lucky young dragon. Let this type of thinking happen naturally rather than by looking at pictures of animals. You can always do that later as you refine your drawing.

Placid dragon

For an easy-going, docile dragon, your mind, attuned to the animal kingdom, couldn't do much better than the relaxed demeanor of a toad.

Drawing dragon demeanor

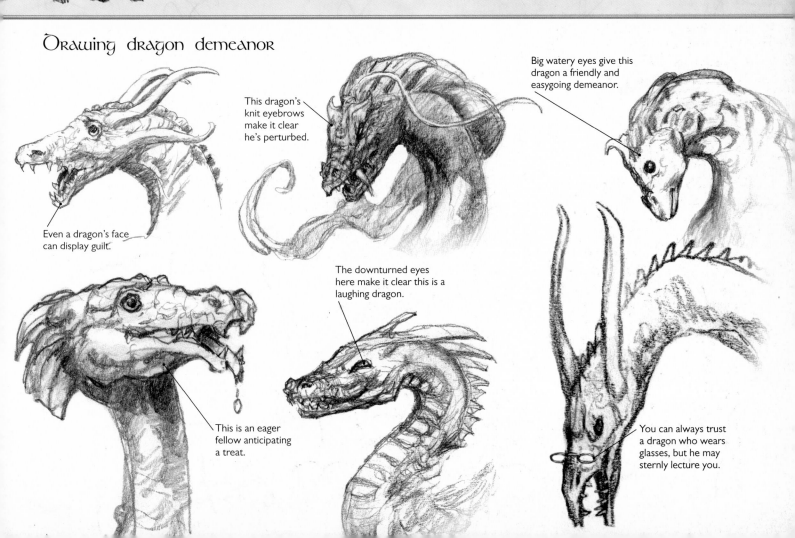

This dragon's knit eyebrows make it clear he's perturbed.

Big watery eyes give this dragon a friendly and easygoing demeanor.

Even a dragon's face can display guilt.

The downturned eyes here make it clear this is a laughing dragon.

This is an eager fellow anticipating a treat.

You can always trust a dragon who wears glasses, but he may sternly lecture you.

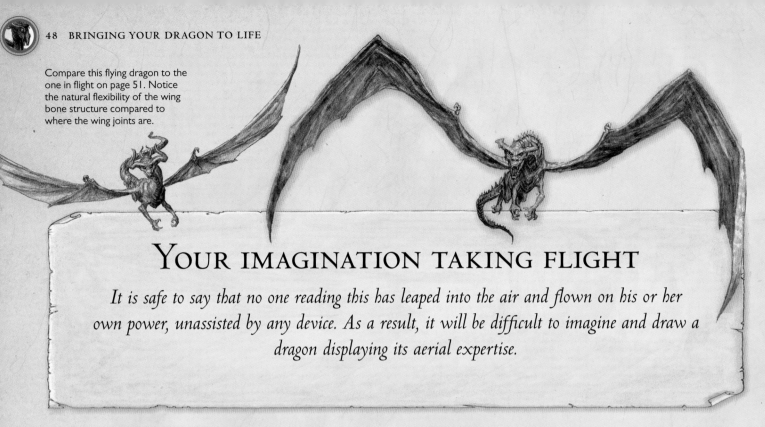

Compare this flying dragon to the one in flight on page 51. Notice the natural flexibility of the wing bone structure compared to where the wing joints are.

YOUR IMAGINATION TAKING FLIGHT

It is safe to say that no one reading this has leaped into the air and flown on his or her own power, unassisted by any device. As a result, it will be difficult to imagine and draw a dragon displaying its aerial expertise.

In the Comparative Anatomy section (pages 24–27), we looked at how you can imagine yourself turning into a dragon and flying. This requires you to envisage your arms turning into wings, and it applies again here. If you've ever flown a kite or felt an updraft on an umbrella, you have some sense of how dragon wings can provide lift. Along with forward momentum, the basic principle will get your dragon off the ground.

Keeping all this in mind, imagine that you're climbing into the clouds, raising and lowering your wings so that there's little resistance when you raise them up and forward and greater resistance as you pull them down and behind you. As you reach your desired height, you'll move your wings less but still in a slightly circular motion. You can choose to circle riding updrafts like a kite, or if you have a great distance to travel you can maintain a regular wing beat. If you're in search of prey and spot it, you can pull your wings back and go into a steep but arcing dive. Unlike birds, you can choose between your front hands or back claws, or use all four to grab your lunch if it's particularly large. To come in for a landing you can use your wings like a parachute to land softly on your hind legs and drop to all fours. Now you've mastered dragon flight . . . in your imagination.

BIRDS IN FLIGHT

You should certainly spend some time studying birds. If you can, take pictures of them in flight. This will build your visual catalog and help you when you want to make your dragons fly realistically. If you watch a heron fishing, you'll see it leap into the air and fly around with its long neck bent backward. This giant bird is both elegant and awkward, and so odd looking that it could easily be the mythical creature, and the dragon the real living one.

Structurally, dragon and bird wings, although at first glance it doesn't seem so, are the same. The aerial acrobatics of birds will be close to those of dragons and bats. If you're having some difficulty getting your dragons into the air, start with a bird and transmogrify it into a dragon.

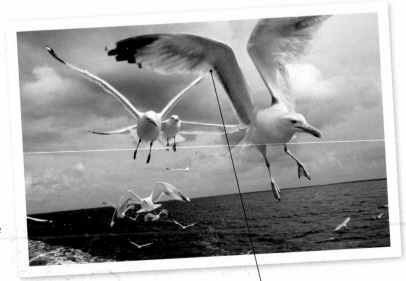

Note how this bird's wings hinge the same way as the dragon's directly above.

Wing flexibility in action

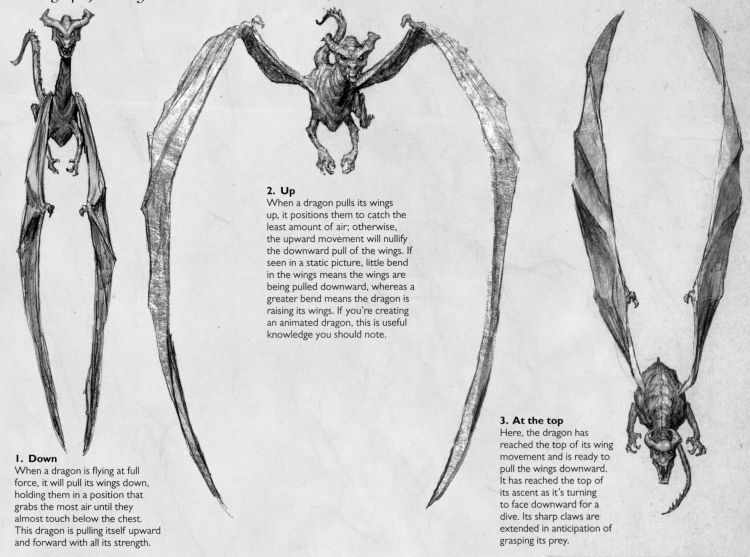

1. Down
When a dragon is flying at full force, it will pull its wings down, holding them in a position that grabs the most air until they almost touch below the chest. This dragon is pulling itself upward and forward with all its strength.

2. Up
When a dragon pulls its wings up, it positions them to catch the least amount of air; otherwise, the upward movement will nullify the downward pull of the wings. If seen in a static picture, little bend in the wings means the wings are being pulled downward, whereas a greater bend means the dragon is raising its wings. If you're creating an animated dragon, this is useful knowledge you should note.

3. At the top
Here, the dragon has reached the top of its wing movement and is ready to pull the wings downward. It has reached the top of its ascent as it's turning to face downward for a dive. Its sharp claws are extended in anticipation of grasping its prey.

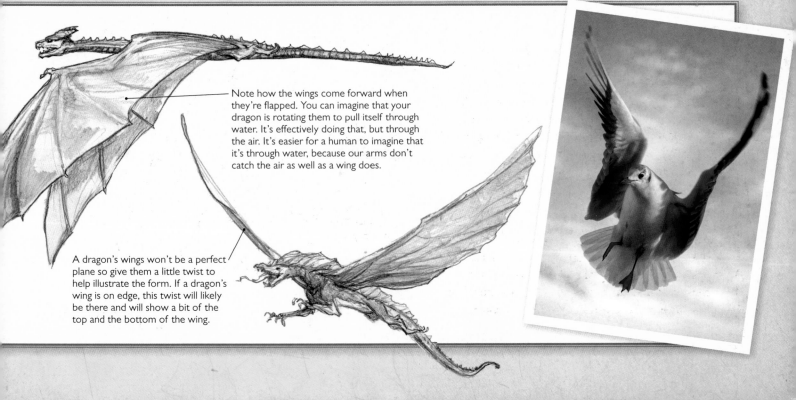

Note how the wings come forward when they're flapped. You can imagine that your dragon is rotating them to pull itself through water. It's effectively doing that, but through the air. It's easier for a human to imagine that it's through water, because our arms don't catch the air as well as a wing does.

A dragon's wings won't be a perfect plane so give them a little twist to help illustrate the form. If a dragon's wing is on edge, this twist will likely be there and will show a bit of the top and the bottom of the wing.

Flight poses

Whether your dragon has just taken to the air, is mid-flight and soaring through the sky, circling in search of prey or diving down to catch it, you'll need a variety of poses at your disposal to suit your dragon's every need. Again, spend some time familiarizing yourself with birds in flight (birds of prey are ideal), and take note of the shapes formed by their bodies at different stages of flight. Studying bird and bat wing mechanics and motions will help you understand how wings move, lift, and thrust, and will allow your dragon to leap, glide, fly, and dive convincingly. A selection of wing poses are shown here; for more, see the templates provided on pages 116–125.

Aerial turns

Because a dragon is often a gangly six-limbed creature, you will need to show its body reacting more to aerial turns than you would a bird. Your typical bird's body is more compact. Imagine that, in mid-flight, this dragon sees something of great interest appear. To help it make a quick turn, it bends its arms backward to reduce drag.

Steep dive

This is the start of a steep dive. Note how the dragon's legs seem to have just pushed off of something. When drawing a dragon in action like this, it's important to imagine that you're there: feel the wind, the sudden drop that you sense in your stomach, the strong torque of unexpected twists, and the jarring power of sudden turns, and hear the sound of the dragon's giant flapping wings. This won't be a smooth ride.

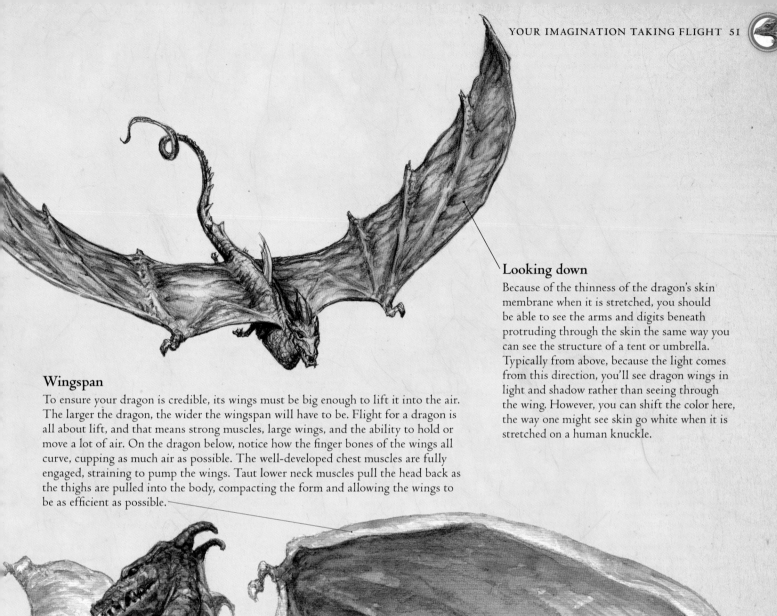

Looking down

Because of the thinness of the dragon's skin membrane when it is stretched, you should be able to see the arms and digits beneath protruding through the skin the same way you can see the structure of a tent or umbrella. Typically from above, because the light comes from this direction, you'll see dragon wings in light and shadow rather than seeing through the wing. However, you can shift the color here, the way one might see skin go white when it is stretched on a human knuckle.

Wingspan

To ensure your dragon is credible, its wings must be big enough to lift it into the air. The larger the dragon, the wider the wingspan will have to be. Flight for a dragon is all about lift, and that means strong muscles, large wings, and the ability to hold or move a lot of air. On the dragon below, notice how the finger bones of the wings all curve, cupping as much air as possible. The well-developed chest muscles are fully engaged, straining to pump the wings. Taut lower neck muscles pull the head back as the thighs are pulled into the body, compacting the form and allowing the wings to be as efficient as possible.

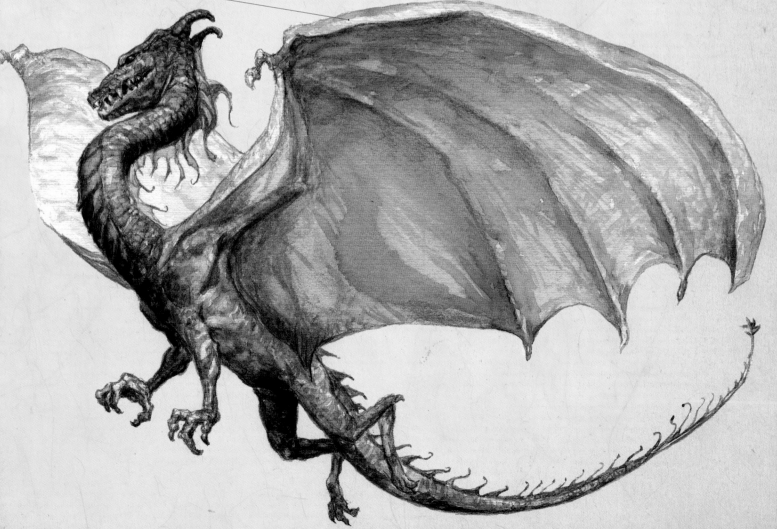

The color of light
In this image the sunlight looks particularly yellow because
of the yellow shift of rocks on the cliff sides. With any
painting, you'll need to know the color of an object and
the color of the light source. Note how the closest dragon
stands out against the bright light reflected off the water.

ENVIRONMENT

Once you've developed your dragons, you'll need someplace for them to live—unless you've already created an environment and subsequently imagined dragons that have evolved to thrive in it. Either approach is a fine one. Whatever the case may be, you'll want to imagine more than you're going to actually paint. Think big.

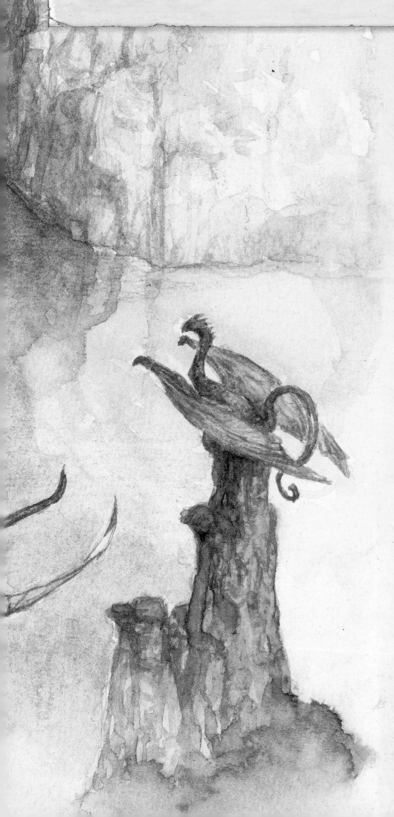

There are a number of considerations that must be taken into account when creating an environment fit for a dragon. Your dragons will need a safe place to raise their young and food to fill their bellies: fish, goats, cattle, or people. As far as we know, all dragons hatch from eggs, and those eggs will be subject to possible consumption by other hungry animals. Any wild dragon would likely live high above where most other creatures can ascend. You should ask yourself if your dragon lives in isolation, with a family, or in a community of other dragons. Does your dragon possess humanlike sentience, and can it make art, architecture, or machines? All this will influence whatever surroundings you invent. The more questions you ask yourself, the more you'll stimulate your imagination and the more convincing your fantasy environment will be.

Build a visual catalog

If you've never drawn or painted a landscape before, making up an environment is likely to be a difficult task for you. Studying nature is a good way to start; go outside and draw or paint from life before trying to invent a landscape. Becoming a keen observer of the world around you, especially if you also try to draw based on your memory of something you've seen, will help you to learn and build a visual catalog. This catalog will prove a useful resource in stimulating ideas when you are inventing fantasy environments for your dragon to inhabit. You'll also train your brain to remember what you see, and your brain will grow to retain this new information—and not just metaphorically, but literally, too. It's been shown with MRI technology that the more you use the visual part of the brain, the larger it becomes.

Things to consider

In order to make your fantasy environment convincing, there are a few key things to bear in mind when drawing or painting.

Perspective should be a prime consideration when creating any landscape or environment scene. In such a scene, all objects should appear smaller as they recede, or bigger as they near. This may seem a simplistic statement,

but it's something that can be easily forgotten when inventing a scene without geometrically shaped objects from which to draw perspective lines. If the components of your scene are to look proportionate and plausible, you'll need to ensure that such perspective rules are observed.

In atmospheric perspective, objects lose contrast when they recede. This is usually as a result of water particles (or humidity) in the air or dust. Once you have decided on where your dragon will live, consider how the surrounding atmosphere might influence the colors and textures that make up your scene.

Light and shadow have important roles to play in art. All objects have a lit side and a side in shadow, unless they are lit solely by diffused light from all directions. Smooth areas on an object will reflect like a mirror and create highlights. These are called specular highlights. Before you begin to paint, consider where your light source is coming from—what will be illuminated, and what will be cast in shadow? Once you have ascertained where shadows and highlights will fall, you'll need to render them realistically. For more on painting light and shadow, see pages 76–79.

Lighting the scene

A natural and realistically rendered environment is lit with direct, diffused, and bounced light. It usually comes from the sun or the moon and follows Newton's laws of reflection. Before you begin a fully painted scene, you'll need to know the origin of your main light source. Typically this is where the sun is in relation to the scene you'll paint—unless you're dealing with a light source

other than the sun, such as an object that's on fire. The sun may light your scene from directly above; a setting sun somewhere on the horizon may be your light source; or the sun may be behind clouds or setting from an angle not even seen. You need to decide on the position of your light source and also be aware of that which can't be seen before you begin to paint. If you choose to use watercolor, you'll need to plan out the light in your painting well. Although you can make some changes with watercolors, it's not as easy as it is with oils or acrylics.

Diffused light

Our atmosphere causes some light to be scattered, and unless you are in space, you will be surrounded by this diffused light. Diffused light will have its own color, and that color will shift shadows in the direction of the light. Blue is a common choice for a diffused color since most situations on Earth require it, but there are many exceptions to this condition. This blue shift is most noticeable when the sun sets and can be easily seen in shadows across a white surface. The key thing to keep in mind when painting is that without diffused light to fill them, shadows would be black.

Daybreak
The thing to note in this scene is the warmness of early morning light, how it reflects off the water below and is seen translucently through the flying dragons' wings. To capture the rich colors needed for this landscape scene, oil paints were chosen.

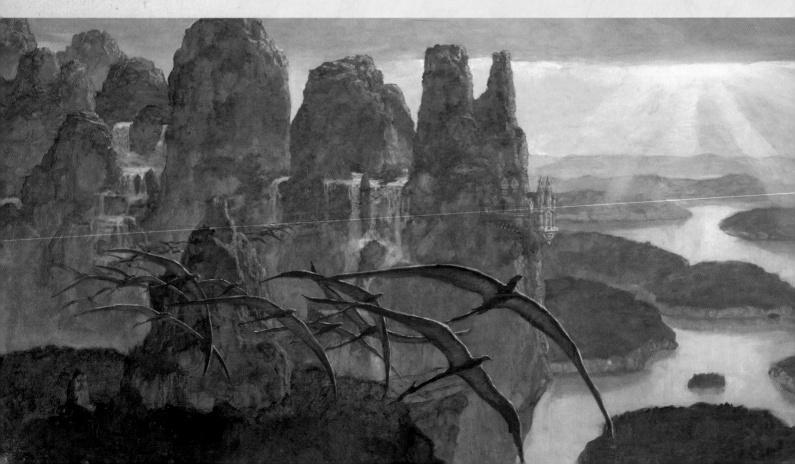

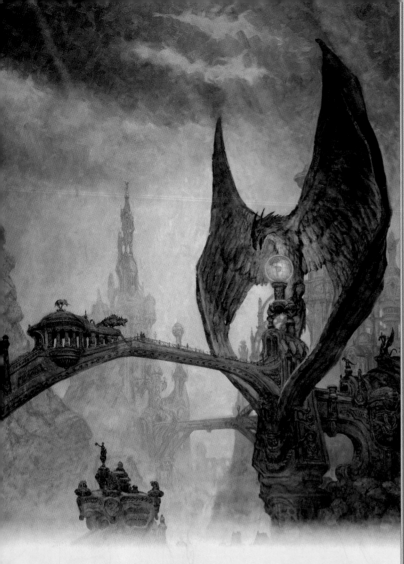

Suggesting a story
In this oil painting, muted and unusual colors are used to depict a dark view of a terrible place and to make the viewer feel uneasy. The composition invites you in to cross the long, impossibly high bridge and to pass under the huge dragon sculpture into a place that's intriguing but clearly dangerous. This might be an entry to a dark castle that is filled with evil, but there are a wealth of other storytelling possibilities. Use your scene to ignite the viewer's imagination.

Bounced light

If light didn't bounce off of objects we wouldn't be able to see them—everything would be black. One sliver of direct light making it into a dark room will bounce around, lighting up that room in soft tones. Do your best to imagine where objects or creatures might pick up bounced light. For example, if you have a dragon next to a large, beige rock, the light from that rock will likely reflect onto the dragon, giving it warm tones in its shadows.

FOUR APPROACHES TO CREATING A SCENE

You may already have your own preferred approach to creating fantasy scenes, or you may use a combination of approaches or find a method that works best for you as you become more practiced. Whatever the case, below are four different approaches to creating a dragon scene.

METHOD 1: Imagine all

The first and most rewarding method, but also the most difficult approach, is to make it all up. You'll need to think through everything: the lighting, the shapes of your objects and their textures, how the scene came to be, and where the action will be. Doing this over and over will help you develop good imagining skills that you can put to work in everyday life. Paint scene after scene and then compare them to similar scenes in nature—you'll soon learn how to mimic nature's patterns.

Be inventive by using nature
Birds are great fishers. Some species can dive off of cliffs and deep into water to catch fish. If birds can dive into water like this, why can't a dragon? Feel free to use nice parallels you find in nature for your dragons. Nature holds no copyrights.

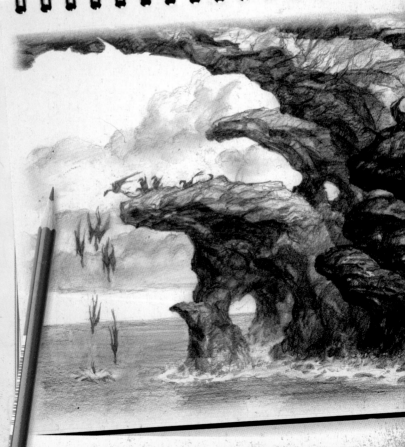

METHOD 2: Use 3-D forms

The second approach, and one that can be combined with the first, is to look around for small, three-dimensional objects that resemble what you've imagined or that you've already done a sketch for. Once you can see your object(s) roughly constructed and lit by the appropriate light, it should help you improve your drawing. Try making figurines out of clay, or even a rough sculpture with a kneaded eraser—such exercises will help you to understand form.

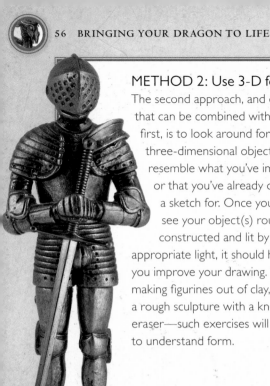

Bringing life to 3-D forms

If you study the basic structure of a 3-D form, you can extrapolate it into a scene and into any position you want. This toy knight has been given life in the drawings on the right.

METHOD 3: Computer-aided design (CAD)

There are a number of computer programs that will help you create a scene, and you can certainly learn a great deal working with these. You can use these programs to import photographs and textures, build model structures on which to base your scene, and then render a fully formed and idealized dragon environment. This approach can also be combined with the first two methods. Working back and forth between them will help train you to imagine better.

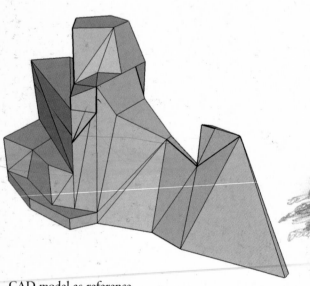

CAD model as reference

This little model of a rocky cliff was made with a free program called SketchUp. It can be downloaded from the Internet at *http://sketchup.google.com/*. It's a nice place to start if you've never tried 3-D drawing.

Drawing from a CAD beginning

This sketch is based on the SketchUp model. Using such models is a way to springboard into 3-D thinking or to break from your standard thinking because you're using a medium you are not so familiar with.

METHOD 4: Use photographic reference

Your fourth option is to draw upon photographs, although this approach works best when combined with the earlier approaches, rather than as a sole method. Don't start from a photograph. Although it's fine to study photographs to better understand how light and color work in nature, it's a mistake to copy them too closely, as your dragon is unlikely to fit the photographed scene and may stand out in a superimposed manner. Similarly, if you assemble a range of photos to make a picture, you'll likely find yourself in trouble because each photo will have different light sources and angles. Your picture will lack the organic quality of an imagined picture. It's much better to imagine something first and do your best to draw it before turning to any kind of reference. Feel free to use photographs of scenes and landscapes (unless you're in danger of copyright infringement), but note that understanding the principles of the natural world will lead to more inventive pictures.

Watercolor effects

Watercolor is an excellent medium for natural forms such as the rocky landscape shown here. Experiment with drips, blotting, making beads of water, and simply sloshing it around to see what effects are yielded. You may make a mess but, over time, you'll become familiar with the properties and natural beauty of the medium.

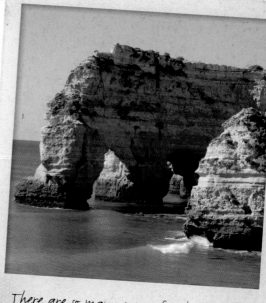

There are so many types of rock structures that it's a good idea to study them all.

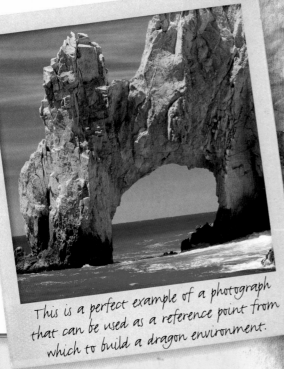

This is a perfect example of a photograph that can be used as a reference point from which to build a dragon environment.

GNEMO

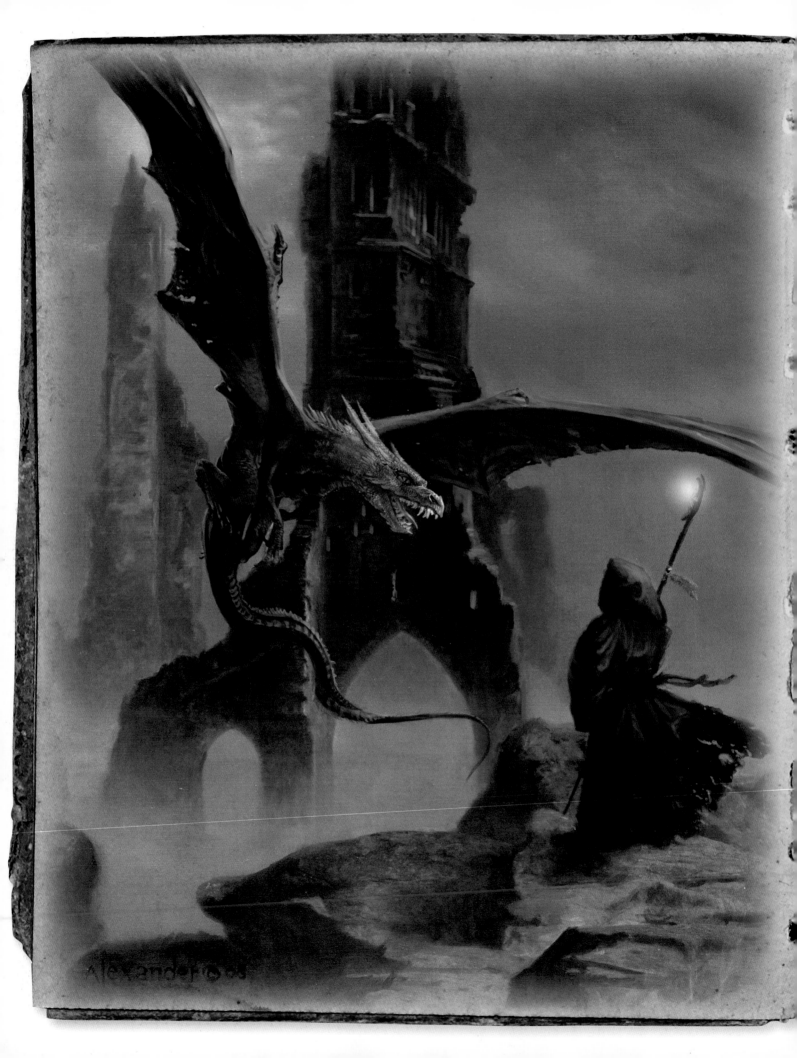

Light, color, and texture

Your job as an artist is to bring out all the subtleties of nature with dabs of a viscous to runny fluid called paint. Not all of us can have a dragon assistant, but it's helpful if you can imagine one. The mischievous little fellow below may seem simple but he's actually a tiny symphony of light, texture, and color. These are the magical tools that will give your dragons substance and presence. Without them, your dragons will be flat. This section will show you how to use these tools effectively and the techniques to accomplish fully formed, three-dimensional dragons.

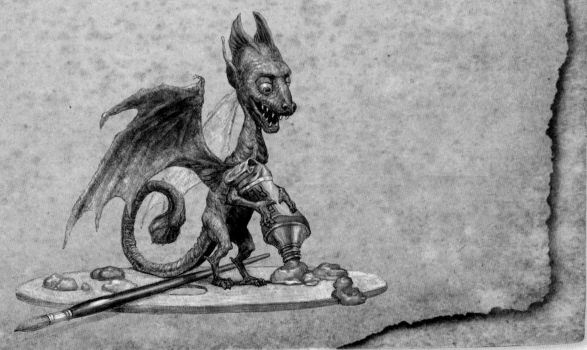

THE ARTIST'S TOOLKIT

To create your own dragon art using traditional drawing and painting methods, you will need a selection of tools and materials. Shown here are a selection of materials and media used in the book. You may already have a favorite medium, or you may like to work with a combination— experiment and find out what works best for you. If you prefer to work digitally, turn to pages 64—67 for more information.

I

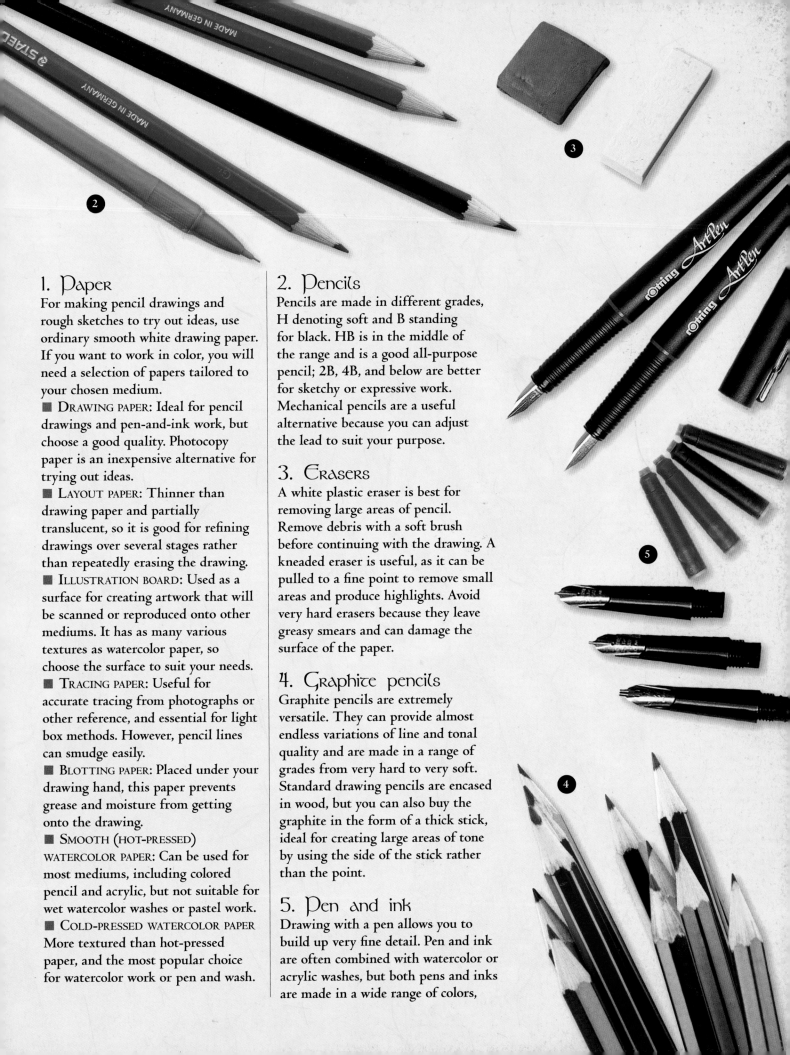

1. Paper

For making pencil drawings and rough sketches to try out ideas, use ordinary smooth white drawing paper. If you want to work in color, you will need a selection of papers tailored to your chosen medium.

■ DRAWING PAPER: Ideal for pencil drawings and pen-and-ink work, but choose a good quality. Photocopy paper is an inexpensive alternative for trying out ideas.

■ LAYOUT PAPER: Thinner than drawing paper and partially translucent, so it is good for refining drawings over several stages rather than repeatedly erasing the drawing.

■ ILLUSTRATION BOARD: Used as a surface for creating artwork that will be scanned or reproduced onto other mediums. It has as many various textures as watercolor paper, so choose the surface to suit your needs.

■ TRACING PAPER: Useful for accurate tracing from photographs or other reference, and essential for light box methods. However, pencil lines can smudge easily.

■ BLOTTING PAPER: Placed under your drawing hand, this paper prevents grease and moisture from getting onto the drawing.

■ SMOOTH (HOT-PRESSED) WATERCOLOR PAPER: Can be used for most mediums, including colored pencil and acrylic, but not suitable for wet watercolor washes or pastel work.

■ COLD-PRESSED WATERCOLOR PAPER More textured than hot-pressed paper, and the most popular choice for watercolor work or pen and wash.

2. Pencils

Pencils are made in different grades, H denoting soft and B standing for black. HB is in the middle of the range and is a good all-purpose pencil; 2B, 4B, and below are better for sketchy or expressive work. Mechanical pencils are a useful alternative because you can adjust the lead to suit your purpose.

3. Erasers

A white plastic eraser is best for removing large areas of pencil. Remove debris with a soft brush before continuing with the drawing. A kneaded eraser is useful, as it can be pulled to a fine point to remove small areas and produce highlights. Avoid very hard erasers because they leave greasy smears and can damage the surface of the paper.

4. Graphite pencils

Graphite pencils are extremely versatile. They can provide almost endless variations of line and tonal quality and are made in a range of grades from very hard to very soft. Standard drawing pencils are encased in wood, but you can also buy the graphite in the form of a thick stick, ideal for creating large areas of tone by using the side of the stick rather than the point.

5. Pen and ink

Drawing with a pen allows you to build up very fine detail. Pen and ink are often combined with watercolor or acrylic washes, but both pens and inks are made in a wide range of colors,

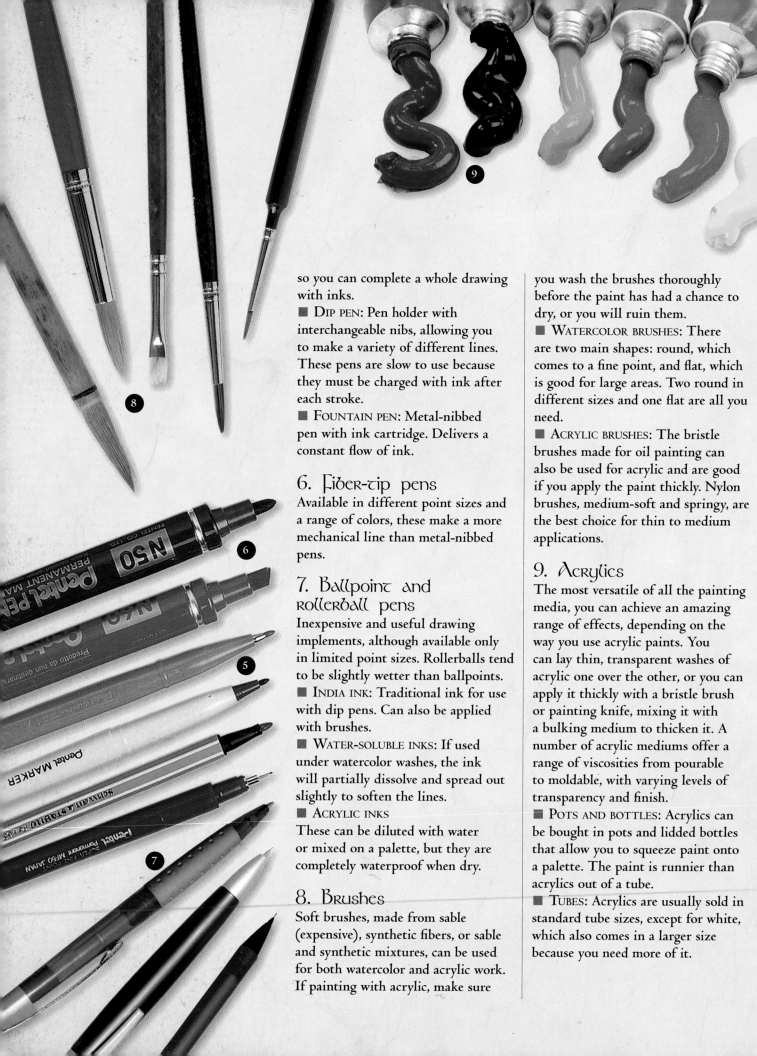

so you can complete a whole drawing with inks.

- **DIP PEN:** Pen holder with interchangeable nibs, allowing you to make a variety of different lines. These pens are slow to use because they must be charged with ink after each stroke.
- **FOUNTAIN PEN:** Metal-nibbed pen with ink cartridge. Delivers a constant flow of ink.

6. Fiber-tip pens
Available in different point sizes and a range of colors, these make a more mechanical line than metal-nibbed pens.

7. Ballpoint and rollerball pens
Inexpensive and useful drawing implements, although available only in limited point sizes. Rollerballs tend to be slightly wetter than ballpoints.

- **INDIA INK:** Traditional ink for use with dip pens. Can also be applied with brushes.
- **WATER-SOLUBLE INKS:** If used under watercolor washes, the ink will partially dissolve and spread out slightly to soften the lines.
- **ACRYLIC INKS**
These can be diluted with water or mixed on a palette, but they are completely waterproof when dry.

8. Brushes
Soft brushes, made from sable (expensive), synthetic fibers, or sable and synthetic mixtures, can be used for both watercolor and acrylic work. If painting with acrylic, make sure

you wash the brushes thoroughly before the paint has had a chance to dry, or you will ruin them.

- **WATERCOLOR BRUSHES:** There are two main shapes: round, which comes to a fine point, and flat, which is good for large areas. Two round in different sizes and one flat are all you need.
- **ACRYLIC BRUSHES:** The bristle brushes made for oil painting can also be used for acrylic and are good if you apply the paint thickly. Nylon brushes, medium-soft and springy, are the best choice for thin to medium applications.

9. Acrylics
The most versatile of all the painting media, you can achieve an amazing range of effects, depending on the way you use acrylic paints. You can lay thin, transparent washes of acrylic one over the other, or you can apply it thickly with a bristle brush or painting knife, mixing it with a bulking medium to thicken it. A number of acrylic mediums offer a range of viscosities from pourable to moldable, with varying levels of transparency and finish.

- **POTS AND BOTTLES:** Acrylics can be bought in pots and lidded bottles that allow you to squeeze paint onto a palette. The paint is runnier than acrylics out of a tube.
- **TUBES:** Acrylics are usually sold in standard tube sizes, except for white, which also comes in a larger size because you need more of it.

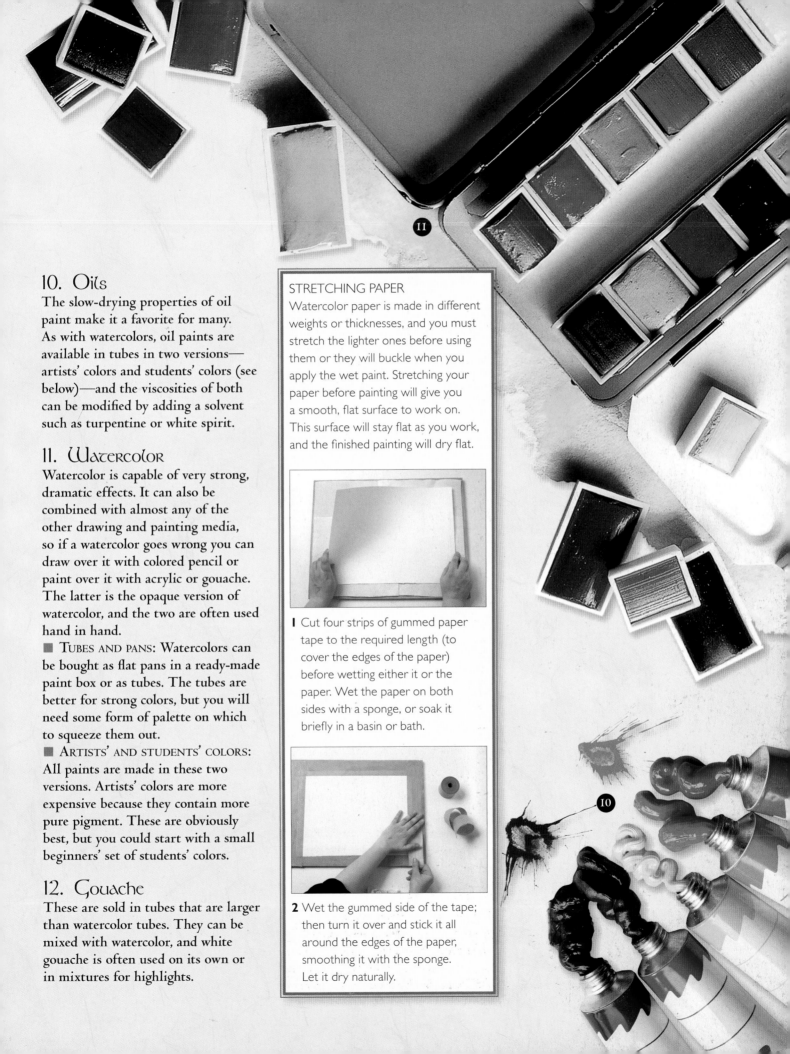

10. Oils

The slow-drying properties of oil paint make it a favorite for many. As with watercolors, oil paints are available in tubes in two versions—artists' colors and students' colors (see below)—and the viscosities of both can be modified by adding a solvent such as turpentine or white spirit.

11. Watercolor

Watercolor is capable of very strong, dramatic effects. It can also be combined with almost any of the other drawing and painting media, so if a watercolor goes wrong you can draw over it with colored pencil or paint over it with acrylic or gouache. The latter is the opaque version of watercolor, and the two are often used hand in hand.

■ TUBES AND PANS: Watercolors can be bought as flat pans in a ready-made paint box or as tubes. The tubes are better for strong colors, but you will need some form of palette on which to squeeze them out.

■ ARTISTS' AND STUDENTS' COLORS: All paints are made in these two versions. Artists' colors are more expensive because they contain more pure pigment. These are obviously best, but you could start with a small beginners' set of students' colors.

12. Gouache

These are sold in tubes that are larger than watercolor tubes. They can be mixed with watercolor, and white gouache is often used on its own or in mixtures for highlights.

STRETCHING PAPER

Watercolor paper is made in different weights or thicknesses, and you must stretch the lighter ones before using them or they will buckle when you apply the wet paint. Stretching your paper before painting will give you a smooth, flat surface to work on. This surface will stay flat as you work, and the finished painting will dry flat.

1 Cut four strips of gummed paper tape to the required length (to cover the edges of the paper) before wetting either it or the paper. Wet the paper on both sides with a sponge, or soak it briefly in a basin or bath.

2 Wet the gummed side of the tape; then turn it over and stick it all around the edges of the paper, smoothing it with the sponge. Let it dry naturally.

WORKING WITH DIGITAL MEDIA

Your choice of computer is your preference. Apple Macintosh is the preferred system among digital drawing professionals, but most industry-standard software is available on both Mac and PC. Most PC operating systems include a program that allows you to draw, paint, and edit images. Microsoft Paint, for example, is part of Windows, and although slightly primitive, it is a good place to start experimenting with digital drawing. You can draw freehand and create geometric shapes, pick colors from a palette or create new custom colors, and combine visual images with type. Scanners also include a basic photo-editing and drawing package or a reduced version of one of the more professional packages.

Tools and equipment

As you begin to discover the possibilities of drawing on-screen, you will probably want to upgrade to more sophisticated software. There are many options, although some programs can be expensive. However, as these are continually being revised and improved, it is often possible to pick up older versions quite cheaply. One of these is Painter Classic I, which is easier to use than the more complex later versions and offers a wide range of drawing implements. Another is Photoshop Elements, which, although basically a photo-editing program, also allows for the production of original drawn and painted images. The other vital pieces of equipment are a stylus and drawing tablet, and a scanner for scanning your drawings or reference images such as background material that you can then digitally paint over.

From drawing to color

Your base drawing can either be a scan of a traditional drawing or drawn digitally in a pixel-based program such as Photoshop. The brush or pencil tool can be used to create a line similar to that of range of point media from pencils to pen and ink or even charcoal. This base drawing might remain a visible element in the finished piece, or you might paint over it, or have it in a hidden underlayer made visible only for your reference (see the box on layers on page 66).

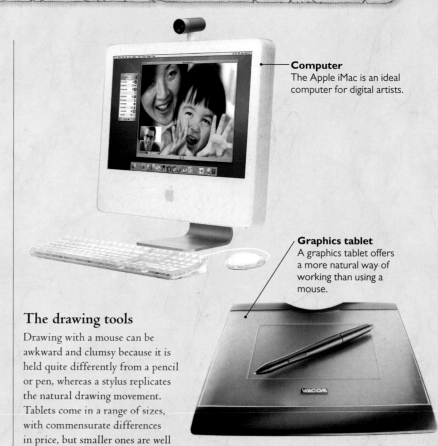

Computer
The Apple iMac is an ideal computer for digital artists.

Graphics tablet
A graphics tablet offers a more natural way of working than using a mouse.

The drawing tools

Drawing with a mouse can be awkward and clumsy because it is held quite differently from a pencil or pen, whereas a stylus replicates the natural drawing movement. Tablets come in a range of sizes, with commensurate differences in price, but smaller ones are well within the budget of most artists.

Scanner
Most scanners have high optical resolutions that are adequate for scanning line work to be colored digitally.

Tool bars, menus, palettes

There are various ways for you to control your work. The main tool bar contains all the principal tools, including ones for selection, drawing, and cloning. The other menus, palettes, and swatches give you mastery over all the tools in the tool bar. Your control over color and the effects that you can create are an important part of your artistic repertoire.

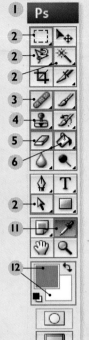

PHOTOSHOP: The coloring tools

There is a range of standard tools in the tool bar (**I**), including tools for selection (**2**), retouching (**3**), cloning (**4**), erasing (**5**), paint bucket (**6**), and more. Having selected your tool there are three ways to select colors in Photoshop: selecting from a standard or personalized grid (**7**), or picking from a rainbow color bar (**8**), or mixing colors using sliders (**9**) and a rainbow bar (**10**). It is also easy to match a color in your work by clicking on the eyedropper tool (**11**) and then on the color you wish to match. The foreground and background boxes (**12**) in the tool bar used with the large color picker window (**13**) give you control over areas of color. There is a range of standard brushes and drawing tools and options for customizing them (**14**.)

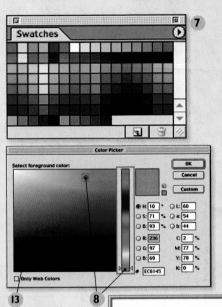

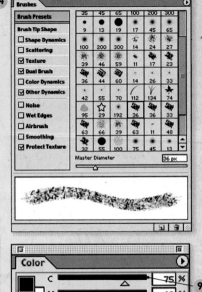

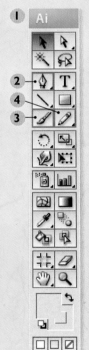

ILLUSTRATOR: The coloring tools

Illustrator's tool bar (**I**) is similar to Photoshop's with pens (**2**) brushes (**3**), and pencils (**4**) for mark marking. As Illustrator is a vector-based program, the pen lines have a different more solid character, and the brush and pencil lines can be modified in the brushes palette to give a more varied line (**5**). The program offers color options for linear work and solid areas. Colors can be selected in three ways: by picking off a color grid (**6**), using sliders of the constituent colors (**7**), or selecting from a rainbow color bar (**8**).

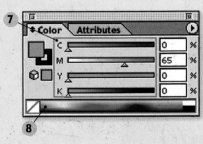

PAINTER: The coloring tools

A tool bar (**I**) with brush (**2**), pen (**3**), and paint bucket (**4**) are the implements to apply color. Color options in Painter are more sophisticated than those in Illustrator or Photoshop. The color selector (**5**) allows you to choose tone with the central triangle and control hue with the outer color wheel. Color can also be chosen with sliding bars (**6**), and tested in the sample window (**7**). You can match colors with the picker tool (**8**).

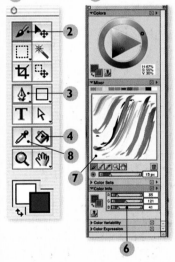

Various drop-down menus give you control over surface (**9**), drawing implement (**10**), and the sharpness or texture of the implement (**11**).

Coloring with layers

Most drawing, painting, and photo-editing programs allow you to experiment with different effects and compositions by using layers. Layers can be visualized as pieces of transparent film stacked on top of one another. When you make a drawing or scan in a photograph, it appears as a background layer called the canvas. If you create a new layer on top of this, you can work on it without altering the underlying image, because the layers are independent of each other. Similarly, you can work on the canvas without affecting any images on other layers.

Layers are especially useful for collage-type compositions, in which images, shapes, or textures are superimposed over others. This type of work involves making selections, which is the digital equivalent of cutting out a shape with scissors. Suppose you want to paste a drawing of a beast onto a hand-painted, textured, or photographic background. You would start with the background in the canvas layer, draw around the chosen image with one of the lasso tools to select it, and put it into a new layer (usually you will find a menu command such as "Layer via selection").

Selection is one of the main elements of digital work. It is the way you isolate the area that you want to work on. You can combine as many selections as you like in one image, and they don't have to be drawn or photographic—you could make collages with pieces of digitally colored or textured pieces of paper, or objects such as leaves that you can scan in. To try out different juxtapositions, you can change the stacking order of the layers at any time, and you can apply various effects to individual layers as well as alter the color and opacity.

PHOTOSHOP:
The layers palette

One of the most useful functions in Photoshop is the ability to put different elements on different layers. The layers window (**1**) allows you to turn the visibility of each layer on or off and to adjust transparency using the opacity percentage slider. A number of tools are available to select various parts of the image, all of which are found in the toolbar (**2**). The marquee tool (**3**) is useful for simple geometric shapes, the lasso tool (**4**) for drawing around chosen areas, the magic wand (**5**) for selecting areas where the color or tone is distinct, the eyedropper tool (**6**) to sample a color that is linked to a selection dialog box, which allows you to adjust the range of the selection through the fuzziness slider, and the quick mask tool (**7**), which allows you to paint a selected area.

PAINTER:
The layers palette

The layers palette (**1**) will help you organize your work, and if you make a mistake it is easier to rectify because you are dealing with only one layer at a time. If you are working with lots of layers, make sure you name them. In the tool bar (**2**) the selection tools contain the normal marquee tool (**3**), both round and circular, a lasso tool (**4**), a magic wand (**5**), an eyedropper (**6**) for selecting items of the same color, and a tool for resizing the selection (**7**).

Coloring with Photoshop

Photoshop is such a dense program—there's so much you can do with it that there's no way to show you all the things it's able to accomplish. Instead, the sequence below shows you how to color with it in a simple, down and dirty step-by-step. Note that you don't need to follow this approach exactly; you should experiment as much as you can. To follow this, you'll need a graphics tablet of some sort. A Wacom is used here.

Step 1:

Many artists draw directly into their computers, but it's best to start with an existing drawing. It doesn't need to be a particularly finished one. Even though this will be a color piece, start by scanning in "grayscale" to remove any color shift. Save as a Photoshop file.

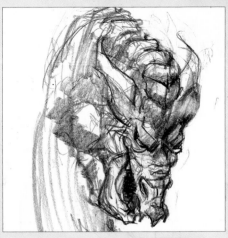

Step 2:

Convert the file to a "RGB Color" or a "CMYK Color" file. Using Image/Adjustments/Color balance, shift the drawing into a color you like. By shifting the color bars toward red and yellow, the above was moved to sepia with "Midtones" and "Highlights" chosen. Keep "Preserve Luminosity" checked.

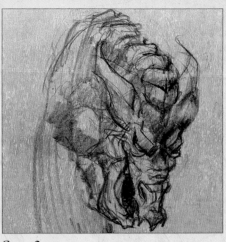

Step 3:

Drag in a texture you've scanned either from an area of a painting that is textural or a photograph that has a textural quality. This will give your piece a patina of painterly quality. Make this a "Multiply" layer (basically a transparent layer), or change the opacity of this layer to allow much of the drawing to show through.

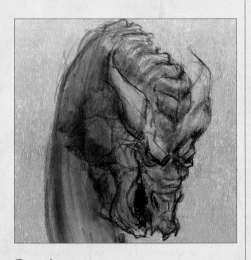

Step 4:

Make a new multiply layer to color over your texture layer. Set your tools (brush, pen, and rubber stamp) to the "Multiply" mode. This will produce rich colors and darker details. Set your tools to "Pen Pressure" so you can vary the opacity. Pressing harder on the pen tool will produce a deeper color. You can use the "Rubber Stamp" to select and draw with a texture from another file. Click the rubber stamp in the middle of it, go back to the art you want to color, and color.

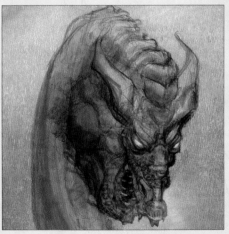

Step 5:

For highlights and light details, create another layer but make this one opaque. The advantage of layers is that you can make many changes without changing the other layers. Set your brush and other tools to "Normal." This will make your colors opaque. Set your brush to "Pen Pressure" so that you can vary the opacity of your line. This could be your last layer, or you may need to continue alternating between multiply and opaque layers.

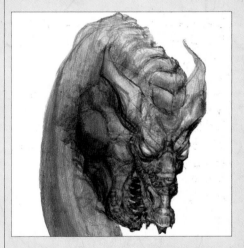

Step 6:

If you want to remove the background, use the "Magic Wand" to select your drawing, and then perfect the selection using the mask tool. It creates a red color for the area that won't be affected by something you do. You can paint it in and erase where needed. Hitting "Command + Q" brings it back and forth, going from red to a broken line. In the broken line mode, hit the delete button to remove the background. You may need to erase a little here and there to complete this.

COLOR

There are many different ways to color a dragon, the only limit being the artist's imagination. Following are examples of possible color combinations to help you begin work. The dragon color schemes featured here are not very complicated, and the red and green examples are the easiest to replicate.

Before you begin painting, make sure you have all the colors you need prepared on the palette. You also need to establish your light source—even if the painting will not include a background—to ensure your dragon will look realistic. Notice that the brightness of the colors in all three examples is typical for normal daylight.

Start with the darkest colors and lay the shadows and the dark parts of the dragon's body. At this initial stage, only apply a fine layer of paint; do not include finished details or impasto since these will likely become obstacles for further painting. Continue working with the basic colors, the "actual" colors of the dragon, as opposed to

deep shadows or reflected bright lights. At the end of this painting stage, lay the lightest colors, the highlights that accentuate muscle forms, giving the dragon's body realistic shape and therefore the visual illusion of three dimensions.

When working with watercolors or pencils, paint the finest details, such as eyes, scales, teeth, claws, and spikes, along with the final light accents, although you may want to touch in some details with the basic colors. If you are working with oils or acrylics, the final details should be added as the last step before completing the painting, when you can use impasto techniques over the previous paint layers.

Green dragon

This is the easiest of the three examples to paint. Start with the darkest green and the browns, and finish with the vivid bismuth yellow. Use cold greens for the shadows and warm tones for the lights.

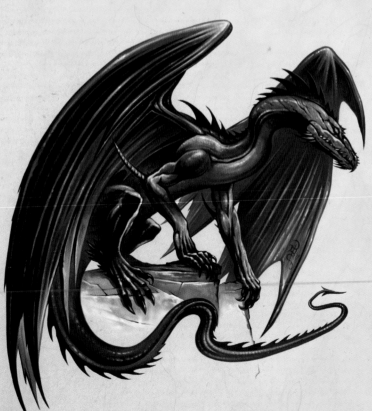

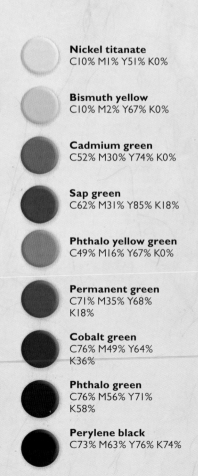

Nickel titanate
C10% M1% Y51% K0%

Bismuth yellow
C10% M2% Y67% K0%

Cadmium green
C52% M30% Y74% K0%

Sap green
C62% M31% Y85% K18%

Phthalo yellow green
C49% M16% Y67% K0%

Permanent green
C71% M35% Y68% K18%

Cobalt green
C76% M49% Y64% K36%

Phthalo green
C76% M56% Y71% K58%

Perylene black
C73% M63% Y76% K74%

Chrome yellow
C11% M9% Y66% K0%

Yellow ocher
C19% M47% Y76% K1%

Cadmium orange
C22% M70% Y90% K9%

Cadmium scarlet
C18% M70% Y90% K9%

Quinacridone red
C26% M93% Y100% K27%

Perylene maroon
C35% M96% Y89% K56%

Mars violet
C55% M69% Y57% K45%

Maroon + indanthrene blue
C47% M95% Y67% K73%%

Maroon + ultramarine blue + phthalo blue
C61% M93% Y65% K87%

Red dragon

The colors for this dragon vary from very deep blue, violet, and brown in the shadows, to vivid red-orange and yellow for the lightest parts, including the head, neck, and front legs.

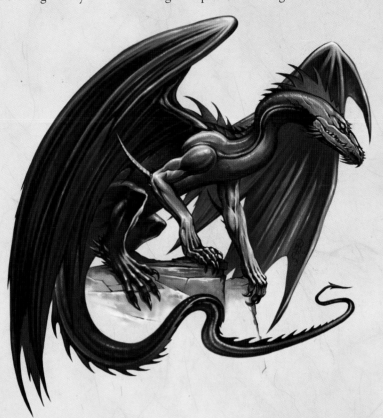

Green/red/gold dragon

This is the most difficult of the three examples to paint. The important first step is to define the light source, then cover the dragon with fine layers of the selected colors. Once the three basic painting stages are completed, work over light and shadows again to make them more contrasting before finishing the small details.

Indian yellow
C11% M20% Y71% K0%

Olive green
C39% M21% Y69% K0%

Chromium oxide green
C67% M47% Y61% K27%

Cobalt green dark
C75% M56% Y58% K42%

Cobalt green + sepia
C70% M59% Y65% K54%

Yellow ocher + olive green
C32% M42% Y69% K4%

Raw sienna + cadmium orange
C23% M62% Y89% K8%

Cadmium red deep
C30% M75% Y67% K18%

Burnt sienna
C42% M74% Y78% K49%

Burnt umber
C54% M75% Y81% K73%

Burnt umber + maroon + ivory black
C58% M85% Y82% K86%

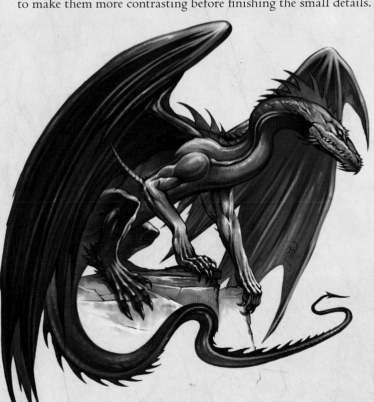

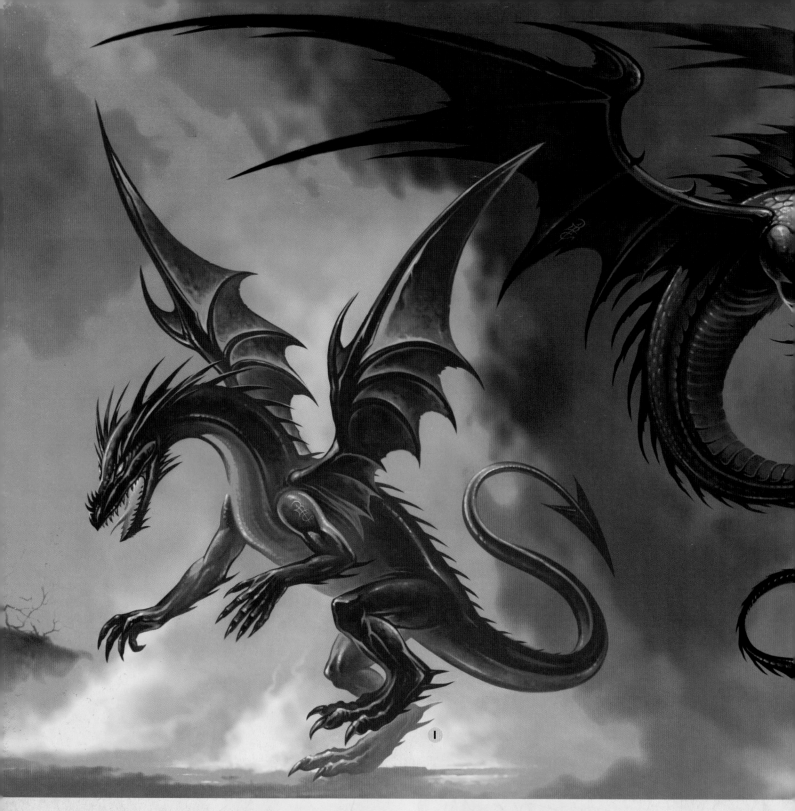

Knowing how the light and color reflections of the background and the surrounding scene affect the dragon is essential in the rendering of a realistic creature. The light intensity of the background and the brightness of its main colors can change the colors of the dragon's body faintly or to a considerable degree.

Before you begin work, imagine at least a rough vision of your idea, taking into account the colors, light source, and shadows. Of course you can change some details during the working process, but beginning with a clear idea is always a good plan.

The backgrounds depicted here represent three of the most often used fantasy concepts. If the background is intense and vivid, you can paint the entire dragon with colors that are similar to those of the background. The intensive red background can change the colors of any dragon to orange, red, and brown, as well as deep blue and black, especially if the dragon is ordinarily painted in similar dark colors. For an effective, realistic rendering of this background, use deep shadows and very active and vivid light on the dragon's body.

A very dark background, perhaps in a cave or on a

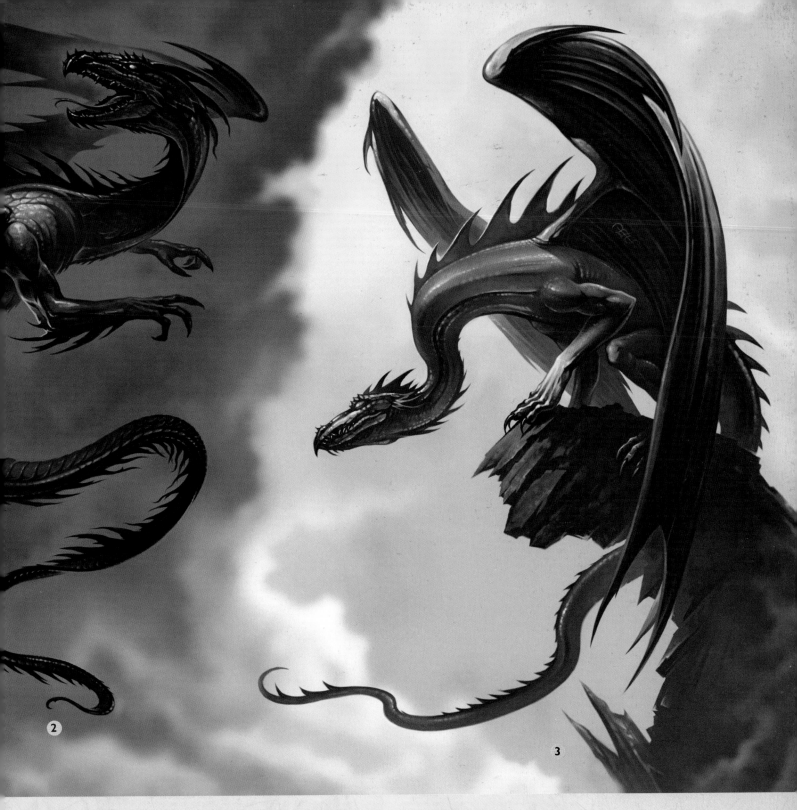

cloudy night, will vastly affect the dragon's colors. The creature will appear almost as a dark silhouette, with some small, bright details, such as eyes or some scales, barely gleaming in the darkness. Therefore, on the darkest backgrounds you will need to employ some kind of additional source of light, such as fire, lightning, or a full moon, to provide the necessary dramatic contrast.

A daylight background will not alter the colors of the dragon too much. The key component in this case is the direction of the light source, which will determine the light details and the shadow colors of the dragon.

I. Red background:
The background colors are vivid and active, so the dragon must be painted in similar colors but with stronger contrast. In that way the dragon will "correspond" with the background colors, and at the same time it will color the center of the composition.

2. Dark background:
On a dark background almost all colors are lost, and the creature is like a demonic shadow. Even a small source of light can change the contrast of all shadows dramatically.

3. Daylight background:
The original colors of the dragon are unchanged by the light. As long as you are aware of the direction of your light source, you can render a realistic-looking beast.

THE DRAGON'S FIRE

Dragons are like mythological flamethrowers. Even though the expression is "fire-breathing dragon," dragons actually spew out their deadly inferno. It's as though they have a highly flammable gas in their bellies that ignites as they shoot flames from their mouths.

Talk to any pyromaniac and he or she will tell you that fire is pretty. All natural forms have their own beauty: sandstorms, erupting volcanoes, tidal waves, tornadoes, lightning, and fire have a deadly magnificence. So, if you are to portray fire successfully, you'll need to feel its deadly burn as well as appreciate its alluring structures.

Fire is incandescent. While most other objects need light to be seen, fire is its own light source. Fire will never have a lit side and a side in shadow as a physically solid object does, and it abhors any regular shape. The glow of the fire will light up anything near it and silhouette objects in front of it. You should be able to feel the heat.

Drawing fire and its many colors

You should be familiar with the term "white hot." The center of a fire, the area giving off the most heat and a full spectrum of light, is the white part. As it radiates outward fire cools, turning to yellow, orange, and then red, but fire can be other colors as well. If you look closely at the step-by-step painting on pages 84–93, you'll be able to see a bit of blue, an igniting gas, at the origin of the flame. The key to painting fire effectively is mimicking its irregular shape while remembering its more predictable colorations, whether it's a small blaze or a conflagration. The bright colors of fire can be enhanced by a complementary color (such as green or blue) near it. Remember, also, where there's fire there's smoke, and you can use the smoke to give your flames greater intensity. For more on painting fire in context, see the step-by-step sequence opposite.

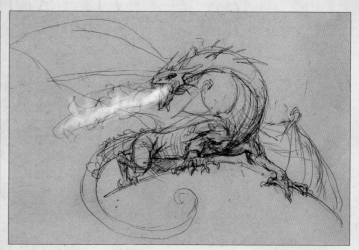

Step 1:
Fire breathing is a violent action and the dragon's gesture should reflect the force of it. In this quick thumbnail drawing on a gray background, the area of fire has been lightened.

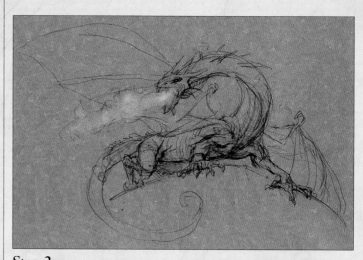

Step 2:
To give the painting a patina, warm fire colors are added, alternating between opaque and transparent colors. Remember, the dominant light source will be the dragon's fire.

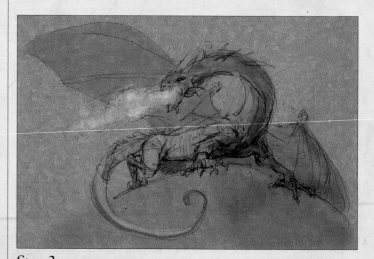

Step 3:
The dragon is painted green but its ultimate color will be influenced greatly by the orange of the fire. Your perception of color will shift based on the surrounding colors, so adjust as you go. Basic shadows are added with a transparent gray.

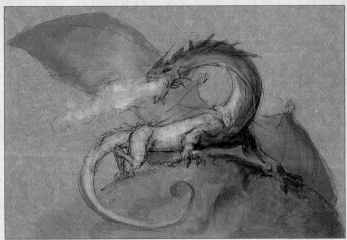

Step 4:
Darker shadows are added where appropriate and highlights where light hits. The outer edges of the wings are darkened since they are farther from the fading light source of the fire.

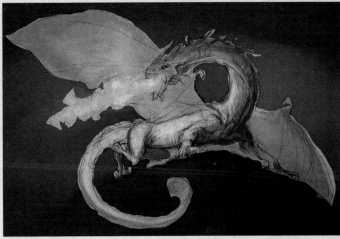

Step 5:
After masking off the dragon, a dark, transparent, softly edged color is added to the background. Its purpose is to give the fire greater emphasis—fire in dim light is much more dramatic.

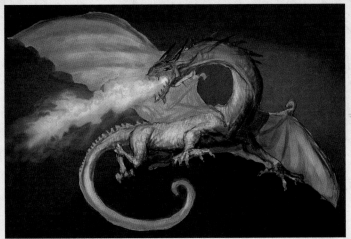

Step 6:
Deeper colors are then added to the dragon. Richer colors are introduced to the flame and blended, before impasto effects are used to reveal the yellowish-white tones beneath.

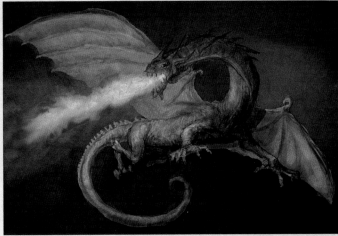

Step 7:
Now that the colors are established, there's time for rendering details such as wrinkles and scales. A blue smoke is then added behind the flame to further complement the orange of the fire.

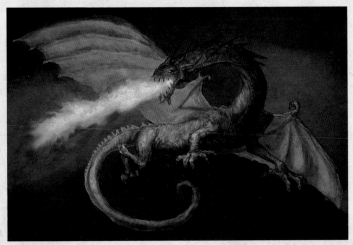

Step 8:
If you look closely or stand back from your painting you'll see little things that will need your attention. Add details to refine your painting or correct possible problems. Don't be afraid to make changes if you think it makes the picture more dramatic.

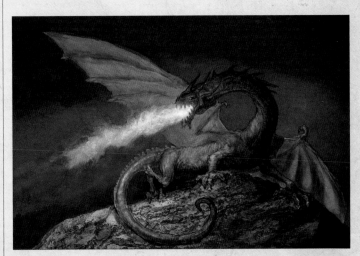

Step 9:
Next, the rock texture is added and shaded. Finally, a yellowish-white glow is painted over the origin of the flame to give the fire a greater sense of radiance. This silhouettes the dragon's teeth and face somewhat, which is exactly how light works.

TEXTURE AND FORM

It's sometimes difficult to see the form in the texture of something. Other times it's difficult to see the texture inside the form. Sometimes there's form over form and texture over texture. All these elements can be confusing to the eye. However, you can train yourself to see all the aspects of a subject, despite how one may camouflage another.

Knowing that something is there doesn't mean that all of it has to make it into a drawing or a painting, but understanding what's there, will help you to make a more convincing image. More so than with other genres of art, fantasy and science-fiction art deals with unfamiliar scenes and creatures. An artist working from life might not need to understand texture as well as a fantasy artist because his or her subject is there for careful examination. As fantasy artists we're making something up, and so it will serve us to delve deeper into texture than other artists, through a number of layers. The following images show a way of thinking rather than a true technique for making a picture, and use Photoshop because of its ability to make layers, which represents a layered way of thinking. Here, you can see physical texture (the bumps and valleys), tonal variegation of texture (the coloration of the skin), and form (represented by light and shadow), all without the others or combined with alternate layers. The point of these illustrations is to show you how to think about a texturally complicated subject before you paint or draw it. Keep these separate layers in mind as you work, and work them together for a fully formed dragon.

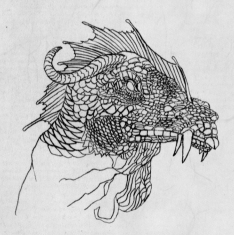

Tactile texture
Your eyes can't always see what your hands can feel. However, knowing what a surface might feel like will help you to paint it. Some surfaces only show up within the highlights. This line drawing is an illustration of only the tactile texture of a dragon. The lines represent the "ins," "outs," and edges of the surface. In the real world this would be represented only by light, shadow, and highlight on a surface.

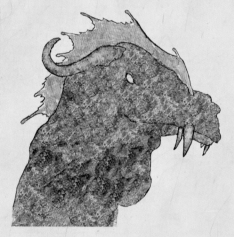

Visual texture
A natural surface usually has a pattern that's speckled or mottled. As such, dragon skin is variegated in color and tone. This coloration has nothing to do with the physical surface and can work independently from it, but quite often it enhances that surface. Dragon skin has so much tactile texture to it that you might not see the tonal variation unless you look closely for it. In this illustration it is separated out so it can be seen entirely on its own. Having a sense of both tactile and visual-only texture will help you make a convincing dragon.

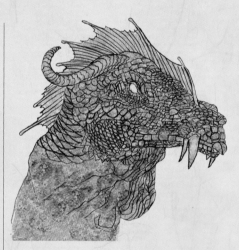

Tactile and visual texture only
Well, this looks pretty crazy, doesn't it? The world would be much harder to decipher if we had no light, shade, and shadow. Note how the lines still don't vary in tonal quality. Light is what provides that tonal variety, and it is absent in this illustration.

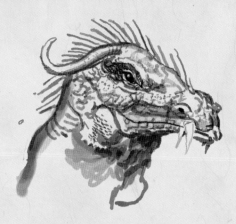

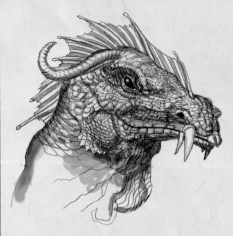

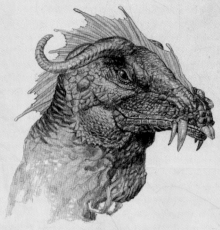

Shading over texture

This illustration gives a sense of the shading that will go over the tactile and visual texture. Even though you will most likely be approaching these layers at the same time, it's good to understand these aspects on their own.

Perfect skin

This is what a dragon lit in normal light would look like if it had entirely nonvariegated skin, that is, skin of all one color and shade. Only the eyes, the teeth, and the dragon's comb have a different tone to them. It looks a bit too perfect, but you can clearly make out all the ins and outs without the confusing extra layer of tonal texture. It almost seems a shame to add the blotches, but I have in the next illustration.

One level only

A worthwhile exercise is to work this same dragon as a pencil drawing. To get a sense of all the texture involved, use the side of the pencil to create random rough lines. Draw the scales in more carefully, though, and add darker spots over lighter lines in the deepest crevices of the dragon's skin. The above looks very close to the finished Photoshop version, but drawing it revealed that little things were worth changing.

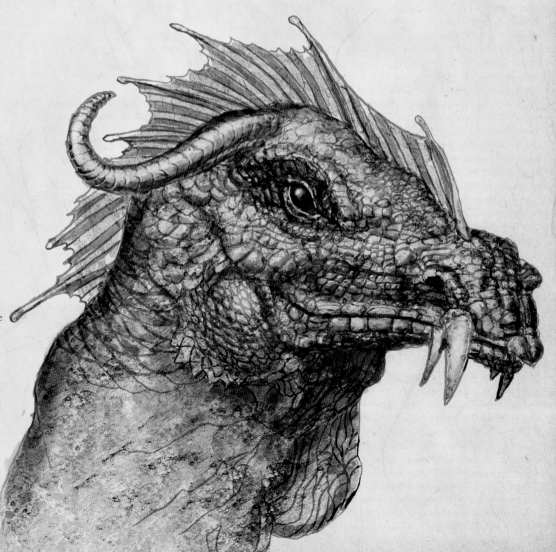

Everything combined

Blotches, wrinkles, and discolorations have all been added. Now you can see some variation in the tonal quality of the lines representing tactile texture, and that the tonal quality of the picture is clearly influenced by light. Highlights have brightened the peaks of the dragon's skin, and the shadows have soft edges.

LIGHT AND SHADOW

Without lights and darks, without values, your painting will look flat. It's only through light and shadow that the three-dimensional form is revealed. Living in such dark places as caves, deep seas, and thick forests, dragons can cast some very big shadows.

Color, texture, warms and cools—these add depth and dimension to your painting, but only if your lights and darks establish a good, solid foundation. When painting, it may help to remember that you're not painting a dragon, you are painting the effect of light on the dragon. Light reveals and sculpts the form. Think of your paintbrush as a flashlight moving over the dragon, revealing some areas clearly, some indistinctly, and others not at all. As you work, remember that the light and shadow "shapes" must describe your dragon. The sketch in Step 2 on page 78 illustrates this very clearly. We see the form of the wings, the curve of the neck and belly, and the musculature of the limbs all taking shape because of clear, well-thought-out shadow shapes. While you're painting, frequently step back and squint at your work. This eliminates color and texture

and lets you see the values and big shapes, and gage how they are working together. If in doubt, simplify. Three values (a light, middle, and dark) are enough to describe the form well, and if you can't make something work with three values, the problem is not the lack of value range but rather that you are not using them to effectively define your dragon's shapes.

In the following examples, one dragon is viewed from different angles and is subject to varying light directions. The dragon sits on a flat surface and casts an even, flat shadow. When you draw a dragon, you want to know where the light is coming from as well as how the shadow will be cast, so that you'll know what's lit by direct light and what's not.

▼ Ambient light

In this illustration the dragon is standing in profile, with the light coming from above and a little to the left, distorting its shadow. Note that the shadow darkens as the dragon's belly comes closer to the ground, due to ambient or diffused light. Ambient light is your constant second light source. Hold a solid object over the ground on a sunny day, and notice how its shadow darkens as you move it closer to the ground.

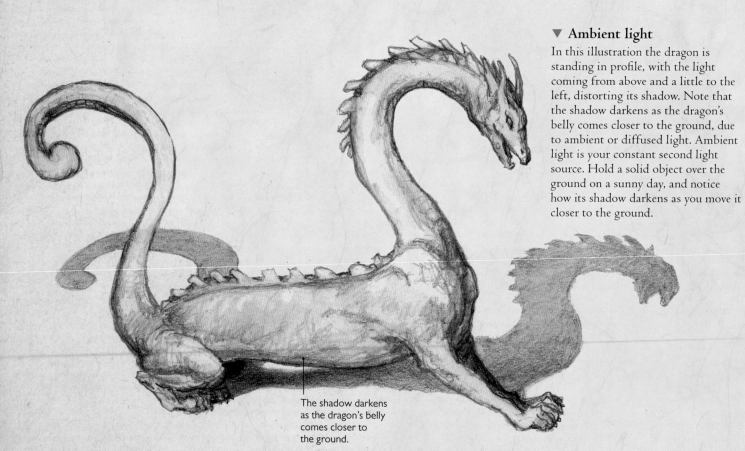

The shadow darkens as the dragon's belly comes closer to the ground.

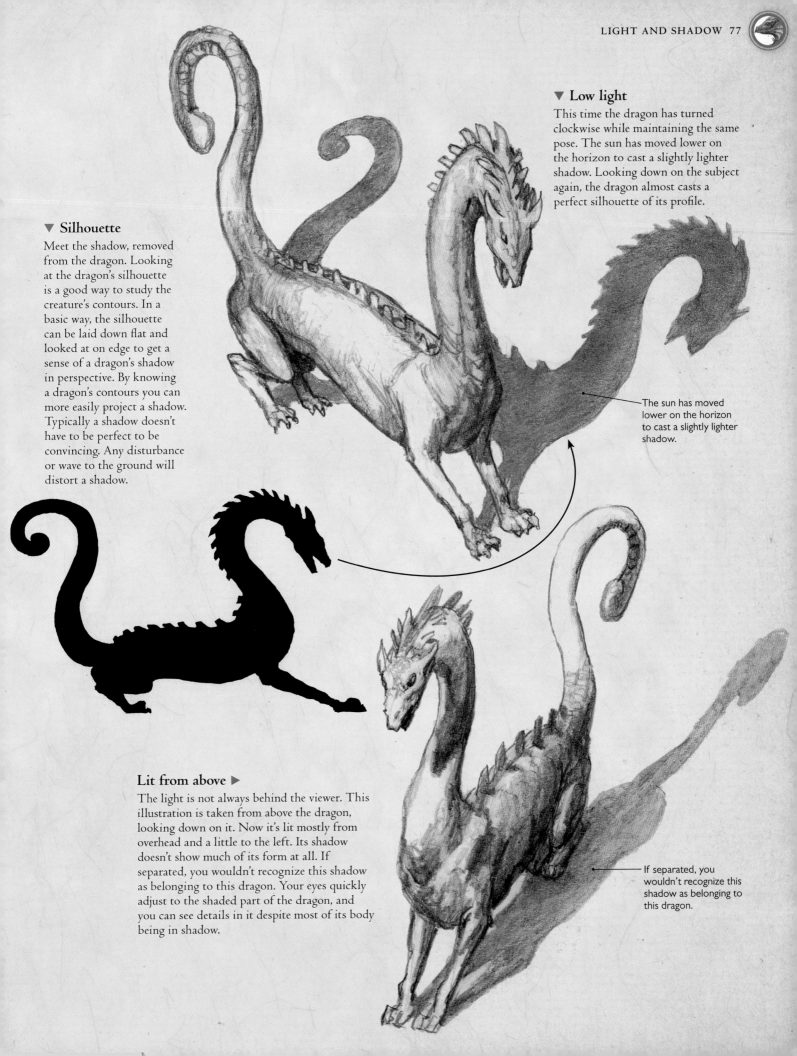

▼ Silhouette

Meet the shadow, removed from the dragon. Looking at the dragon's silhouette is a good way to study the creature's contours. In a basic way, the silhouette can be laid down flat and looked at on edge to get a sense of a dragon's shadow in perspective. By knowing a dragon's contours you can more easily project a shadow. Typically a shadow doesn't have to be perfect to be convincing. Any disturbance or wave to the ground will distort a shadow.

▼ Low light

This time the dragon has turned clockwise while maintaining the same pose. The sun has moved lower on the horizon to cast a slightly lighter shadow. Looking down on the subject again, the dragon almost casts a perfect silhouette of its profile.

The sun has moved lower on the horizon to cast a slightly lighter shadow.

Lit from above ▶

The light is not always behind the viewer. This illustration is taken from above the dragon, looking down on it. Now it's lit mostly from overhead and a little to the left. Its shadow doesn't show much of its form at all. If separated, you wouldn't recognize this shadow as belonging to this dragon. Your eyes quickly adjust to the shaded part of the dragon, and you can see details in it despite most of its body being in shadow.

If separated, you wouldn't recognize this shadow as belonging to this dragon.

Painting light and resulting shade

This demonstration begins with a pencil drawing that has been imported into Photoshop. The idea here is to show the difference between thinking and practical application. Each of the four steps in this process will add layers of complexity. Missing from the first three illustrations are distracting elements such as small details, texture, specular highlights (shiny bits), or any natural tonal variations in the dragon's skin. To keep things even simpler with the first three, we will use only 25 percent and 50 percent grays to add shadows. Life, of course, is made up of considerably greater tonal variance—not to mention color. In Step 4 the highlights are added, while the steps in the panel on page 79 go back to the original drawing to show how to apply layered thinking on one simple layer.

If you're drawing with a pencil or working in watercolor, it's unlikely that you would work in this way, you would keep in mind all the levels—texture, specular highlights, and tonal variation—at once.

The dragon in the sequence opposite is lit from a typical direction, with the light source in front of it and to the left of the viewer. It's sometimes difficult to tell why an area of something you're drawing from life is darker or lighter. Sometimes it's because less light is on the area; sometimes it's simply a darker area (i.e., absorbing more light); sometimes it looks lighter or darker because it's a shiny area angled toward you, reflecting the light source back at you, or it's angled away from you and reflecting a dark area. By drawing from life regularly, you'll develop an instinct for this and be able to make your dragons more believable.

Tonal strip

To test your values, use a tonal chart. A pencil drawing won't be able to make the darkest dark on the chart, but you can see how close you've gotten because tonality and color are relative to the way the eye perceives them, meaning they seem lighter or darker compared to what they're next to; for example, below, where a medium gray meets the edge of a darker gray, the medium gray's edge appears lighter, and its edge appears darker where it meets a lighter gray. A strip is a great way to test that the values in your shadows are uniform where they should be.

Appears darker | Appears lighter

Step 1:

The drawing was made with a pencil in a simple line-only form. It resembles coloring-book art, which is a good comparison because it will be colored-in with grays. Each layer of gray will add detail and depth to the dragon.

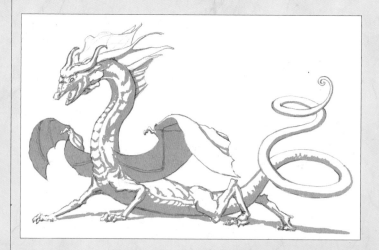

Step 2:

This light gray, 25% K, represents all the areas of the dragon that are not receiving direct light, as well as the cast shadow of the dragon. Note that "K" signifies black in the CMYK color printing system, because black is the plate that all other colors are "keyed" to, hence the "K." Because the dragon is seen at a low angle and on a curved surface, you can't see all of its cast shadow. However, you can see how just this simple amount of shading has already added a great deal of form to the drawing.

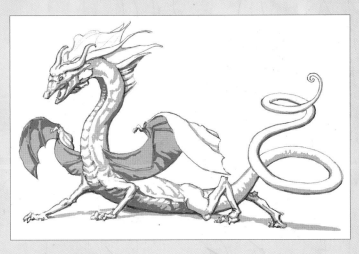

Step 3:
Your dragon will have varying tones in its shadows because there is almost always some ambient light bouncing into shadowed areas. Because it's coming from all directions, certain areas, such as the underside of the dragon, pick up less ambient light and are therefore darker. In the areas of the dragon that turn from the viewer, less light is reflected—more light is reflected to the side rather than back at the viewer. All of this helps give the dragon a sense of form, weight, and reality. This layer is a middle-toned gray, 50% K.

APPLICATION
Now that you can see the thinking behind the demonstration, it seems reasonable to show you how the process would take place in a pencil drawing.

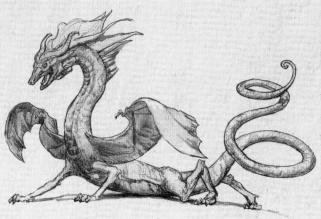

Step 1:
You can't add highlights to a pencil drawing, so you have to know where they will appear and take note to not draw in those areas. It's best not to go too dark at the beginning stage of a drawing. Compare this drawing and the drawing in Step 2 (below) to the earlier illustrations.

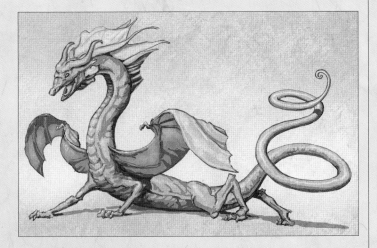

Step 4:
To introduce specular highlights, a gray texture as a "Multiply" layer in Photoshop is put over the entire drawing, making it a little darker. Unless something is purely white it won't look like any of the earlier steps do. For effect, some of the gray texture behind the dragon is lightened. On top of that, touches of white are added. These represent the peaks and valleys of the dragon's smooth skin that reflect light like a mirror. These specular reflections are what give skin highlights and add a sense of volume to a subject. You can easily overdo them, however, so only a few are needed. At this stage the dragon's skin tone is also varied, since animals in nature rarely have a perfectly even skin tone.

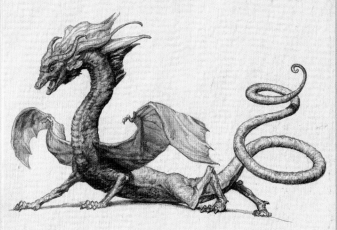

Step 2:
In the final drawing, more detail has been added to the dragon's skin, along with darkened areas, reflected light off the surface below the dragon, and a better sense of translucency to the thin skin on the dragon's wings. Note that the eye has a bright highlight to it despite being almost black. Eyes are kept watery because of tear ducts, and this water in the eyes makes for full mirror reflections.

COMPOSITION

Everything in a painting affects the viewer: color, subject matter, light, shadow, and perceived action are all tools that evoke a response. Composition is no different, and how you arrange elements matters a great deal. Composition is your tool for putting emphasis on one area over another.

Compose in simple shapes

For the most part, you'll do well to compose in simply shaped geometric masses such as squares, triangles, rhomboids, and circles, and in three-dimensional shapes such as cubes, spheres, cones, cylinders, and tetrahedrons. Also, think in terms of the shapes of letters—"A," "B," "C," "D," "a," "b," "c," "d," and so on—as they are or turned, flipped, in three dimensions, and edge forward, as well as combined with other letter shapes.

Remember that as long as you create simply-shaped masses, your painting will be pleasing no matter how many details there are, and it won't be perceived as "busy."

Massing

A common mistake when composing a painting is to arrange according to subject matter rather than working with tonal masses. Carefully planning your painting so

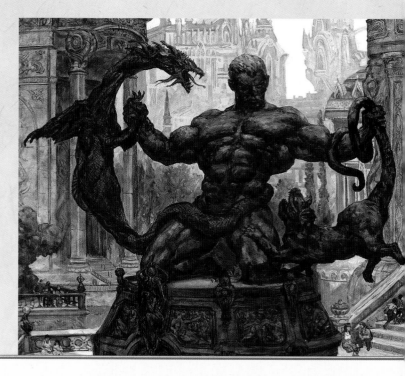

COMPOSITIONAL GALLERY

There are a range of compositional choices to make when creating a dragon scene. Here, paintings from the gallery section (pages 96–115) are analyzed for their compositional elements. In general, dynamic thrusting lines and swooping curves are used to create the dramatic compositional schemes suitable for dragon art. Decide on what you want the overriding atmosphere of your painting to be and use the compositional tools to emphasize it.

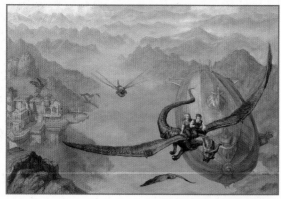

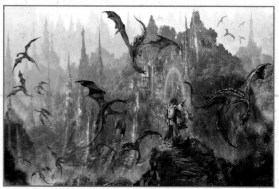

The towering pinnacles of these rocky mountains act as a triangular backdrop to the scene depicted here. Although tonally similar, the rocky towers create contrasting shapes to the swooping, dancing dragons as they circle the main character.

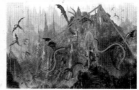

Perspective is the main compositional force here. The wide valley narrows into the distance, and the viewer's eye is led into the painting in a zigzag—from the zeppelin and wide wing span of the dragon flying in the foreground to the smaller dragon and mountains in the distance. The wider landscape increases the storytelling aspect of the piece.

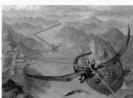

that tonal masses complement your subject will enhance the picture's overall effect. In its simplest form, if you want a dark subject matter to stand out, put something light behind it, and do the reverse if your subject is primarily of a lighter color.

Chink in chree dimensions

If you compose only with basic tonal masses in mind, your finished art could end up looking flat, so it's a good idea to imagine how your shapes come forward and move back in the composition. This is even more important if you want your composition to have a sense of movement.

◀ **Dark mass**

This heroic sculpture is a good example of the center of interest standing out as a darker mass. Also note the sweep of form leading from the top of one dragon's head to the other dragon's tail. Even though the sculpture is made of stone, you get the feeling of action because there's a clear rightward lean. Although this is a rather complicated scene, its main form is a simple reversed "e" shape turned a quarter turn clockwise.

▶ **Light on dark**

Artificial light makes this massive dragon skeleton stand out against a darker background. In this immensely complicated scene, depicting a giant celebration with thousands of attendees, the composition couldn't be more basic, taking the simplest two-dimensional geometric form possible—a triangle.

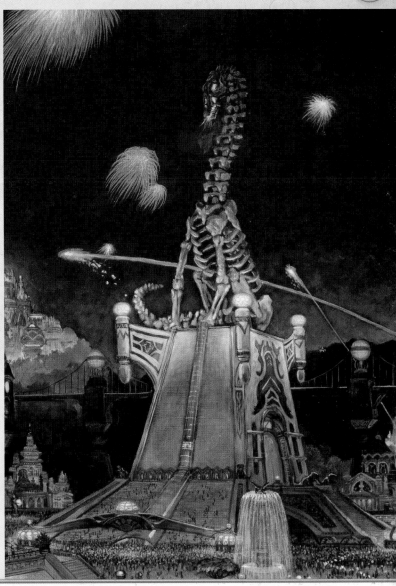

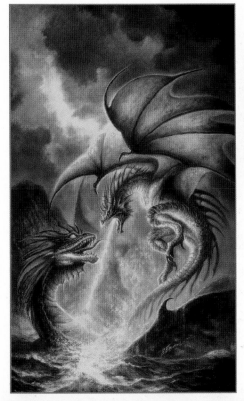

Here, implied movement through a spiral of curved lines pulls the viewer's eye into the center of action. Even the skeletal bones of the dragon's wings radiate toward this point. The optical effects of the color composition—the warm bright colors against cool, dark colors in the background—adds emphasis to the spiral and flames.

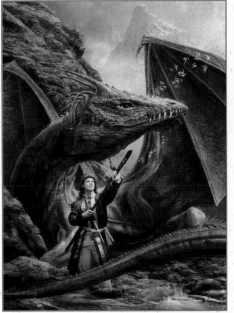

The solidity and enormity of the dragon form is exaggerated here by cropping the beast through its wings—it is too huge to fit within the picture plain. The compositional lines cradle the diminutive hero, and the triangular shape of the dragon's wing is echoed in the distance.

Verticals, horizontals, and diagonals

To make your picture feel solid and balanced, you'll need to put in strong horizontal and vertical elements. If you wish to throw off the viewer's balance, you'll want to feature strong diagonals leaning mostly in one direction. If you want your painting to feel especially solid and balanced, your best choice is a triangle or tetrahedron, or a domed or pyramid shape.

Symmetry

Nature abhors symmetry, but it has its place. It's especially useful when creating a frame decorated with dragons. Back in the days before computers, mirror-image symmetry was created by drawing one half of a picture, then tracing over and transferring it with carbon paper to the other side of the drawing. Cleaning up would be necessary, and if the drawing was a preliminary for a painting, some time spent using a mirror to compare the two sides was also useful. Today symmetrical design can be created in no time on a computer, which can also be used to show how an image appears when flipped, as a test for symmetry when working on an actual painting.

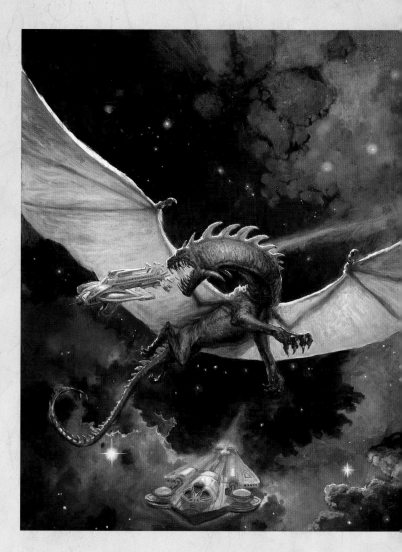

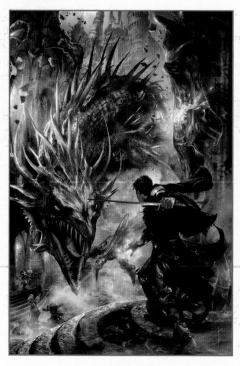

Two arcs form the main compositional forces: the curving spikes of the dragon's neck thrust forward and the dark, rocky cliff create a frame for the action. The artist has cleverly lit the scene so that the character is almost in silhouette but can be seen. His gaze is locked onto the dragon's, and where their eyes meet is almost the center of the composition.

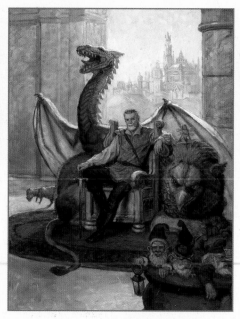

In this tranquil scene, the underlying composition fits into a grid, with many elements positioned on aligning points, giving the painting a solidity. The main character's gaze has been positioned exactly on the central vertical axis, and this balances the composition. Only the diagonals of the wings break the grid.

◄ Color mass and motion

This dragon's wings are backlit, so that a light mass stands out against a dark background—a warm yellow-orange against a cool blue—and the wings form a "C" shape that leans toward the viewer. The darkest part of the sky is behind the dragon, so that the dragon not only is flying forward as an action but pops forward as a color mass as well. Even the dragon's green skin is a complementary warm to contrast with the blue. Because this dragon is so massive, the artist has also exaggerated the perspective in its twisting form.

► Verticals and triangles

Although she's a small element in the picture, the viewer's eye is drawn to the dragon's intended victim, held to the side of the picture but in the middle of the iron gate. The heavy verticals and triangular shapes of the gate and window stand as opposites to the dragon's sinewy form, the arm and tail of which almost point to the victim.

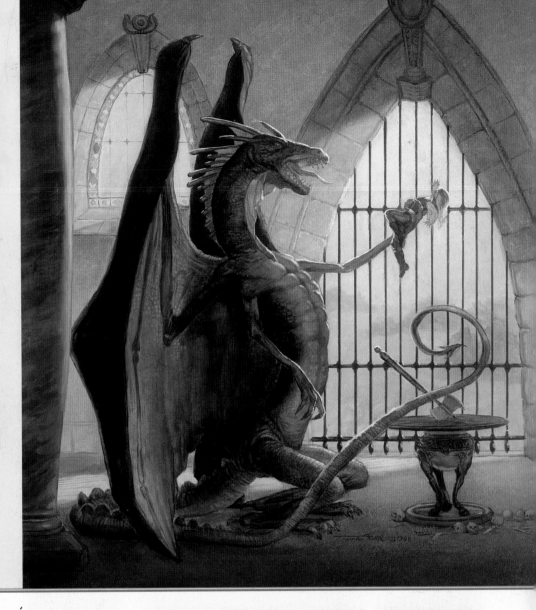

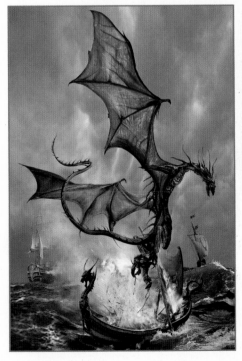

The dynamics of the dragon's wings are clearly displayed here. The curves created imply fluid movement echoed in the curve of the Viking ship. The principles of warm and cool color theory work well here—bright reds and yellows highlight the action against the cool, dark background.

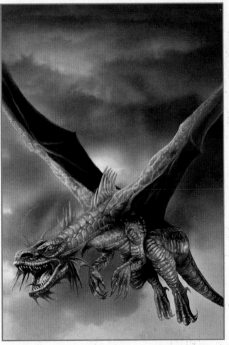

A classic composition for dynamism, diagonals—which are usually active singular lines—are doubly active here, where they form a cross. The intersection of the diagonals in the center provides a central focus, while the oblique angle of the dragon allows for greater definition of shape and form.

PAINTING A DRAGON IN OILS

It takes a magical medium to capture the qualities of a legendary creature, and oil paint has rightly been seen as such for centuries. It has tremendous versatility and can be used in any number of ways—thick and thin, opaque, and semitransparent. If you've only seen reproductions of fantasy oil paintings printed on a page or on the Internet, you may be astonished when you see these paintings "in the flesh," where they have a depth and richness you cannot fully experience in reproduction. This is why I highly recommend that you take the time to master this wonderful medium.

This demonstration will show you how to sketch out an idea, develop a composition, tell a story, invent specific lighting conditions, and produce a variety of textures. The idea is to utilize all the knowledge gained in earlier chapters in order to produce a final piece. When you are ready to begin your own painting, think of the medium as your friend and partner in the enterprise. Don't be afraid to make mistakes, as you can always wipe them away or paint over them until you're satisfied. More important, oil paint will present you with its own gifts in the form of little unexpected touches that give your painting character. It's your job to notice these and learn from them.

YOU WILL NEED
- **Pencils and pens** for sketching
- **Masonite** or similar. Here ¼ in. (0.5 cm) thick board at 20 × 32 in. (50 × 80 cm)
- **Acrylic gesso**
- **Bristle brushes**
- **Sable brushes**, brights and rounds
- **Acrylic paints** for laying ground—umbers and violets are classic colors, but use what works for your painting
- **Fast-drying linseed oil** (used as a glazing medium)
- **Oil paints:** titanium white, ivory black, cadmium red, alizarin crimson, ultramarine blue, phthalo blue, phthalo green, manganese blue, manganese violet, burnt umber, burnt sienna, and cadmium yellow; include flake white (it's lead paint, so be careful), transparent white (for glazing back subtly), alizarin yellow, permanent rose, Mars black, raw umber, and Payne's gray
- **Alkyd paints:** all whites, ivory black, cadmium red, yellow, and permanent rose
- **T-square**

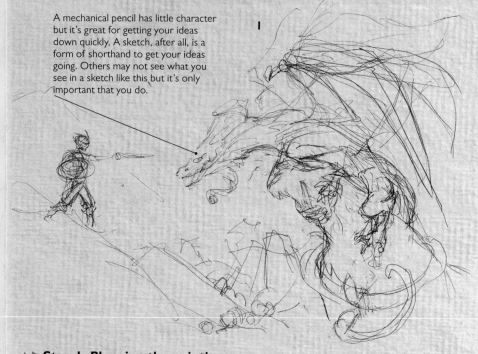

A mechanical pencil has little character but it's great for getting your ideas down quickly. A sketch, after all, is a form of shorthand to get your ideas going. Others may not see what you see in a sketch like this but it's only important that you do.

1

▲▶ Step 1: Planning the painting
The best way to start is by making sketches, drawing until you have something you are happy with. In the case of professional illustrators this is essential, as most art directors will want to see a sketch of what you intend to paint. Sometimes you'll find that an idea comes fully formed, and other times it comes in pieces you have to assemble. In this case, I was happy with the first pencil sketch (1), after which I developed the dragon more (2), and then the knight (3), working in both line and tone.

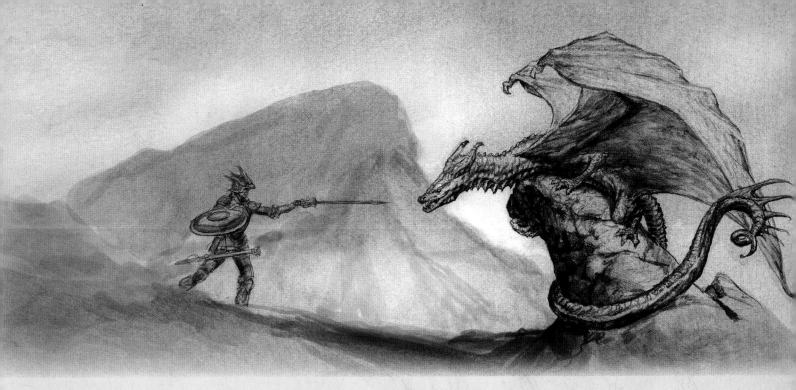

At one point I considered putting a paintbrush in the knight's hand and having him hold a giant palette. This section is, after all, titled *Painting a Dragon in Oils*. That seemed a bit too cute though. The knight's pose will change drastically.

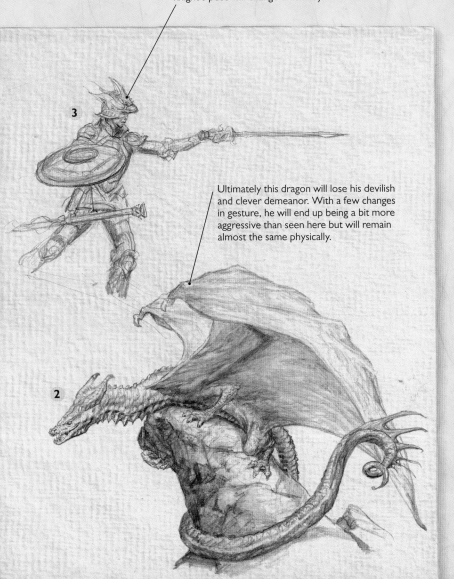

3

Ultimately this dragon will lose his devilish and clever demeanor. With a few changes in gesture, he will end up being a bit more aggressive than seen here but will remain almost the same physically.

2

◀▲ Step 2: Adding tonality

Even though your most developed plans may be changed later, you can't go wrong with a detailed tonal sketch, and the computer is a great way to accomplish this. The drawings for the composition above were done separately, scanned, and brought into Photoshop for arranging and adding tonality. Later, various adjustments were made using contrast tools and by dodging and burning the surface. Even though this is just a sketch, I gave it a bit of texture to resemble pencil and watercolor. You can see the real pencil drawings that were used below.

ACRYLICS AND OILS

Some artists use acrylics in the same way as they do oil paints, and in a finished work it is often hard to tell the difference between the two. So this painting could also be done in acrylics, the only major difference in technique being that acrylics dry very fast. Instead of my linseed oil system in Steps 3 and 11, I suggest using the acrylic medium in the same way —it will stay moist for some time. If you want to duplicate the sheen of oil paints, mix your colors with acrylic gloss medium, and for the blending method in Step 5, try mixing your colors with acrylic retarding medium. The brushes and surface are exactly the same as for oil, and glazing methods are ideal for acrylics, though you will need a glazing medium specifically designed for this medium.

▶ Step 3: Drawing with paint

I prepared my Masonite with a coat of acrylic gesso, a type that accepts and holds oil paint—most are formulated for this purpose. When it was dry, I toned the surface with a variety of colors to form an interesting texture. Drama rather than subtlety was the desired effect so instead of going back to the pencil drawing stage, I created a new drawing with paint. The first step was to rub a thin layer of linseed oil over the surface, then paint into it using violets and umbers. Use a rag to erase with.

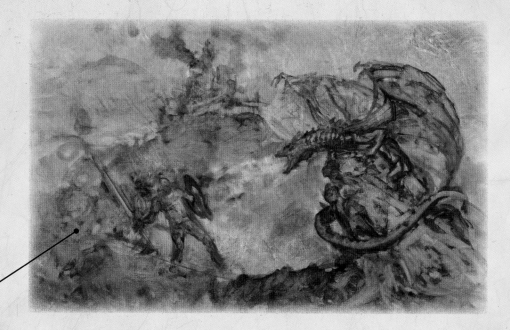

A colored and textured ground is more sympathetic than a flat white surface and will keep your painting interesting.

▼ Step 4: Digital help

It's a good idea at this stage to take a digital picture of the underpainting and import it into a program like Photoshop; this allows you to do a quick color sketch of what you intend to paint, and this was my next step. If you're not familiar with digital media, I suggest you do your color sketch in oil. This way you can get a sense of how you'll apply the paint and know what colors you'll use. The advantage of the computer is that you can adjust the colors and tones until you feel you have a good balance.

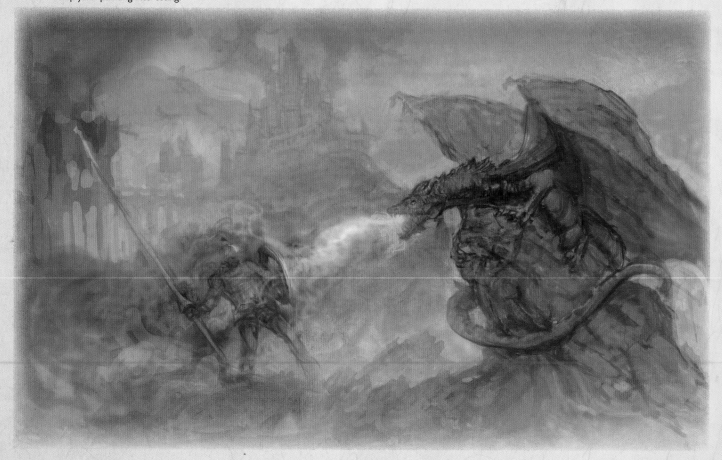

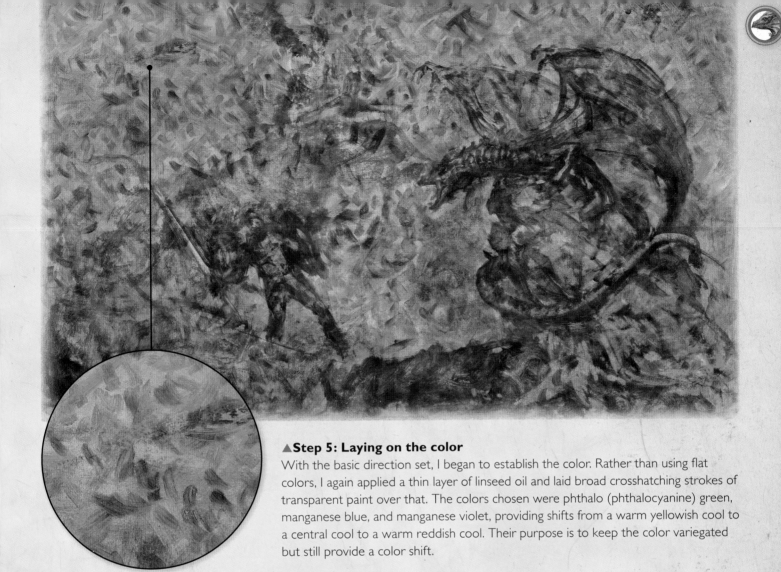

▲ Step 5: Laying on the color

With the basic direction set, I began to establish the color. Rather than using flat colors, I again applied a thin layer of linseed oil and laid broad crosshatching strokes of transparent paint over that. The colors chosen were phthalo (phthalocyanine) green, manganese blue, and manganese violet, providing shifts from a warm yellowish cool to a central cool to a warm reddish cool. Their purpose is to keep the color variegated but still provide a color shift.

This method makes for a messy looking beginning, but it is more flexible than flat color.

▼ Step 6: Working wet-into-wet

For the dragon's fire, you want the colors and tones to mix on the painting surface, so a wet-into-wet method is best, with the minimum of blending. I used a translucent white, which does not dull the colors, and large bristle brushes.

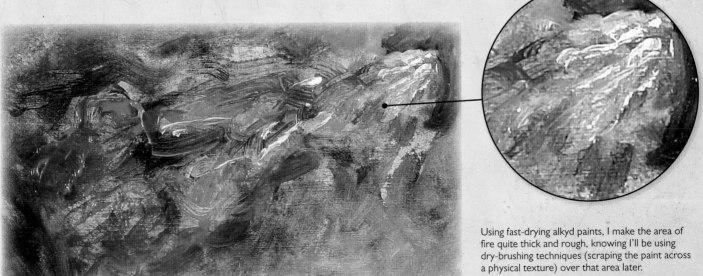

Using fast-drying alkyd paints, I make the area of fire quite thick and rough, knowing I'll be using dry-brushing techniques (scraping the paint across a physical texture) over that area later.

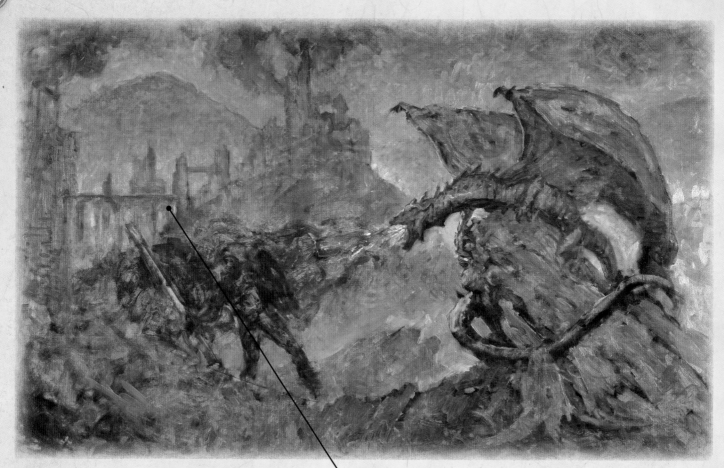

▲ Step 7: Layering

To dry-brush over the previous layer, I used alkyd paint because it dries quickly. One of the beauties of oil paint is that it dries slowly, but knowing how to control the drying time is important. Each layer has an effect on the next, so you should always be thinking ahead. Little time has passed between this and the previous stage, and the painting still looks quite untidy, but this indirect approach will ultimately yield more interesting results.

▶ Step 8: The background

While the previous layer is still wet, you can start using opaque colors to paint in some of the background while you wait for the foreground to dry. It works well to work from background to foreground and then repeat the process as you add details, building up the painting slowly.

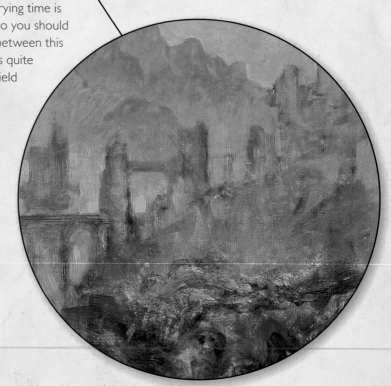

I paint in the sky and mountains using opaque colors that will allow me to make any changes needed to the color or composition. If you're new to oils, it's a good idea to test all your colors for transparency/opacity by running a thin strip of each across a white, gray, and black surface.

▶ **Step 9: Adding definition**

Up to this point, the castle has been treated very broadly, and I now give it some extra definition, taking care to achieve true verticals—a wobbly vertical in the center of the picture would be disastrous. Use a triangle or a T-square to check your verticals.

Creating architecture is a great deal of fun. It has to look right but when you paint it you can build and rebuild a bit more easily than any construction worker could. I say go crazy with your design and then bring it back to something that looks plausible. As I've mentioned, sable brights are a good choice here. You can use them to cut into your castle with the colors of the background as well as to add the tiny details.

◀ **Step 10: Spatial relationships (aerial perspective)**

I continue to work on the castle. It is very important to the composition but must take its proper position in space. I have pushed it back by making the tones paler and closer together (distinctions between tones are less obvious when things are far away). Notice that I have brought in a tiny glow of reflection from the fire. I used sable bright brushes for the building to give both softer edges and sharp, square angles.

The castle in the distance tells a story of its own. Dragons have attacked it and set it ablaze with their fiery breaths. Still, this castle needs to observe the effects of atmospheric perspective. Usually that means cooler tones. Fire is normally painted in the warmest of warms but aerial perspective causes the reds to shift towards violet.

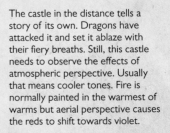

▼ Step 11: Working on the dragon

Now add some details to the dragon. Dragon skin should be mottled in both color and tone. Sometimes an object requires only one texture if it's dominant, but you should create at least two for dragons. The lower level is tonally rough and variegated, while the second layer describes the scales and wrinkles and will help to describe form and volume.

After creating the lower level, apply a thin layer of linseed oil and begin to add details. For little shadows that form the skin and scales, use a mixture of burnt umber and Payne's gray, the latter because it's a transparent color and will help retain some of the texture underneath. Paint the rock in the same way using a round sable brush, which can be rolled around on its side as well as used on its point. To further vary your line, take a soft object such as a kneaded eraser, a piece of rubber, or a clean bristle brush to push into the paint to vary your line.

The warm orange brought in at the extreme left of the picture balances the dragon's fire and gives the impression that the main source of light is the fire itself.

▶ Step 13: Assessment

When you're working on the details, it is easy to lose sight of the whole. Look at the painting from a distance and try to figure out if anything bothers you. Look back at your original picture references to check for accuracy, or find more references that might take your piece in a different direction. You might, for example, look for an image of a flamethrower to work out how a dragon would spit fire. Finally, build up any unfinished areas, such as the dragon fence, the knight, and his shield and lance.

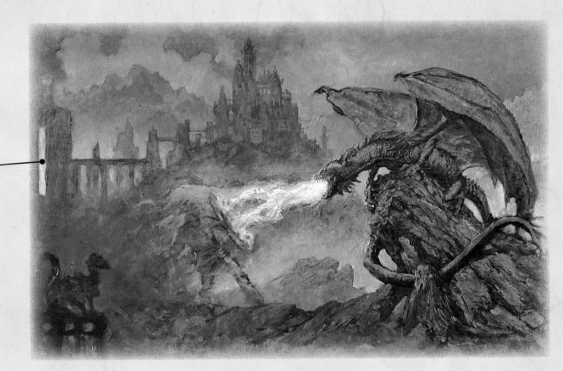

◀ **Step 12: Glazing into dry paint opaquely**

Glaze into dry paint opaquely when the paint is dry and you are confident it won't mix with earlier layers. Blending orange into blue or green (a complementary color) will result in a muddy color. However, if you glaze into it, you can blend into your medium instead of the color beneath and maintain the luminosity of both colors.

A railing with a small wrought iron dragon on it is added in the foreground to balance out the composition. Working all over the painting at the same time, the piece really starts to come together.

Adjust the tones of any underworked parts of your painting to give them more form and make them stand out.

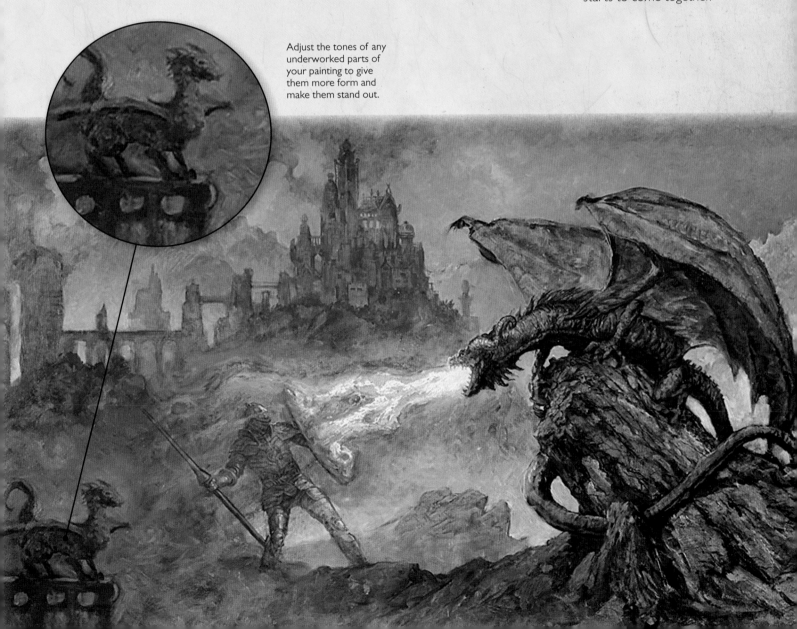

Step 14: Completion

It's important to know when to stop, or the painting will become overworked. To finish, I worked a bit more on the dragon, added two dragons on either side of the castle to help tell the story of this dragon attack, and gave more emphasis to the knight's lance, which provides an important diagonal to balance those of the rock and dragon's wings.

When should you stop painting, when should you call it quits, when have you made the painting as good as you could have? I never really know. I think I've gone too dark. I think I like the mistier look of the color sketch so I try to adjust some of these things in Photoshop to see if I can better the painting.

The dragon's horns are too dominant. I decide to shorten

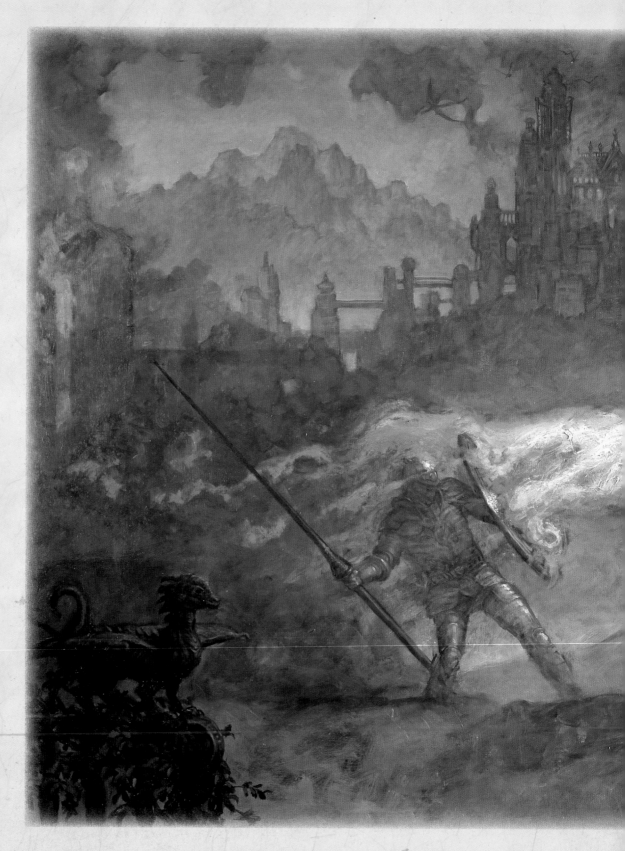

them. Now they look like a cat's ears pulled back when they hiss (compare with those in the roundel below). I've added more dragons attacking the castle in the distance. If you look closely, you can see one spray the top of the castle with fire. Comparing the finish to the color sketch, I add brighter reflection to the knight's armor. The dragon's forearm has

been shortened, there's a greater glow around the fire, and the background has been lightened in many areas. It's little things like this you may find yourself fiddling with at the end. Sometimes you need to have someone come in and tell you if you've improved the picture or if you've been obsessing. It's time to put down my brush.

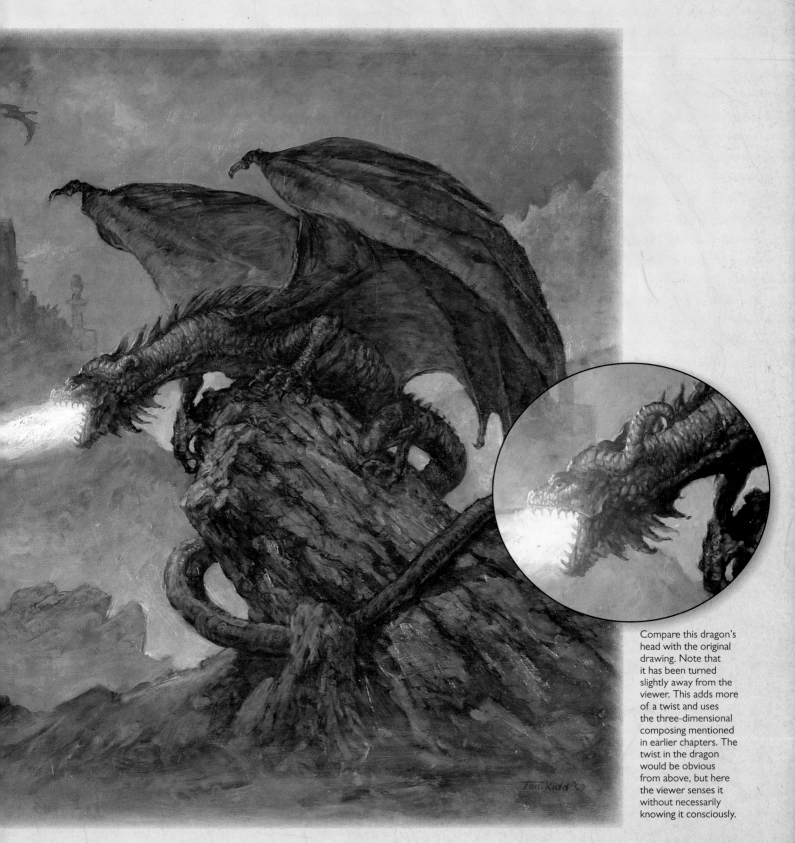

Compare this dragon's head with the original drawing. Note that it has been turned slightly away from the viewer. This adds more of a twist and uses the three-dimensional composing mentioned in earlier chapters. The twist in the dragon would be obvious from above, but here the viewer senses it without necessarily knowing it consciously.

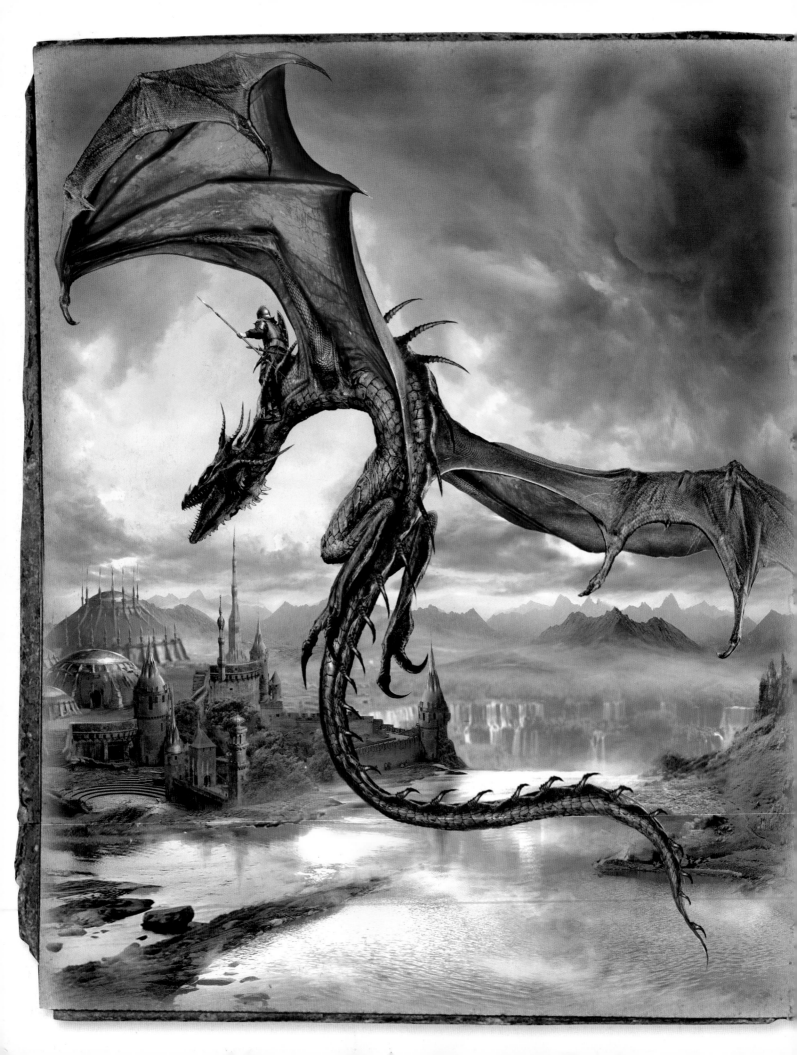

GALLERY

In this chapter you'll find a collection of work from some of the finest dragon artists around. Browse through and use these selected pieces to inspire your own artwork.

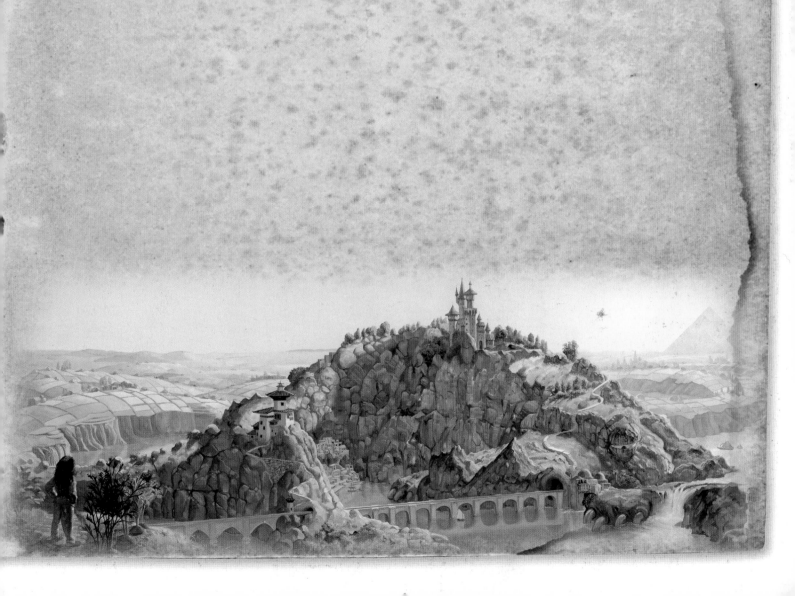

COMBAT

The way your dragon fights provides the viewer with a wealth of information about its size, speed, and nature. Carefully consider what you need to convey about your dragon, including why, how, and where it is fighting, and what that tells us about it. The following pages showcase different scenarios, from the primal mano-a-mano combat to the battle of wits and magic and a wary gauging of opponents. Think about which side initiated combat and how your dragon might react to add subtle distinction to your work.

◄ *Maritime Melee,* **Jennifer Miller**
In this wonderfully delicate handling of line, form, and lighting, the largely greenish monochromatic palette allows the subtle traces of blood to read clearly, and connects the dragons to the ocean in a very direct way. The design of the dragons themselves strikes a great balance between being mirror images of each other and opposing forces.

Archwizard, **Jon Sullivan** ►
This fantastic composition depicts a battle between might and magic, between the strong hero and the unstoppable force. The dark vertical on the right echoes the strong shape of the figure, and the concentric rings of the steps form a visual shield, almost a barrier to the dragon's head. Between the steps and the horizontal line of the sword is a center of interest right at the juncture of the figure's magically glowing hand and the dragon's gaze, creating a wonderful tension and sense of impending conflict.

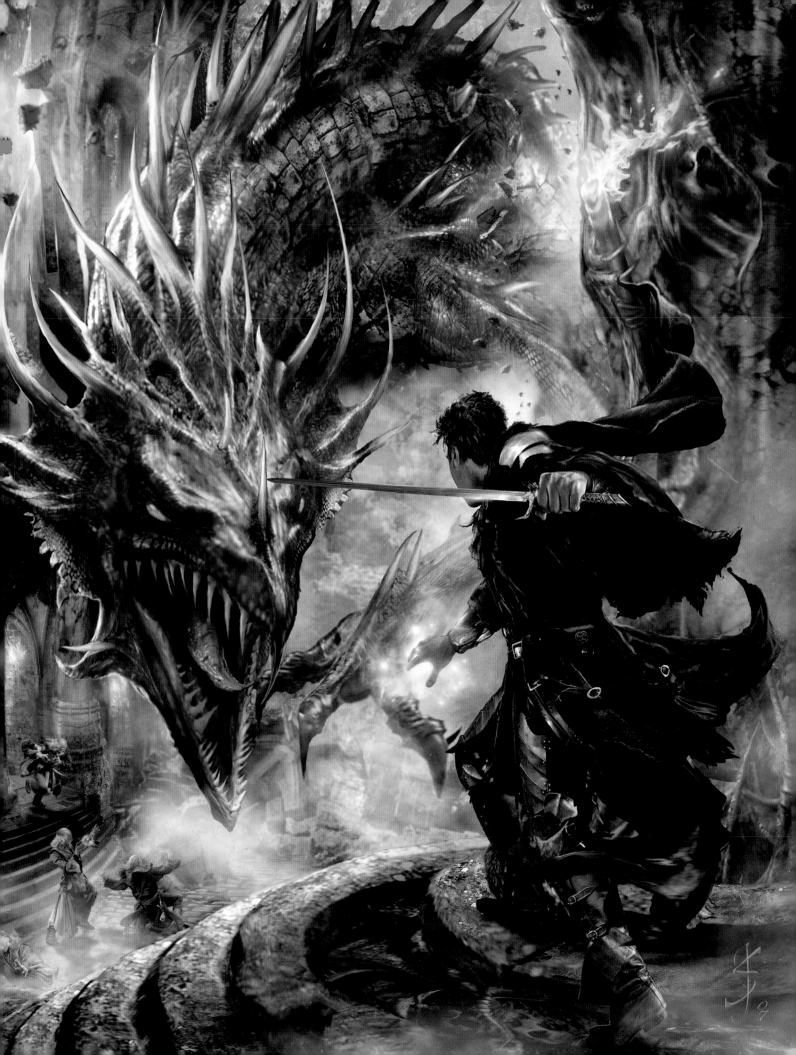

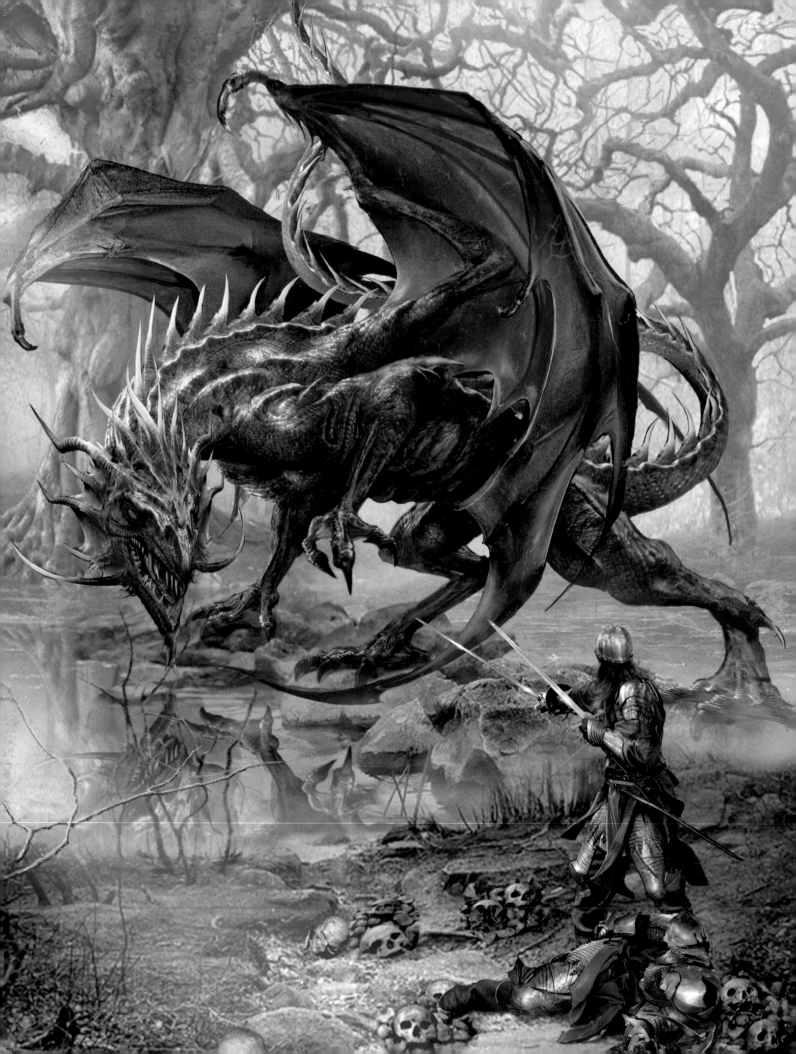

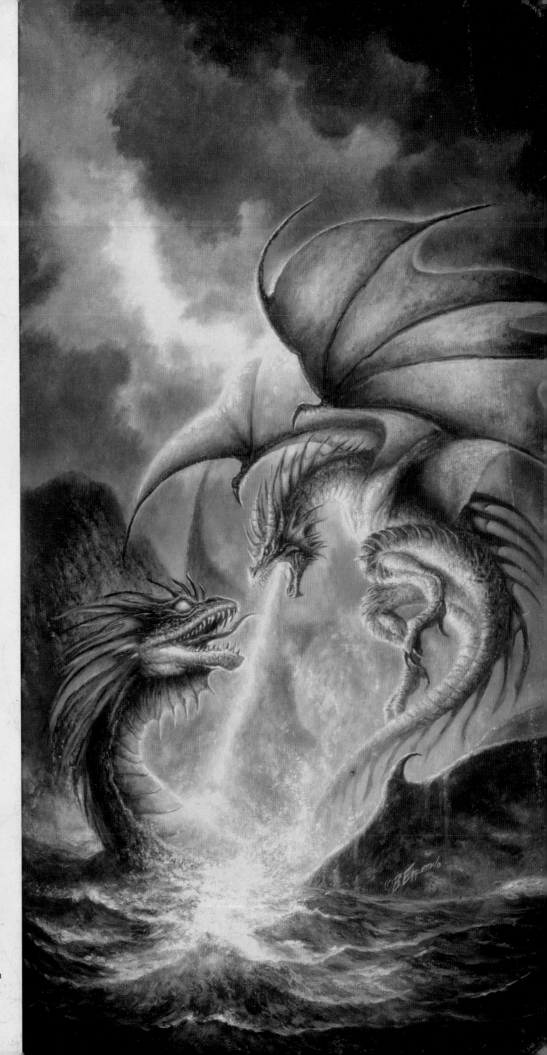

The Pass, Jon Sullivan

The two adversaries here warily circle and size each other up, gauging their strengths. Note how the composition creates two ovals that keep the eye moving around the picture plane: the first within the dragon itself, formed by the wings, the second between the dragon's and the warrior's heads, with the twin swords directing us back to the dragon. These ovals move the eye constantly around the image and between the two opposing forces, almost as if we as viewers are actively involved in the battle.

Dragon and Kraken, Bob Eggleton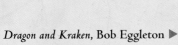

Depicted here is a strong symbolic and elemental conflict, not only between the two creatures but also between their respective elements. Note how the colors and textures of the sky and water are repeated in the dragon and kraken, respectively. The lights of the sky seem to flow into and through the dragon, becoming fire and flame, while the kraken seems to represent water made solid.

STORYTELLING

Learn to think of your dragons as characters in the story: as varied, as full of personality, and as unique as any person. You wouldn't cast the tall, thin librarian type for a Conan-style hero, at least not without good reason, and your dragons should be the same. How you paint scales or textures and horns or teeth, how your dragon flies, stands, or tilts its head—all these elements combine to give your dragon a unique personality and enable you to tell a story—your story—effectively.

◄ *Enchanter,* **Tom Kidd**
Here, the dragon stares off out of the painting, but strong highlights on the dragon's left wing lead the eye right toward the man's head, creating a dynamic tension. We would expect similarly strong lights on the man's head, the right tip of the throne, and his left arm, but these would compete with the highlights on the wing and stop the eye from moving about the image, eliminating the visual tension between figure and dragon.

Dragon Songs,
Rob Alexander ►
The closed mouth and intense focus of the dragon is at odds with its immense scale and creates an interesting story dynamic. Are the figure and the dragon partners or adversaries? By engaging the viewers with such questions, you hold their attention and direct it where you wish. Note how the curved spines of the outstretched wing bring the eye from the dragon's head and the runes down and back into the composition.

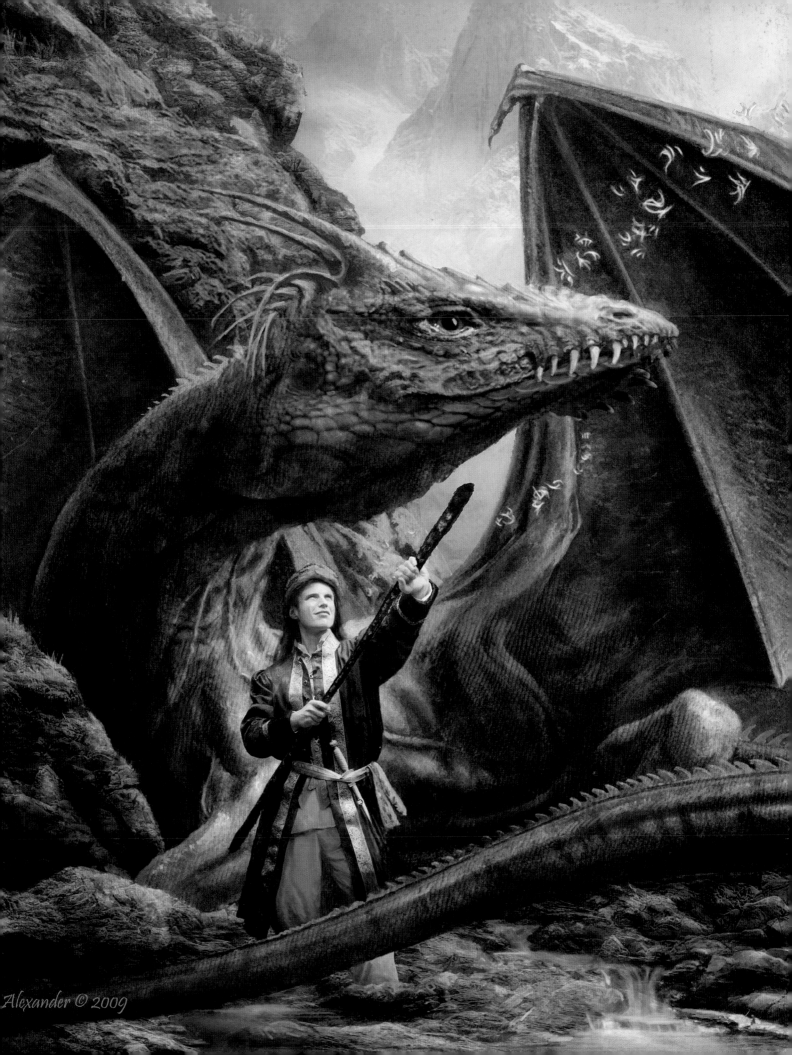

Alexander © 2009

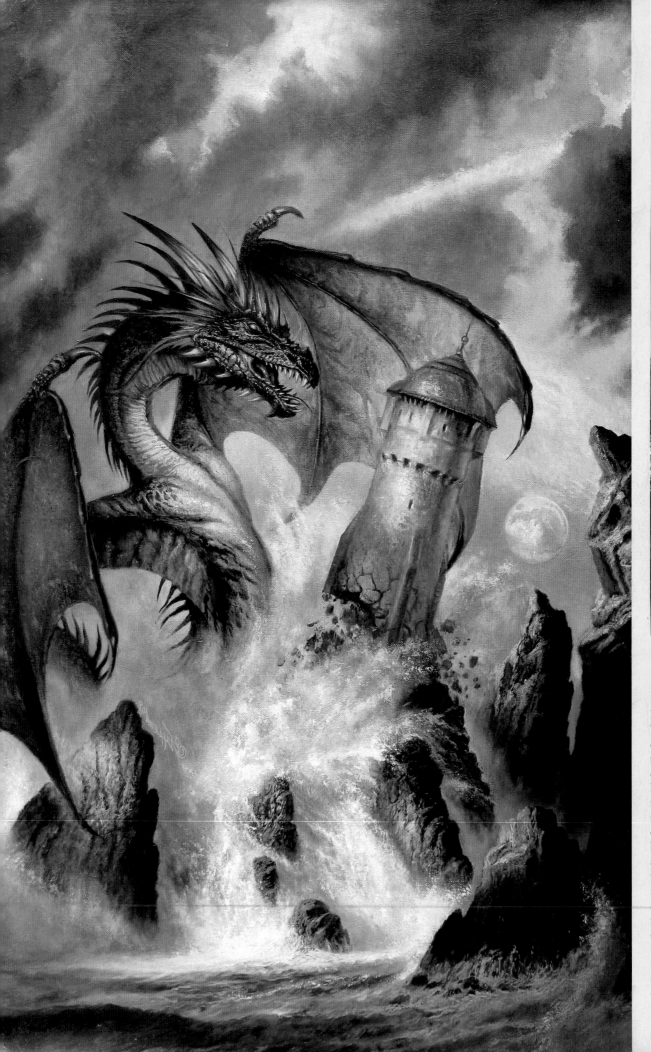

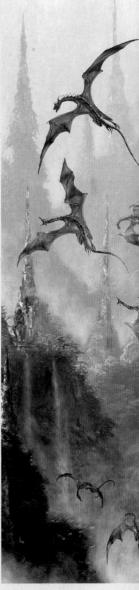

◀ *Dragon's Ring,*
Bob Eggleton
The arc of the
crashing waves and
the curves of the
dragon's wings and
body combine with
the rocks on the left
to drive the eye not
only to the tower,
but right through it,
as if the elemental
power of the dragon
is as unstoppable
as the sea. The
rocks on the right
echo the angle of
the falling tower,
further reinforcing
this suggestion
of power.

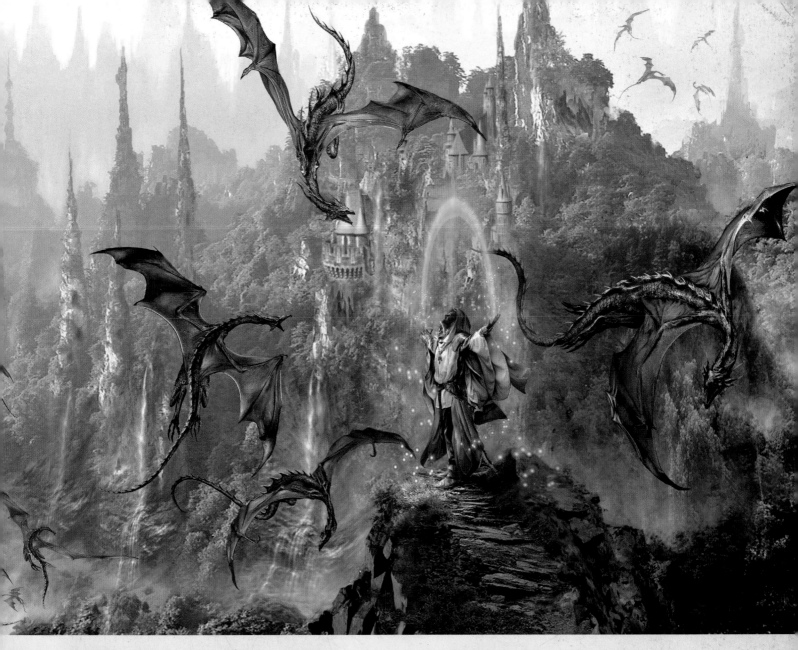

▲ *Whistle and They Will Come to You,* Jon Sullivan

The strong verticals of the background towers and waterfalls, and the well-established horizontals of the foreground rocks emphasize the curving, circular motions of the dragons, allowing them to stand out clearly. Because our eyes want to focus on the dragons' heads, the artist is able to lead us continually around the arch and wizard, creating a strong sense of motion and rhythm. Note how well each of the main dragon heads is set off against the background, allowing each to read clearly and direct our attention. Grouping the dragons into sets of four also adds depth and intrigue to the story of the piece, engaging the viewer's imagination.

EVERY HEAD TELLS A STORY

Just as with human subjects, our attention is most naturally drawn toward a dragon's head. We look for visual clues in the eyes, the set of the mouth or lips, or the tilt of the head to tell us about the personality and nature of the dragon. All the visual details begin to describe the dragon, and the portrayal can be as varied, interesting, and intimate as any human portrait. The four very different dragons here each have a distinct personality that we are able to discern clearly, in spite of often seeing no more than the dragon's head.

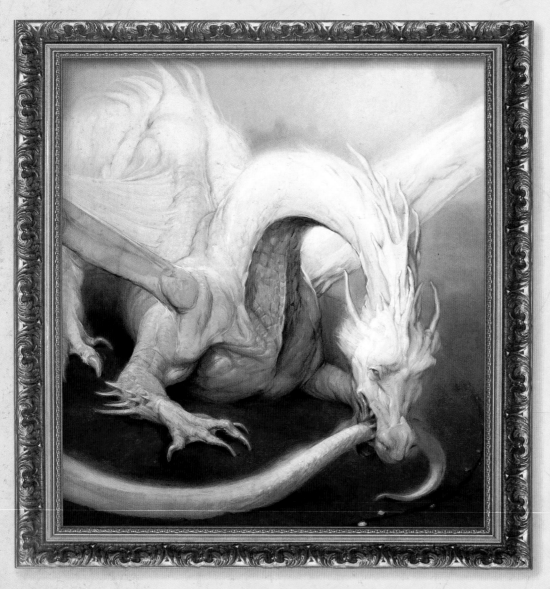

Earthquake, Eric Belisle ▶
A wonderfully unusual perspective and head design are the focus of this portrait. Strong, clear, and distinct edges and a powerful gesture draw all the attention to the descriptive dragon head. The colors of the body are allowed to fade and merge with the rocks of the foreground, further focusing the eye on the dragon's head, while the small birds passing by give scale and motion to the piece, even as the dragon stands rooted and proud.

▲ **Eternal Dragon, Adam Rex**
Here the head tells one story and creates another. The soft, subtle colors and values, the downcast expression, and the wrinkles around the eyes all convey a sense of age and an almost parchment-like frailty. Our eyes go first to the dragon's head, and we are forced to ask what the dragon is doing—why is it biting its tail, what is the circle on the ground, and does it imprison, protect, or bind the dragon? These questions immediately engage us in the image.

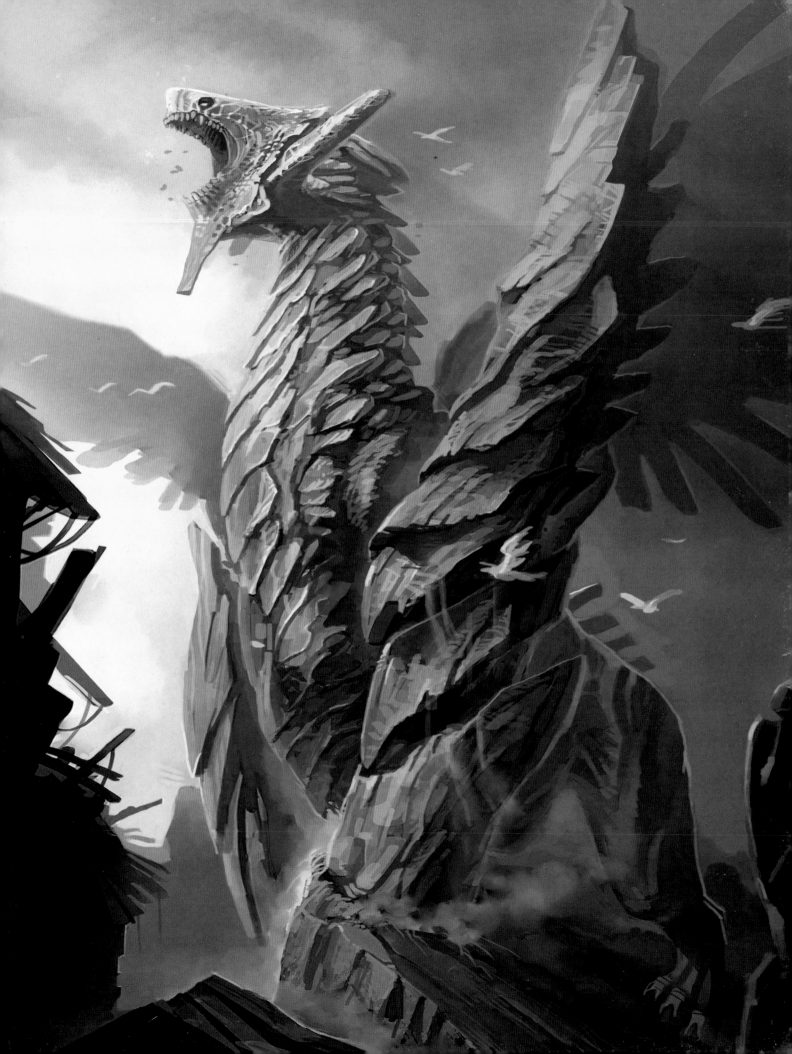

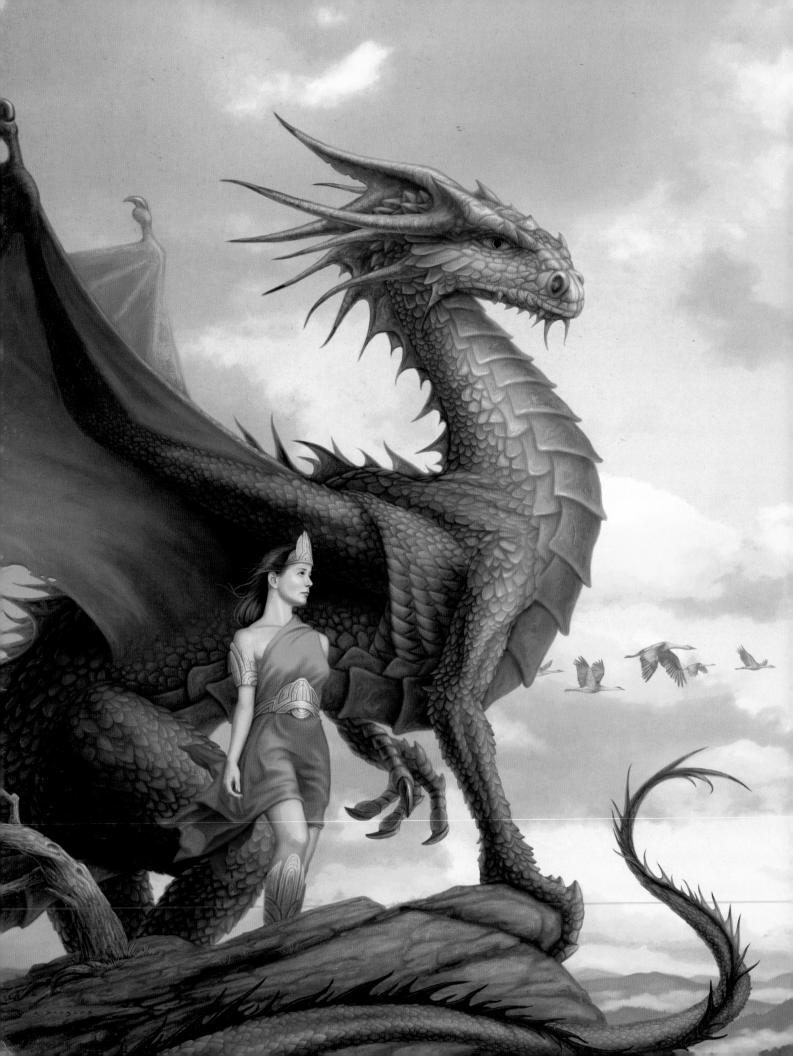

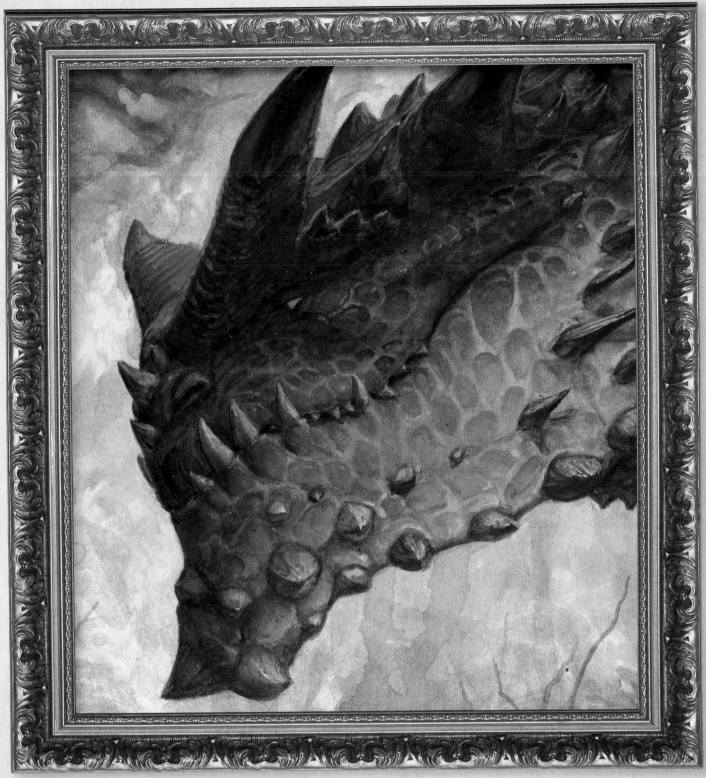

◄ *Winds of Hope*, **Alan Douglas**
The strong forearms, the graceful curve of the dragon's neck, and the tilt of its head all echo those of the female figure and imbue the dragon with strength, nobility, and intelligence, becoming both champion and protector. Note the deliberate repetition of shape between the figure's metallic adornments and the dragon's chest scales, as well as the fluid handling of her robe and the membrane of the dragon's wing, further connecting the two characters.

▲ *Sloth*, **Michael Phillippi**
So much can be revealed with just the eyes. The tight, narrow focus and intense stare convey such intelligence, purpose, and determination that they carry the entire painting. The overall design of the dragon's head—heavy, bony, and jutting forward—accentuate the message we get from the dragon's eyes to the point that we need to see no more. The light, warm background sets off the cool darks of the head, setting the stage for the small but crucial warm light of the eye in the midst of deep, dark shadows.

FLIGHT

Dragons are as varied as the creatures that inspire them, and their manner of flight is no exception. Ask yourself if your dragon is small, agile, and incredibly fast, or powerful and lumbering. Is the range and nature of motion realistic or fantastical, something based on real-world creatures or completely invented? Study the creatures that fly, glide, hover, and dive, paying close attention to wing size and shape, what portion of the body mass it encompasses, and the wing mechanics in order to convey exactly what you want.

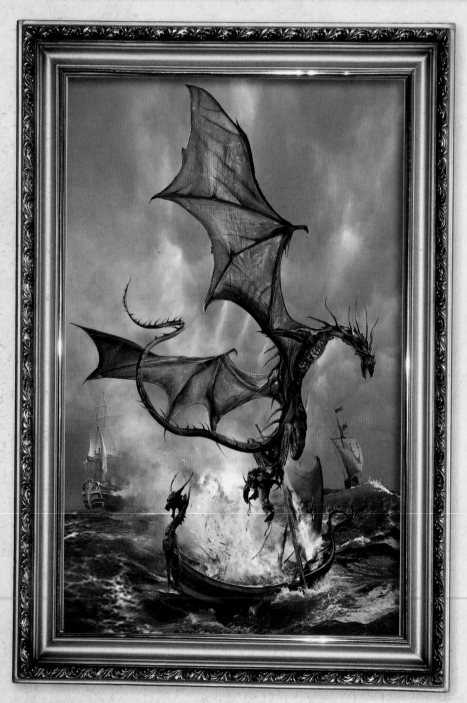

◀ *Saviour*, **Jon Sullivan**
Here is an excellent example of strong, natural flight. The long, lean lines and taut muscles of the dragon's legs, the whip-like motion of the tail, and the straining chest muscles all create a sense of strength, power, and determination as the dragon struggles to lift its burden. This is not a dragon powered by magic so much as by force of will. Note how the shapes of the dragon's wings and head echo those of the waves, while the body mimics the shapes in the sky, creating a visual repetition that unifies the composition while setting off the dragon effectively.

Flying Dragon, **Jan Patrik Krasny** ▶
The compacted, indrawn limbs, large dark shapes of the wings, and the arching of the body create a strong sense of mass and weight, suggesting that this dragon is heavy and ponderous. Placing the dragon at the bottom of the image area further reinforces the sense of the dragon's struggle to rise above the pull of gravity, as does the single-minded focus of the eyes and head. All together, they speak of simple, primal determination and effort to overcome the forces that fight to keep the dragon on the ground.

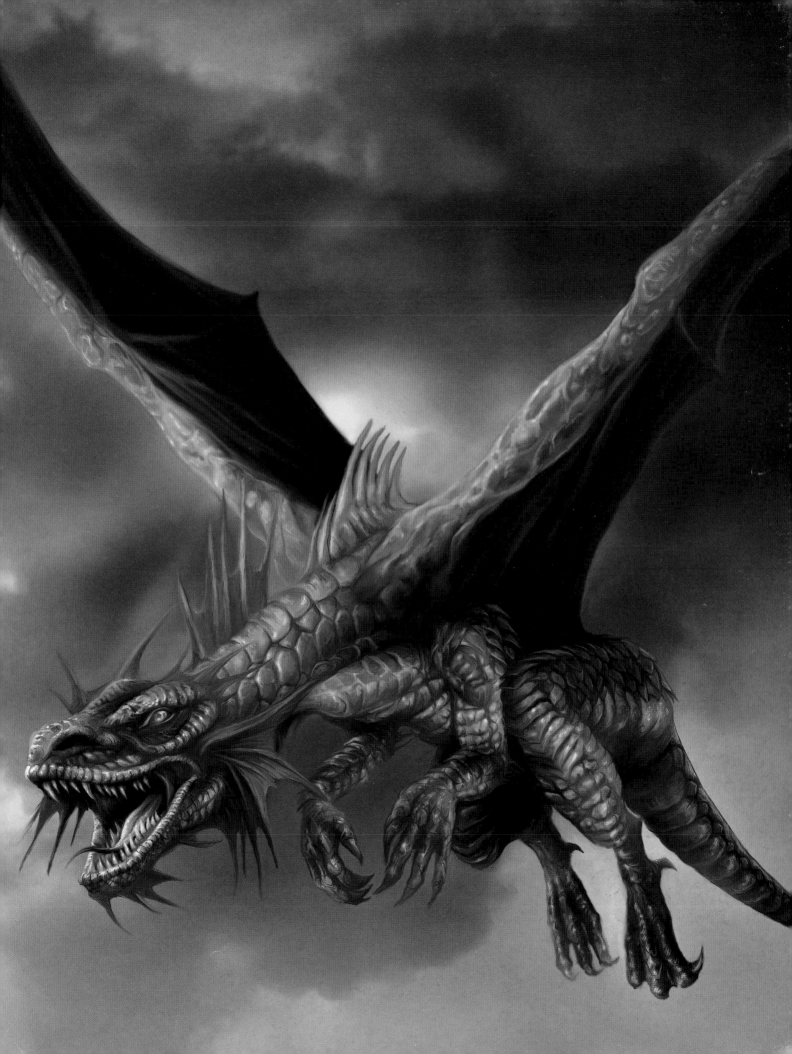

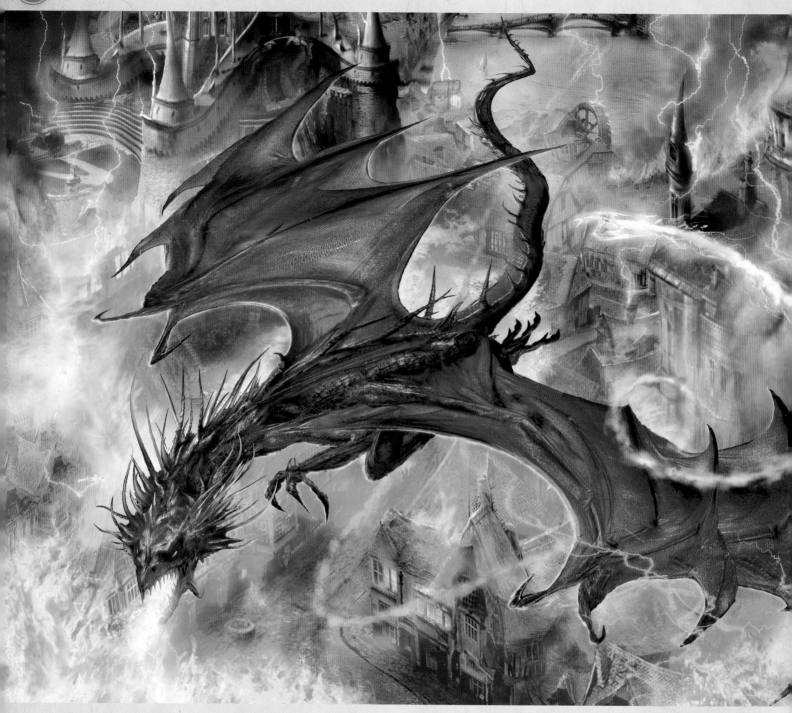

▲ *The Red Dragon—Discworld 2009 Calendar,* Jon Sullivan
The wide, flaring wings, lazy curves of the tail, and the dragon's horizontal attitude all convey the impression of a glider, a dragon much like an albatross or a large raptor, floating and circling, rather than being a particularly fast or powerful flier. Here is a dragon who will expend tremendous energy up front, perhaps flying very high, and then gliding and soaring for a long time on the currents, wreaking havoc as it descends.

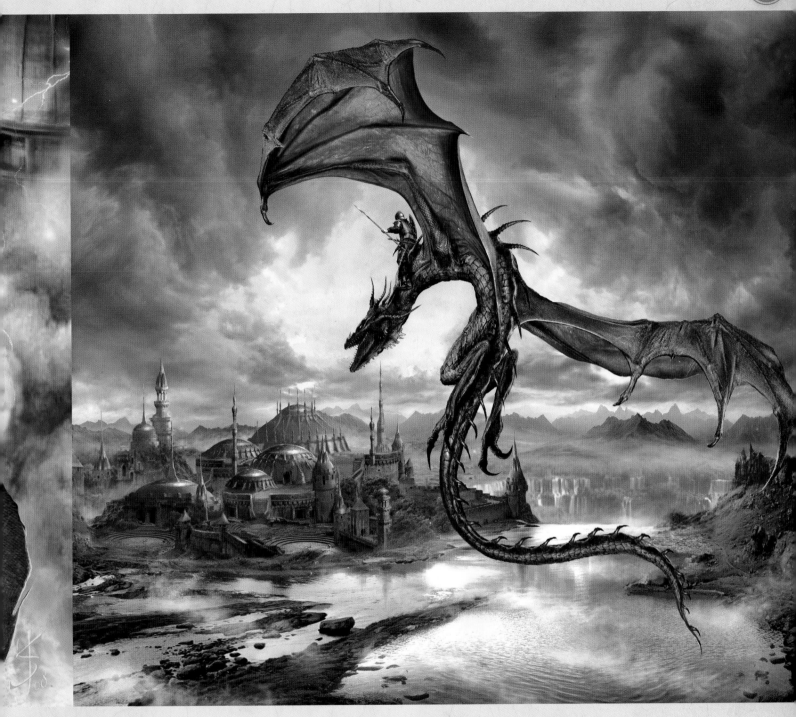

▲ *Solaris Fantasy Anthology,* Jon Sullivan

The sharp, serpentine curves of the dragon's tail and body, the arch of the neck, arcing wings, and relaxed but strong limbs all speak of speed and strength. This dragon is dexterous and agile, as fast as it is deadly, and perhaps more comfortable in the air than anywhere else. Its gesture brings to mind small, fast, and deadly hunters such as hawks and falcons.

CHARMED

Dragons are not all massive, fire-breathing creatures of destruction. Literature is full of examples where the dragon becomes a companion or friend, where the interaction between people and dragons is exciting but not threatening. Should this approach be what you need for your piece, define exactly what you want your picture to convey and ask yourself how best to show it.

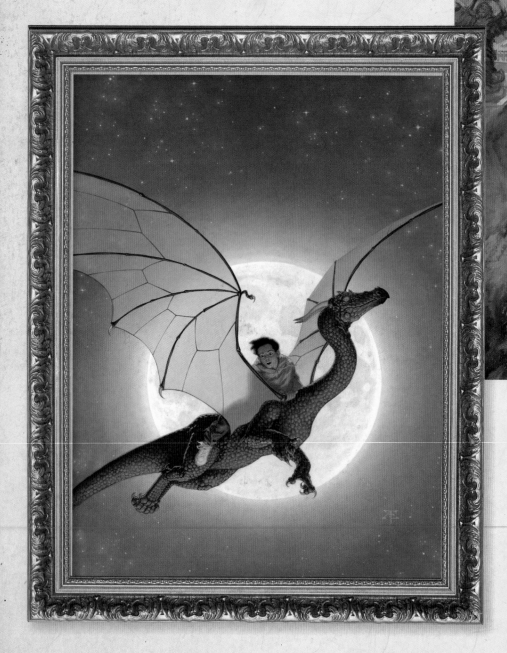

◄ *Dragonfly, **Tristan Elwell***
By combining familiar elements from several known animals, the artist has created a small, personal-sized dragon, more in keeping with a friend or beloved pet than a menacing terror. The arched, heron-like neck and the translucent fly- or butterfly-like wings create a dragon that is both approachable and inviting. The cool shadow of the boy creates a sense of translucency in the wing; and an area of contrast, cools to warms, draws the eye to the figure, who sits at the juncture of the two strong wing shapes, catching and holding the viewer's attention.

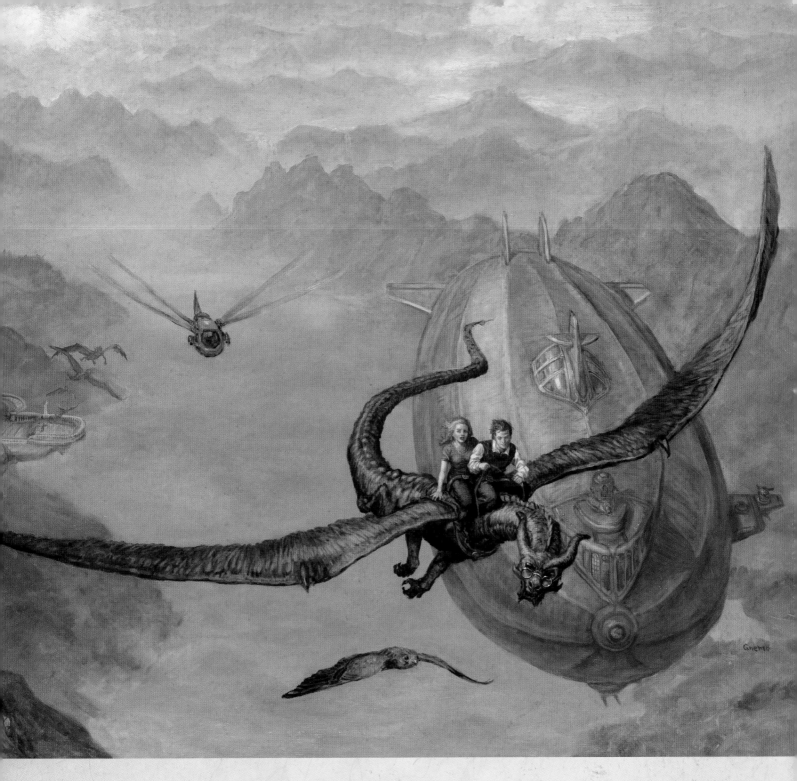

▲ *Starfinder,* **Tom Kidd**

The dragon in this piece is nonthreatening and whimsical. Notice how small it is, the spectacles it wears, its curious expression, and the cock of the head. Its personality is strengthened by the utopian-like setting and the effective use of body language, which tells us a lot about what the dragon's doing and feeling, and its role in the story. The warm colors of the dragon, while not overly warm or aggressive, still contrast to the cool colors of the foreground, bringing it forward and making it read clearly as the focus of the painting.

GREAT WYRMS

Given the mythological roots of dragons and how they are imagined by various cultures, there is an abundance of sources of body size, shape, and style to draw from. It's easy and tempting to create dragons with reptilian bodies, large bat wings, and pointed snouts over and over again, and while this can be very satisfying, it can also be limiting. Play with other body shapes and research how dragons are represented in other cultures to add depth and variety to your dragon designs, and perhaps create entirely new ones.

▼ *Riding High*, **Rob Alexander**

By combining seemingly disparate but familiar elements, the artist has created a believable dragon that rides the updraft of the waterfall, but with wings more reminiscent of underwater creatures, such as the manta ray. The large scale of the waterfall allows it to be reduced to an almost abstract series of verticals, and as the dragon cuts across them, the eye perceives and creates motion. Our natural tendency to move the eye from left to right brings us back into the picture and keeps the focus on the dragon without ever reducing the sense of motion in the dragon itself.

Wyrm, **Stanley Morrison** ▶

A strong, simple, and direct approach to dragon design is the great, wingless wyrm. This excellent composition shows the twisting, undulating curves of the body in such a way that they lead the viewer directly toward the dragon's head, where the subtle use of color in the eyes and the orange and lavender underbelly hold our attention. The lone tree provides a sense of scale and stillness in what is a very active composition.

Dragon
Templates

On the following pages are a collection of flat drawings of dragons, organized into the dragon types identified on pages 32–37. Use them to experiment with different concepts and overall approaches, or use them as a training tool to play with lighting, color schemes, focus, or points of interest, to help you define the characteristics of the dragon and the image that you want.

Serpents

Masters of the water or the air, these mighty serpents are often wingless, and those that fly do so because it's their nature to do so. This magical nature gives them a grace, fluidity, and effortless motion unrivaled by their more traditional counterparts, making them spiritual as well as dangerous.

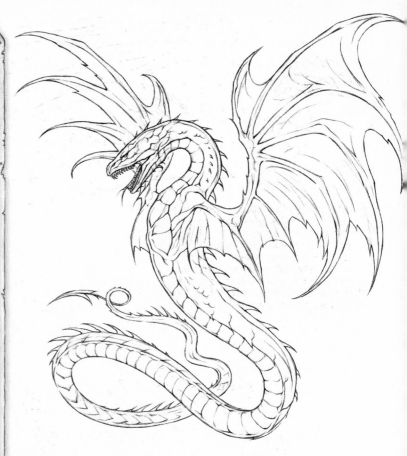

▲ The head is the most important, and most descriptive, part of the dragon, so you might start there, experimenting with colors and values. Once you're happy, carry that concept through the rest of your dragon, exploring different color schemes, value arrangements, or environments. You may find placing your dragon in an unusual environment creates unusual solutions and design choices for the dragon.

▼ Very common and popular in Chinese mythology, and often depicted in warm reds, oranges, and yellows, this dragon can also make an excellent study when taken out of context. Ask yourself what it would look like as a forest dragon or a swamp phantom, and allow your imagination to take flight.

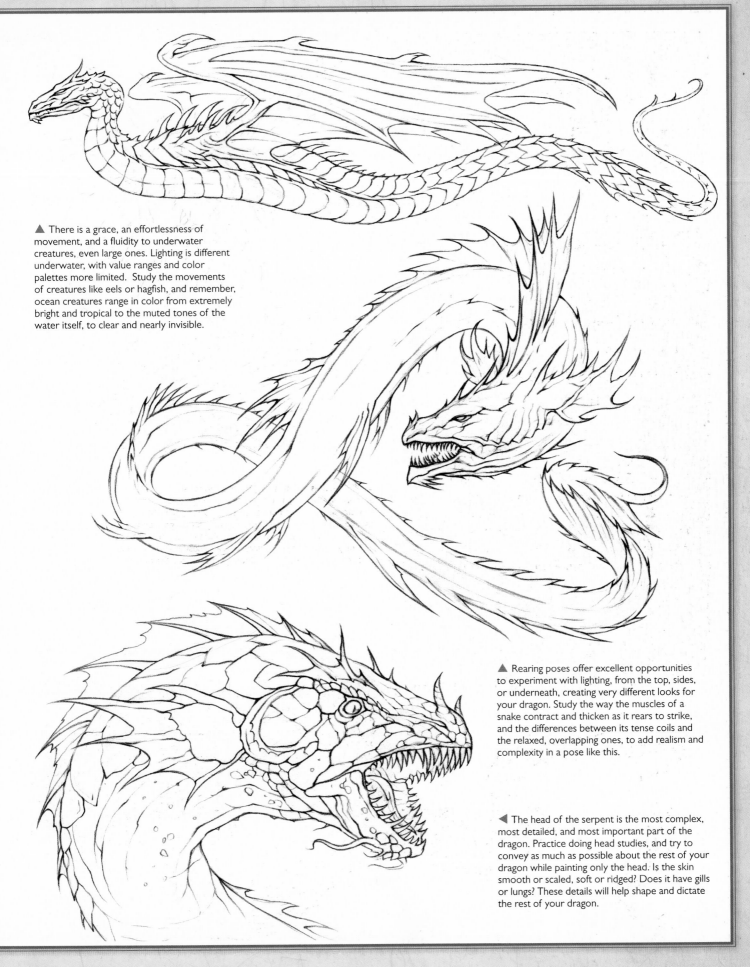

▲ There is a grace, an effortlessness of movement, and a fluidity to underwater creatures, even large ones. Lighting is different underwater, with value ranges and color palettes more limited. Study the movements of creatures like eels or hagfish, and remember, ocean creatures range in color from extremely bright and tropical to the muted tones of the water itself, to clear and nearly invisible.

▲ Rearing poses offer excellent opportunities to experiment with lighting, from the top, sides, or underneath, creating very different looks for your dragon. Study the way the muscles of a snake contract and thicken as it rears to strike, and the differences between its tense coils and the relaxed, overlapping ones, to add realism and complexity in a pose like this.

◄ The head of the serpent is the most complex, most detailed, and most important part of the dragon. Practice doing head studies, and try to convey as much as possible about the rest of your dragon while painting only the head. Is the skin smooth or scaled, soft or ridged? Does it have gills or lungs? These details will help shape and dictate the rest of your dragon.

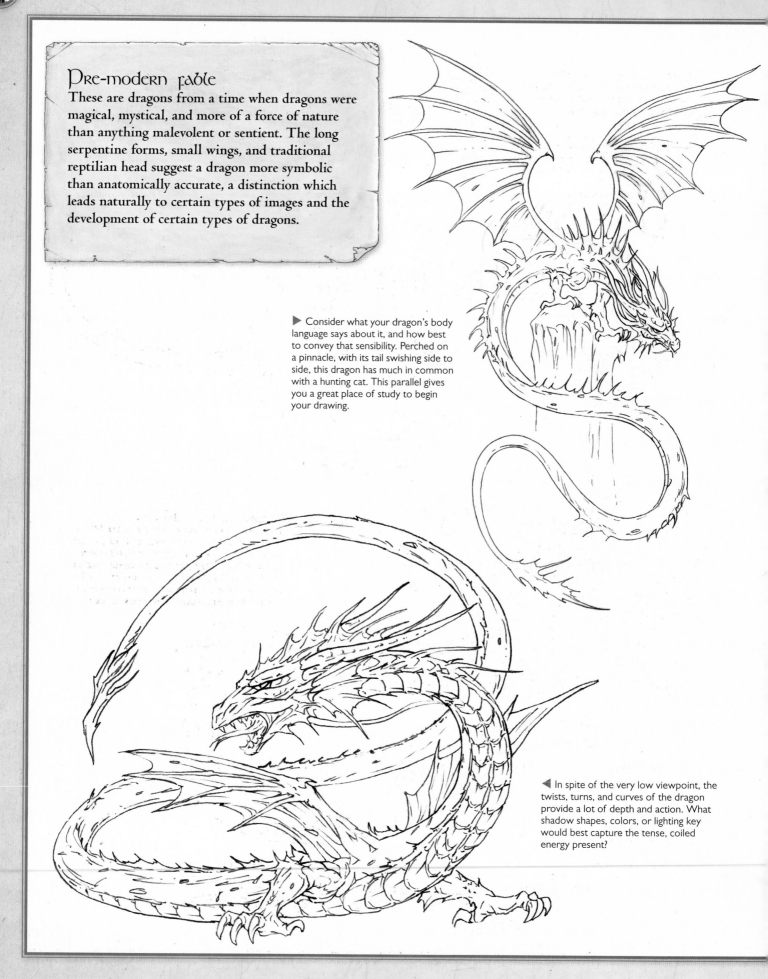

Pre-modern fable

These are dragons from a time when dragons were magical, mystical, and more of a force of nature than anything malevolent or sentient. The long serpentine forms, small wings, and traditional reptilian head suggest a dragon more symbolic than anatomically accurate, a distinction which leads naturally to certain types of images and the development of certain types of dragons.

▶ Consider what your dragon's body language says about it, and how best to convey that sensibility. Perched on a pinnacle, with its tail swishing side to side, this dragon has much in common with a hunting cat. This parallel gives you a great place of study to begin your drawing.

◀ In spite of the very low viewpoint, the twists, turns, and curves of the dragon provide a lot of depth and action. What shadow shapes, colors, or lighting key would best capture the tense, coiled energy present?

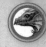

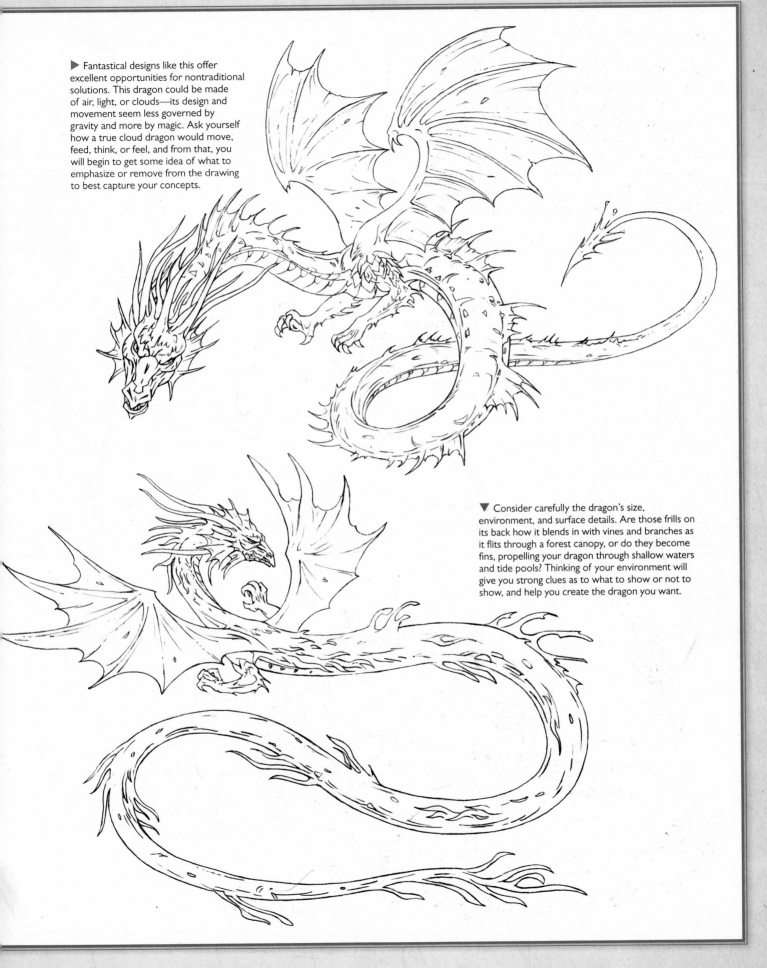

▶ Fantastical designs like this offer excellent opportunities for nontraditional solutions. This dragon could be made of air, light, or clouds—its design and movement seem less governed by gravity and more by magic. Ask yourself how a true cloud dragon would move, feed, think, or feel, and from that, you will begin to get some idea of what to emphasize or remove from the drawing to best capture your concepts.

▼ Consider carefully the dragon's size, environment, and surface details. Are those frills on its back how it blends in with vines and branches as it flits through a forest canopy, or do they become fins, propelling your dragon through shallow waters and tide pools? Thinking of your environment will give you strong clues as to what to show or not to show, and help you create the dragon you want.

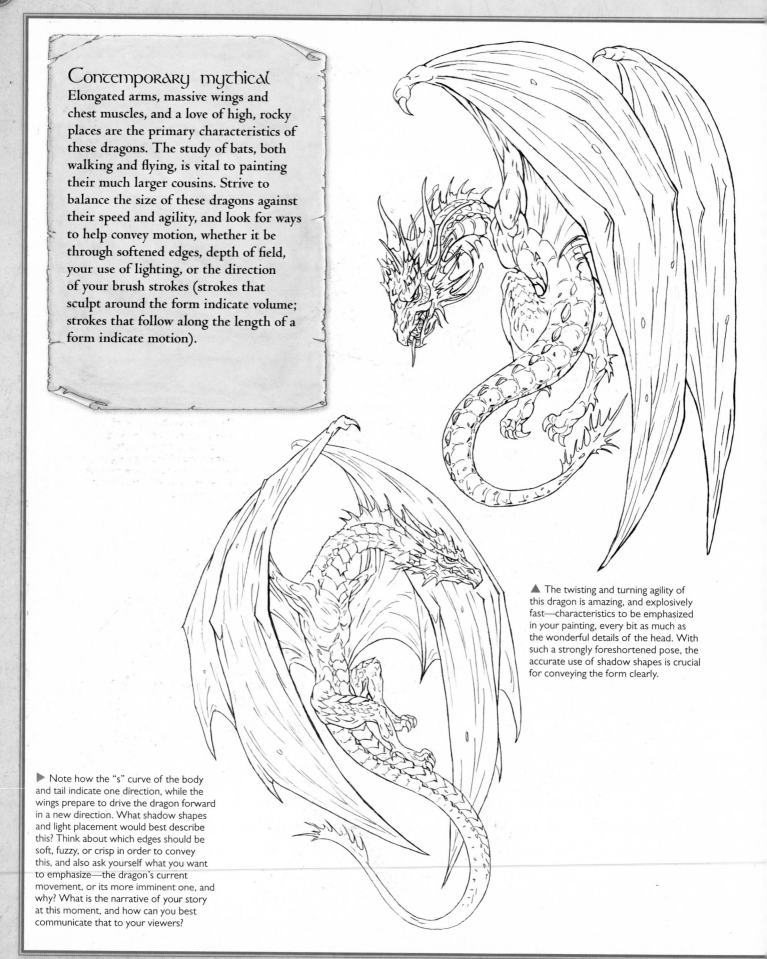

Contemporary mythical

Elongated arms, massive wings and chest muscles, and a love of high, rocky places are the primary characteristics of these dragons. The study of bats, both walking and flying, is vital to painting their much larger cousins. Strive to balance the size of these dragons against their speed and agility, and look for ways to help convey motion, whether it be through softened edges, depth of field, your use of lighting, or the direction of your brush strokes (strokes that sculpt around the form indicate volume; strokes that follow along the length of a form indicate motion).

▲ The twisting and turning agility of this dragon is amazing, and explosively fast—characteristics to be emphasized in your painting, every bit as much as the wonderful details of the head. With such a strongly foreshortened pose, the accurate use of shadow shapes is crucial for conveying the form clearly.

▶ Note how the "s" curve of the body and tail indicate one direction, while the wings prepare to drive the dragon forward in a new direction. What shadow shapes and light placement would best describe this? Think about which edges should be soft, fuzzy, or crisp in order to convey this, and also ask yourself what you want to emphasize—the dragon's current movement, or its more imminent one, and why? What is the narrative of your story at this moment, and how can you best communicate that to your viewers?

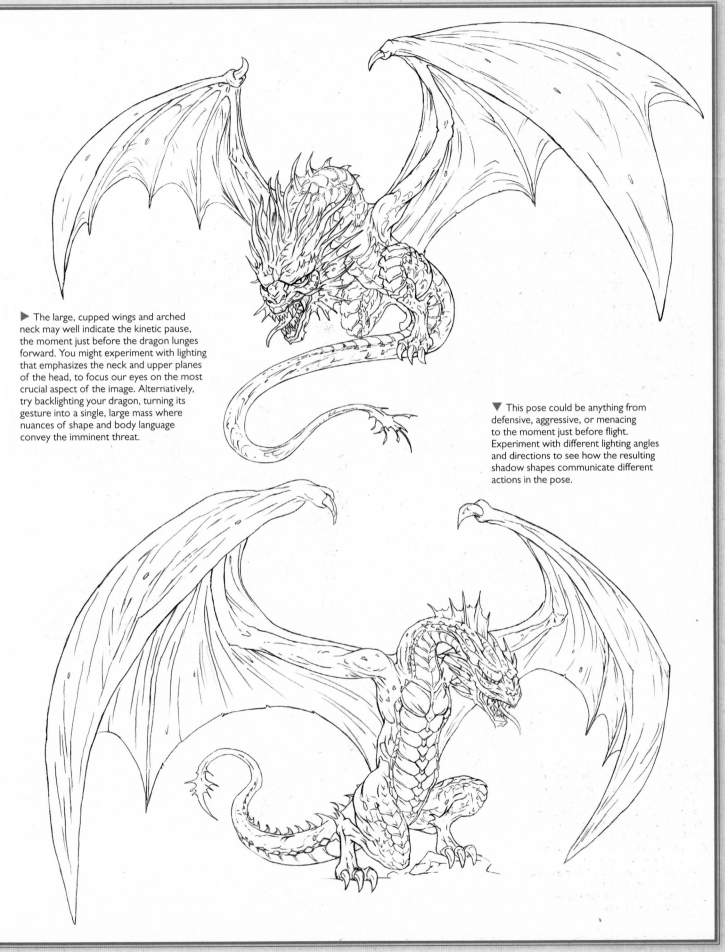

▶ The large, cupped wings and arched neck may well indicate the kinetic pause, the moment just before the dragon lunges forward. You might experiment with lighting that emphasizes the neck and upper planes of the head, to focus our eyes on the most crucial aspect of the image. Alternatively, try backlighting your dragon, turning its gesture into a single, large mass where nuances of shape and body language convey the imminent threat.

▼ This pose could be anything from defensive, aggressive, or menacing to the moment just before flight. Experiment with different lighting angles and directions to see how the resulting shadow shapes communicate different actions in the pose.

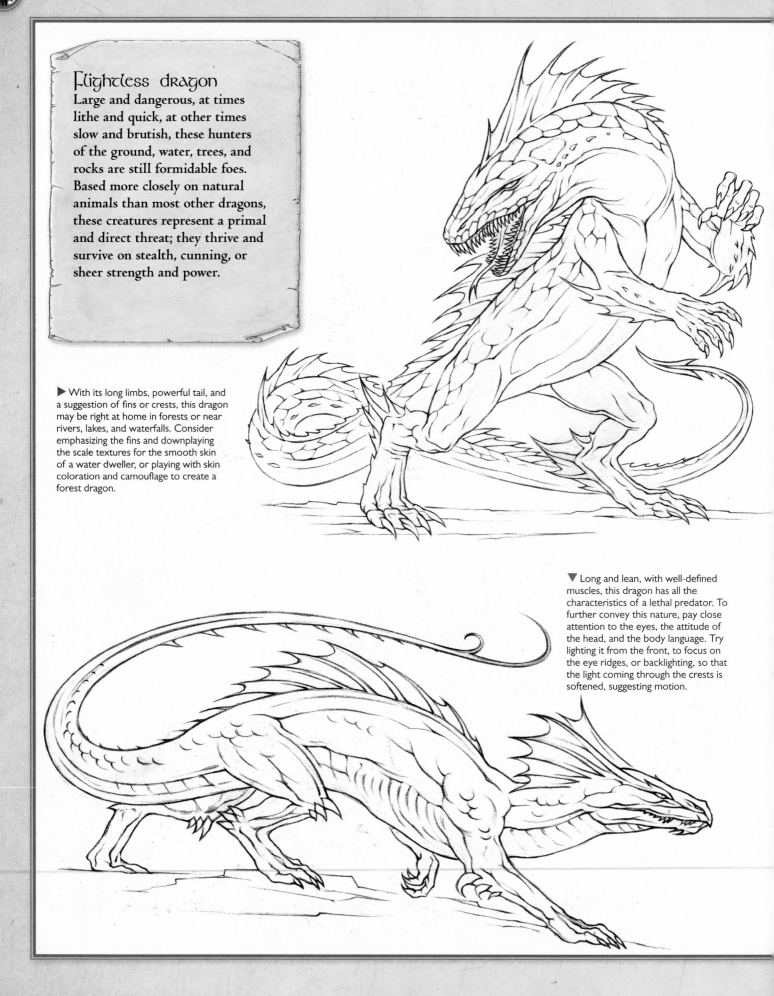

Flightless dragon

Large and dangerous, at times lithe and quick, at other times slow and brutish, these hunters of the ground, water, trees, and rocks are still formidable foes. Based more closely on natural animals than most other dragons, these creatures represent a primal and direct threat; they thrive and survive on stealth, cunning, or sheer strength and power.

▶ With its long limbs, powerful tail, and a suggestion of fins or crests, this dragon may be right at home in forests or near rivers, lakes, and waterfalls. Consider emphasizing the fins and downplaying the scale textures for the smooth skin of a water dweller, or playing with skin coloration and camouflage to create a forest dragon.

▼ Long and lean, with well-defined muscles, this dragon has all the characteristics of a lethal predator. To further convey this nature, pay close attention to the eyes, the attitude of the head, and the body language. Try lighting it from the front, to focus on the eye ridges, or backlighting, so that the light coming through the crests is softened, suggesting motion.

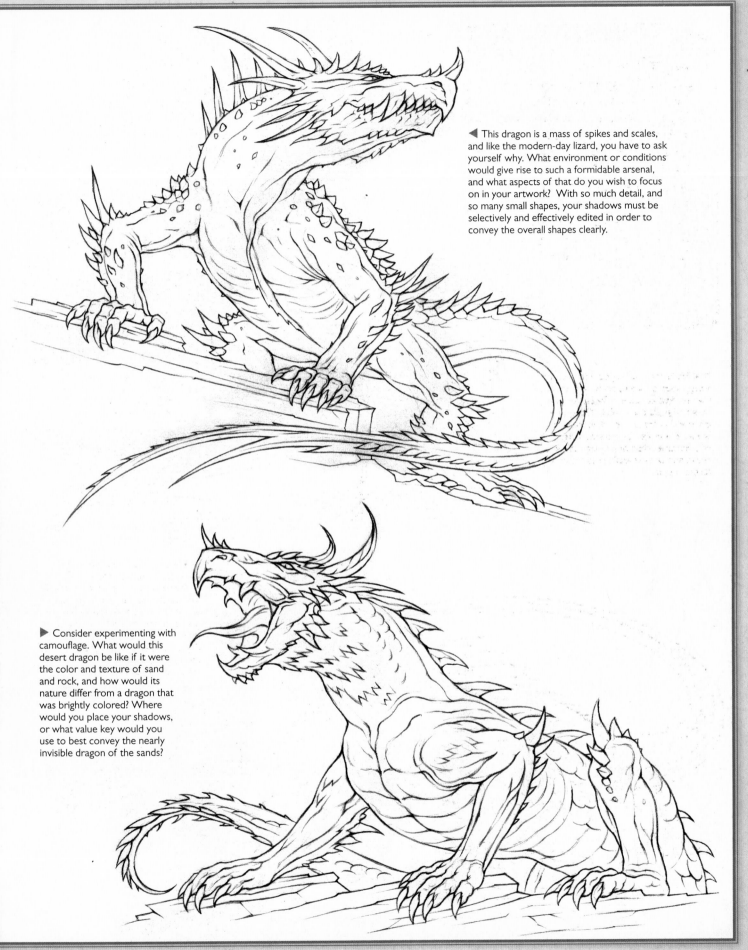

◀ This dragon is a mass of spikes and scales, and like the modern-day lizard, you have to ask yourself why. What environment or conditions would give rise to such a formidable arsenal, and what aspects of that do you wish to focus on in your artwork? With so much detail, and so many small shapes, your shadows must be selectively and effectively edited in order to convey the overall shapes clearly.

▶ Consider experimenting with camouflage. What would this desert dragon be like if it were the color and texture of sand and rock, and how would its nature differ from a dragon that was brightly colored? Where would you place your shadows, or what value key would you use to best convey the nearly invisible dragon of the sands?

Legendary classic

These are the true mythological dragons, intelligent and fearsome. Combining traits of lions, lizards, dinosaurs, and bats, they become something greater than the sum of their parts. Let your imagination reign when approaching these classics, and let your inner eye guide the design, staying true to the spirit, rather than any specific reference.

▶ Start with a strong, clear concept, and be sure all your design choices support it. This dragon is turning, its back arched in attack. Try choosing your values to emphasize motion, aggression, and attack, rather than anatomy, and consider what will most clearly convey these aspects of your dragon.

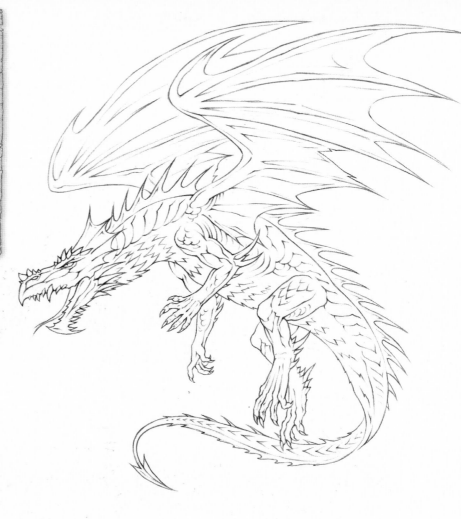

▼ As comfortable and as formidable on the ground as in the air, your dragon should pose a threat and a danger, even standing still. Study large predators in nature, and strive to capture the essence of the grace and power of these mighty hunters in your own dragons.

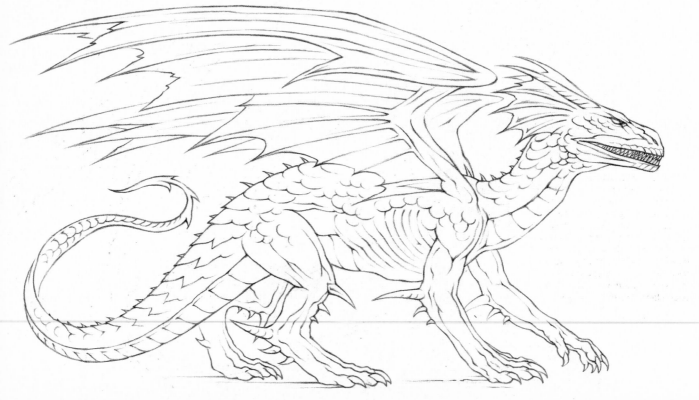

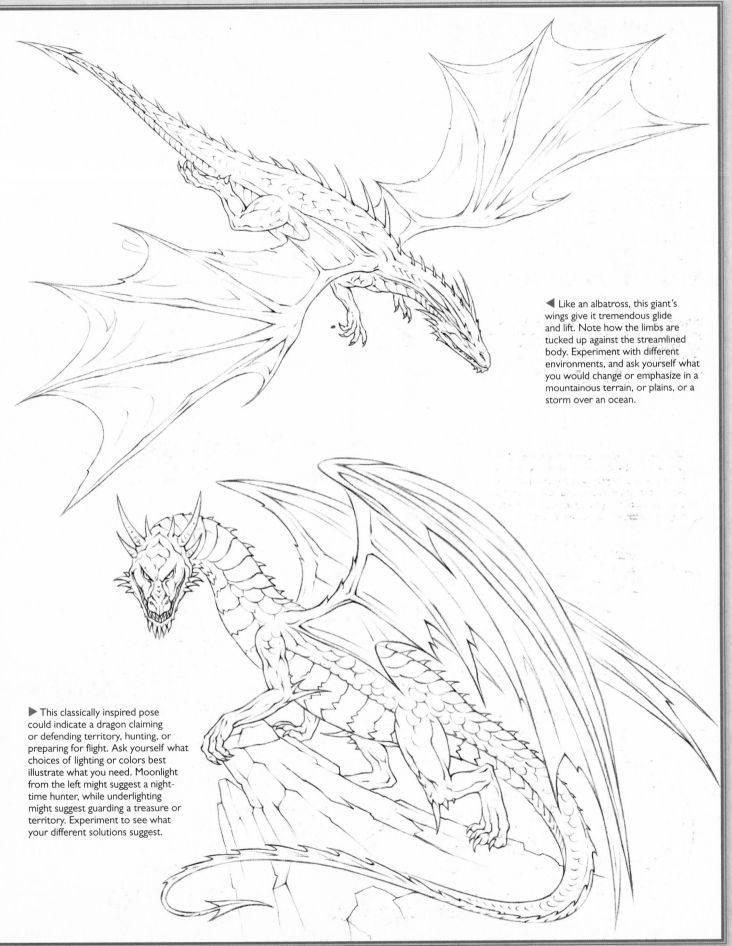

◀ Like an albatross, this giant's wings give it tremendous glide and lift. Note how the limbs are tucked up against the streamlined body. Experiment with different environments, and ask yourself what you would change or emphasize in a mountainous terrain, or plains, or a storm over an ocean.

▶ This classically inspired pose could indicate a dragon claiming or defending territory, hunting, or preparing for flight. Ask yourself what choices of lighting or colors best illustrate what you need. Moonlight from the left might suggest a night-time hunter, while underlighting might suggest guarding a treasure or territory. Experiment to see what your different solutions suggest.

INDEX

2 1982 02770 9702

CREDITS

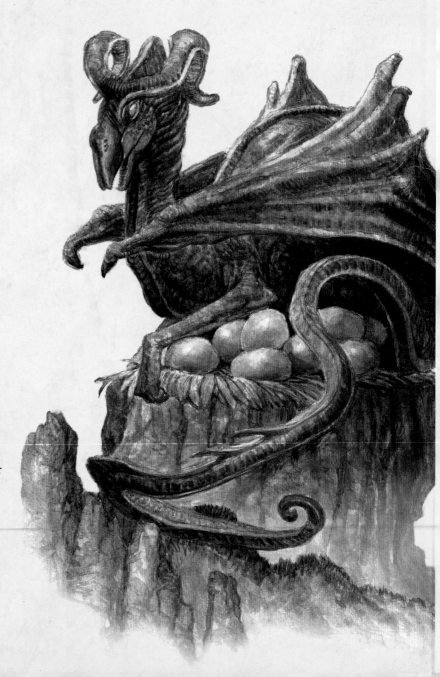

Quarto would like to thank the following for kindly supplying images for inclusion in this book:

- p. 96 Jennifer Miller,
 http://jensdragons.daportfolio.com/
- pp. 97, 98, 103, 108, 110–111 Jon Sullivan,
 www.jonsullivanart.com
- pp. 99, 102 Bob Eggleton
- pp. 100, 103 Tom Kidd,
 http://spellcaster.com/tomkidd/
- pp. 56, 101, 114 Rob Alexander,
 www.robalexander.com.

The image on page 101 first appeared in *The World of Shannara* by Terry Brooks and Teresa Patterson, published by Del Rey Books (© Del Rey Books). The image on page 114 © Wizards of the Coast LLC. Wizards of the Coast and Magic: The Gathering are trademarks of Wizards of the Coast LLC. Images used with permission of Wizards of the Coast LLC.

- p. 104 Adam Rex, © Wizards of the Coast LLC. Wizards of the Coast and Magic: The Gathering are trademarks of Wizards of the Coast LLC. Images used with permission of Wizards of the Coast LLC.
- p. 105 Eric Belisle, www. ericbelisle.com
- p. 106 Alan Douglas.
 www.allendouglasstudio.com
- p. 107 Michael Phillippi,
 www.slothproductions.com
- p. 109 Jan Patrik Krasny, http://krasnyart.eu
- p. 112 Tristan Elwell
- p. 115 Stanley Morris

We would also like to thank Rob Alexander for additional text, Dimitar Nikolov for his contribution to the Color article (pages 68–71), and both Dimitar and Jan Patrik Krasny for their contribution to the Dragon Templates (pages 116–125).

While every effort has been made to credit contributors, Quarto would like to apologize should there have been any omissions or errors—and would be pleased to make the appropriate correction for future editions of the book.